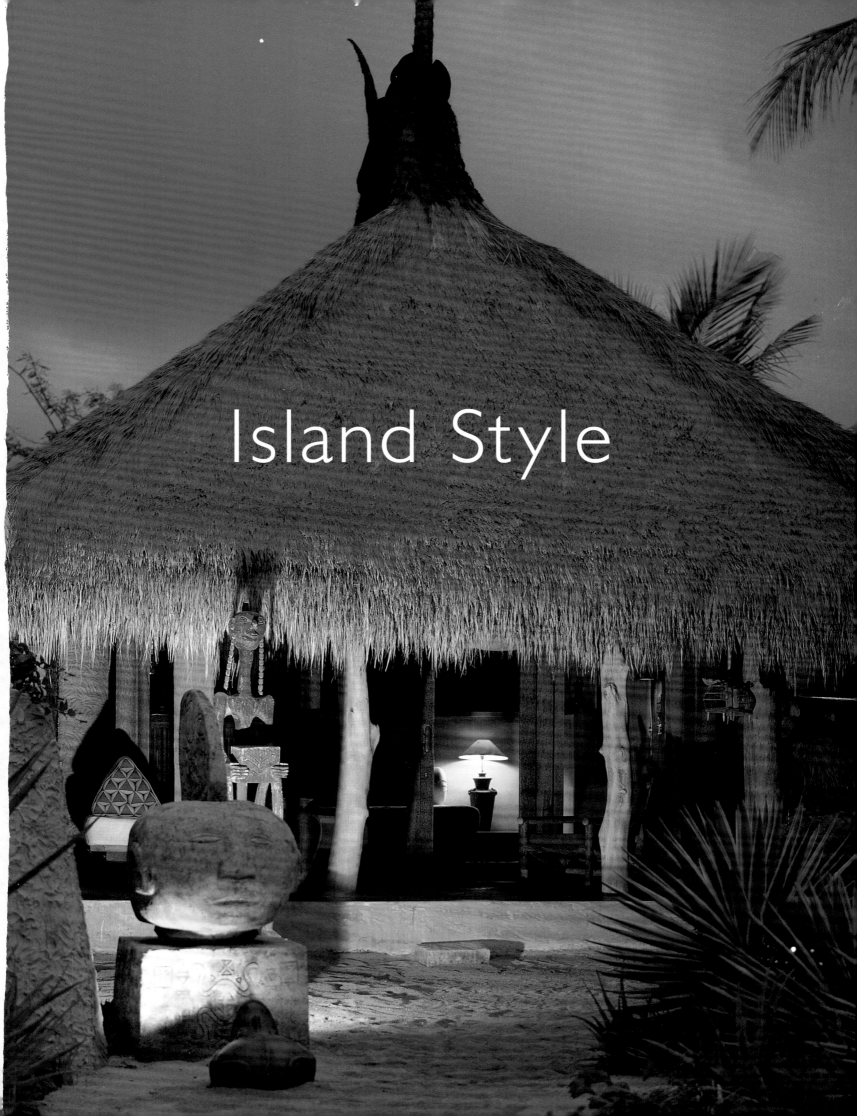

Island Style

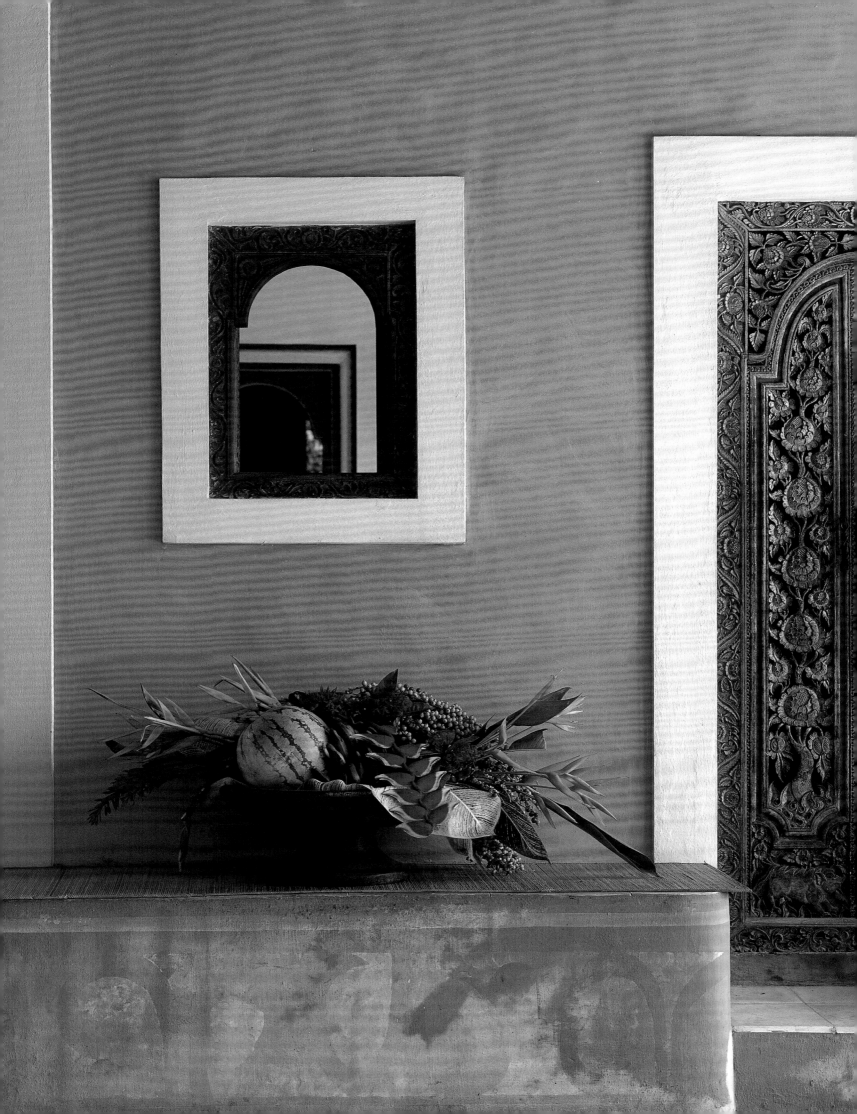

Island Style

Tropical Dream Houses in Indonesia

text by Gillian Beal
photos by Jacob Termansen

PERIPLUS

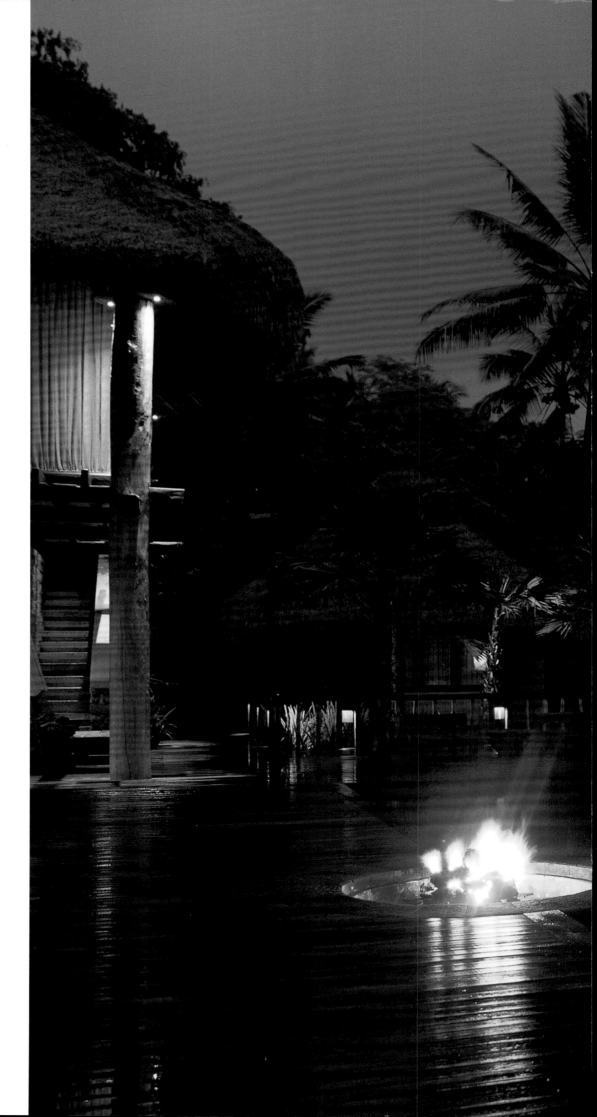

Published by Periplus Editions
with editorial offices at 130 Joo Seng Road
#06-01, Olivine Building
Singapore 368357

ISBN 962-593-415-4

Printed in Singapore

Creative director: Christina Ong
Editor: Kim Inglis
Assistant editor: Jocelyn Lau
Styling: Pia Marie Molbech
Designers: Loretta Reilly, Felicia Wong

Distributors:
North America, Latin America and Europe
Tuttle Publishing, Distribution Center,
Airport Industrial Park,
364 Innovation Drive,
North Clarendon,
VT 05759-9436, USA
Tel (802) 773 8930; fax (802) 773 6993

Asia Pacific
Berkeley Books Pte Ltd,
130 Joo Seng Road, #06-01/03,
Olivine Building, Singapore 368357
Tel (65) 280 3320; fax (65) 280 6290

Japan and Korea
Tuttle Publishing,
RK Building, 2nd Floor,
2-13-10 Shimo-Meguro,
Meguro-Ku, Tokyo 153, Japan
Tel (813) 5437 0171; fax (813) 5437 0755

Indonesia
PT Java Books Indonesia,
Jl. Kelapa Gading Kirana,
Blok A14 No. 17, Jakarta 14240
Indonesia
Tel (62-21) 451 5351; fax (62-21) 453 4987

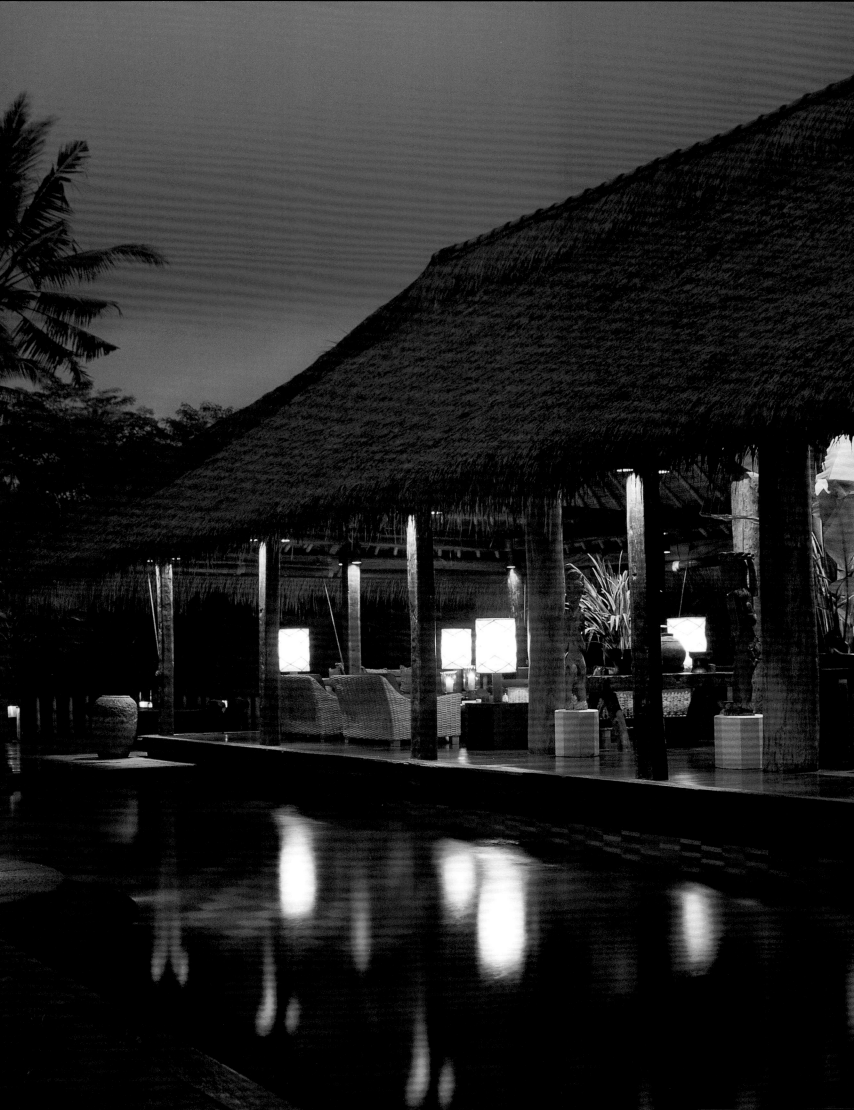

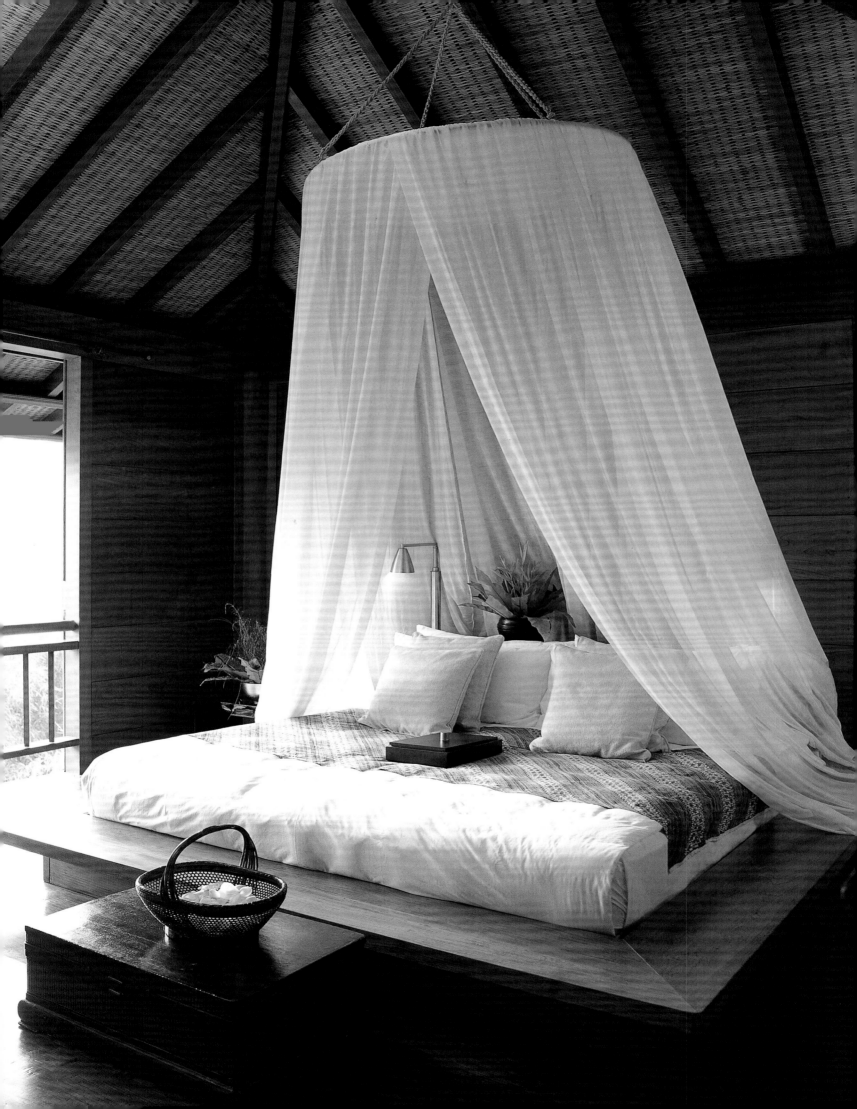

contents

island dream houses

"In Xanadu did Kubla Khan
A stately pleasure-dome decree
Where Alph the sacred river ran
Through caverns measureless to man
Down to a sunless sea ..."
– Kubla Khan, S.T. Coleridge

When you first visit Indonesia as a tourist, which usually means a stay on Bali or Java, you find yourself imagining what it would be like to live there—permanently. I know I did. I surprised myself by turning the dream into a reality when, five years after my initial visit to Bali, I threw caution to the wind, packed in my career and moved to the mountain village of Ubud.

As I got to know the island better, I quickly realized I was in illustrious company; that many people before me had fallen in love with this tropical idyll and its kaleidoscopic culture. Many more had started their journey in Java, and had settled there. But while I had been content to rent a house, I met people with a grander vision. Deciding that Indonesia would be their permanent home, they bought land and built their own houses—some simple, fashioned after the local architectural style, others more elaborate, drawing on their own vivid imaginings.

What these people—and the others I met throughout the archipelago during research for this book—have in common was an ability to dream on a grand scale. Men and women of vision, not frightened to embrace change, with the courage to build extraordinary houses within an extraordinary land; to draw on the past and reduce its many lessons into a contemporary composite made potent by individual fantasy.

Looking back, it is easy to see how Indonesia can work its magic. American Robert Koke, writing in a magazine article that vividly captures his time on the island of Bali with his wife Louise, describes his feelings on first visiting the island in the 1930s: "One day when we were exploring on our hired bicycles, we pedalled through a coconut grove to come out on the most beautiful beach in the world: clear surf lapping miles of white sand fringed with palms, and no trace of human habitation as far as the eye could see.

"Within just three weeks we had leased part of the beach, and in four months we had built on it the Kuta Beach Hotel. We built it in the native style—little guest houses of bamboo and thatched roofs, bamboo furniture and batik cushions and couch covers. The Dutch tourist agents snorted their disapproval and described our hotel as a collection of dirty native huts, but that description seemed to do us more good than harm... soon we were turning guests away."

More than a century earlier Sir Stamford Raffles, Lieutenant-Governor of Java between 1811 and 1816 and the man credited with the creation of much of the archipelago's colonial architecture, entertained similar fantasies. Choosing not to live in the stifling heat and ill-health of Batavia, now the capital of Jakarta, he made his primary residence in the cool Javanese mountain resort of Bogor, where he instigated the planting of the world-renowned Botanic Gardens.

Raffles described the view from his window thus: "A prospect of the most delightfully picturesque scenery. The descent from the house almost precipitate—in the bottom of a valley filled with rice, with a romantic little village at the beginnings of a stream which rushes down by twenty torrents and roars booming over rocks innumerable; in the background a magnificent range of mountains, wooded to the top and capped in clouds, the nearest not more than 20 miles off; nothing indeed can exceed the beauty of the scene."

It is the stunning natural aspect of Indonesia and the 13,677 islands that make up the archipelago that go some way to explaining what captures so many people's minds and hearts. Blessed with a tropical climate, the landscape that greets the first-time visitor is the stuff that dreams are made of. Rousseau-esque images of swaying palms, lush green foliage, unspoiled tropical beaches, exotic cultures, friendly people—all contribute to the magic of Indonesia.

And then there are the volcanoes. Indonesia is home to over 400 of them, many of which are still active. Indeed, most Indonesians live—and die—within sight of a volcano. A British writer, Anna Mathews, in her book *The Night of Purnama*, provided an account of the 1963 eruption of Bali's imposing volcano, Gunung Agung. She describes the view from her terrace in the mountain village of Iseh in north Bali: "Once you have lived in this place," she wrote, "you can never be the same again. You are driven mad by beauty."

Volcanoes play their part in many of the developments featured in this book. Both the coffee plantation Losari and the super-deluxe hotel Amanjiwo are surrounded by a ring of these majestic mountains, and both have views of the active Merapi. At night, seeing the red glow of molten lava flowing down from the cone adds to the mystery of what has become known as "The Ring of Fire".

The story behind Indonesian designer Jaya Ibrahim finding a site for his house Cipicong at Bogor also features a volcano and is as romantic as his magnificent villa. When he lived in London in the 1980s, he was captivated by an early Dutch painting of Gunung Salek at Christie's. Although he lost the painting at auction, the image always stayed with him and it was within the shadow of the same mountain that he chose to build his weekend retreat.

The islands have always attracted aesthetes and artists who build stunning island retreats, the prerequisite for the property being an inspiring view. One of the most famous was German painter and musicologist Walter Spies, who originally spent time as a court musician for the Sultan of Yogjakarta. He moved from Java to Bali in 1927 and built in the hills of Ubud. It became a stopping off point for rich and often titled guests—Barbara Hutton, Charlie Chaplin, Noel Coward….

Louise Koke describes her first visit to his Ubud home —now part of the Campuhan Hotel—in her delightful memoir *Our Hotel in Bali*. "A dark brown two-storey house clung to the side of a steep ravine. Dense foliage screened it from the road and made a secret stillness. Below the house an oval swimming pool lay half hidden among the trees, fed by a bamboo pipe from a hillside spring. The house was decorated with Balinese paintings and antique carvings. The servants bought a low table laden with bottles, glasses and ice and set it in the water at the shallow end of the pool. I sat up to my waist in the cool, mountain water… imagining what exotic parties could take place in that hidden ravine. At night the wooded slope would be mysteriously lit by burning wicks set in hanging coconut shells. Metal threads in the servants' garments would shimmer in the warm glow. The air would be a little heavy with burning incense, and with the odour of coconut oil in freshly washed anointed hair."

These days much of what those early explorers found so beguiling about Indonesia continues to fascinate today's dreamers. This book is full with their tales. Take, for example, English couple Bradley and Debbie Gardner. Their journey started when they fell in love with a piece of land situated between two rivers north of the Balinese

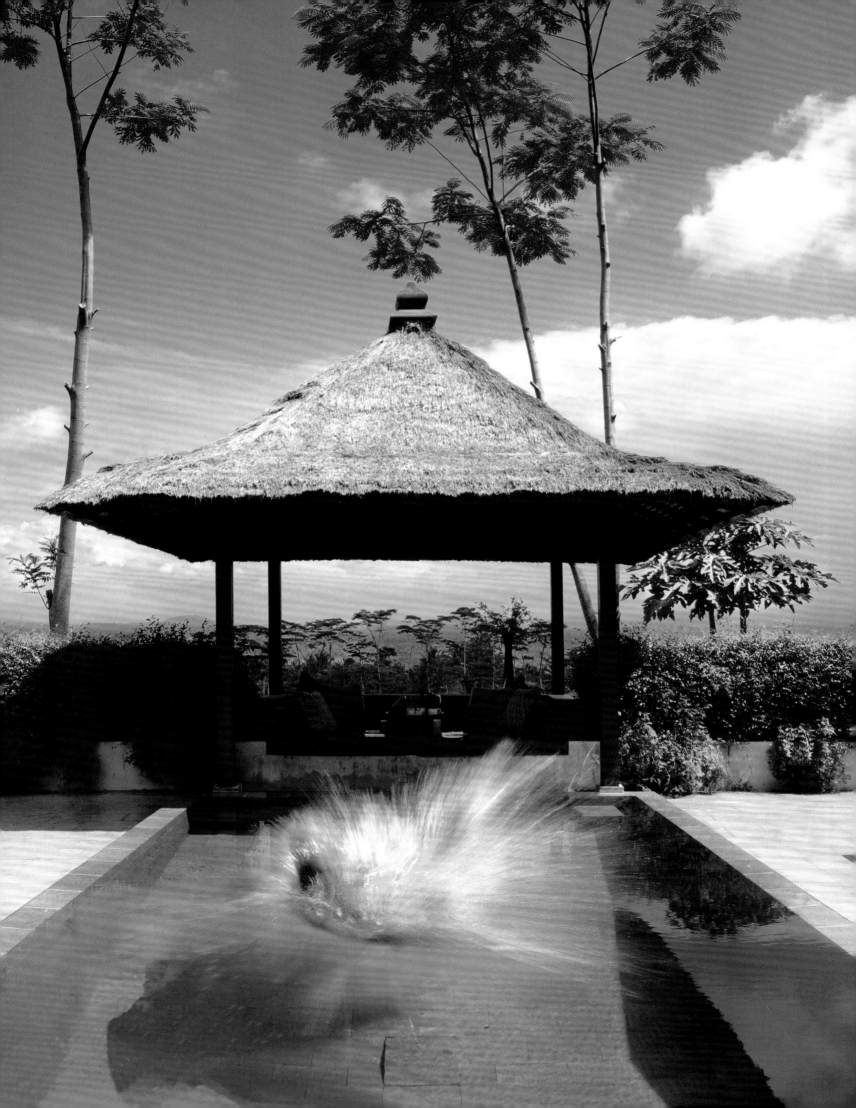

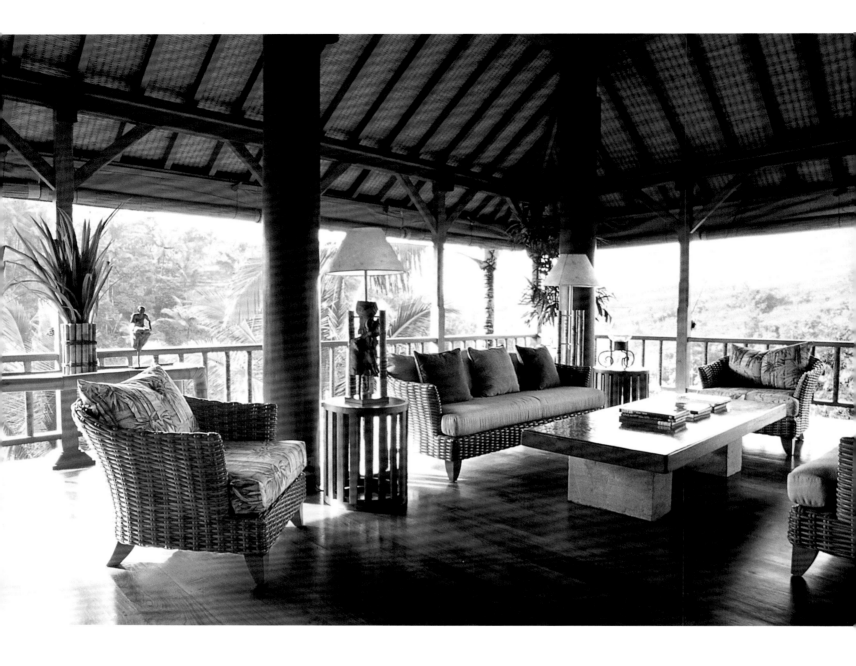

mountain village of Ubud. What started as a holiday home project developed over a decade into the Begawan Giri Estate, a five-villa property that is somewhere between a top-class luxury hotel and an ultra-private hideaway.

According to Bradley, when reduced to its simplest, their tale is essentially a love story with fairytale overtones. "Man meets land, man falls in love with land, man builds dream on land, man overcomes all obstacles in his path to keep land and dream, and man, finally, with his family live on the land happily ever after."

"We somehow knew we had found paradise," he adds "but it was not until some time had passed before we were sure what we wanted from the land—or, more accurately, what the land wanted from us."

The five villas that make up Begawan Giri take their design inspiration from a variety of Indonesian influences ranging from the Majapahit era to the remote island of Sumba—and, in a wider context, Indonesia's architectural style comprises many ingredients. Hinduism, Buddhism and Islam have all greatly influenced the architecture of the country, while the traders that brought these religions to the islands—Indians, Chinese, Arabs—left their mark on the indigenous cultures. And after colonization, European influences were absorbed.

It is, in fact, impossible to define "Indonesian architectural style", as there are so many disparate forms spread among the islands—from the saddle-back roof design of Sumatra's Batak people to the longhouses of Borneo.

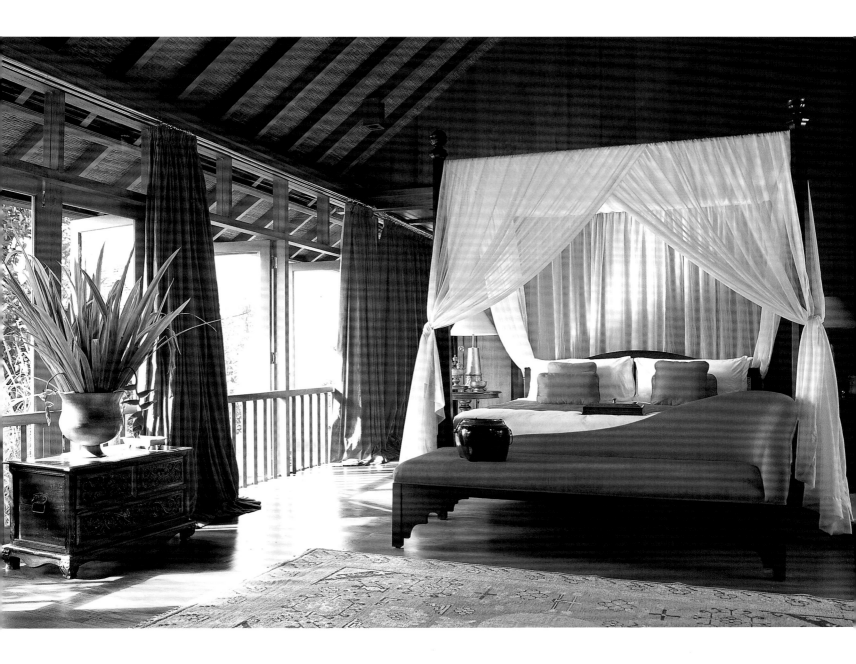

But what all the houses in this book have in common is that they fuse the traditions of local architecture and the influence of modernism; they blend into their environment and also use traditional materials. Indeed, throughout the archipelago house building has a spiritual dimension, and the local people are skilled master craftsmen. From stone masons to carpenters, they can be called upon to add a magical element to a house. Their skill is exemplified in the Kudus style, the high-relief open-work wood carving that is one of the most technically accomplished in Indonesia.

Ultimately, life in the tropics has always been about living out of doors. Most of the houses in this book highlight the relationship to nature, the natural environment. Gardens form an integral part of most properties, merging the

dwellings with their surroundings and blurring the distinction between the interior and the exterior. Architect Robert Powell notes that the best Asian houses are "an interface between the built world and the tropical greenery with open-to-sky spaces and in-between spaces" and Geoffrey Bawa, the father of contemporary tropical design, puts it another way: "In a house in the tropics, an open-to-sky space must be the focus; permanently open, not peripheral or ancillary to the main activities."

All the houses showcased express their owners' individual personalities and they are as disparate as the many influences that have shaped the archipelago's contemporary style. Geoffrey Bawa (again) sums it up: "Pleasure… is just as important as shelter from the rain."

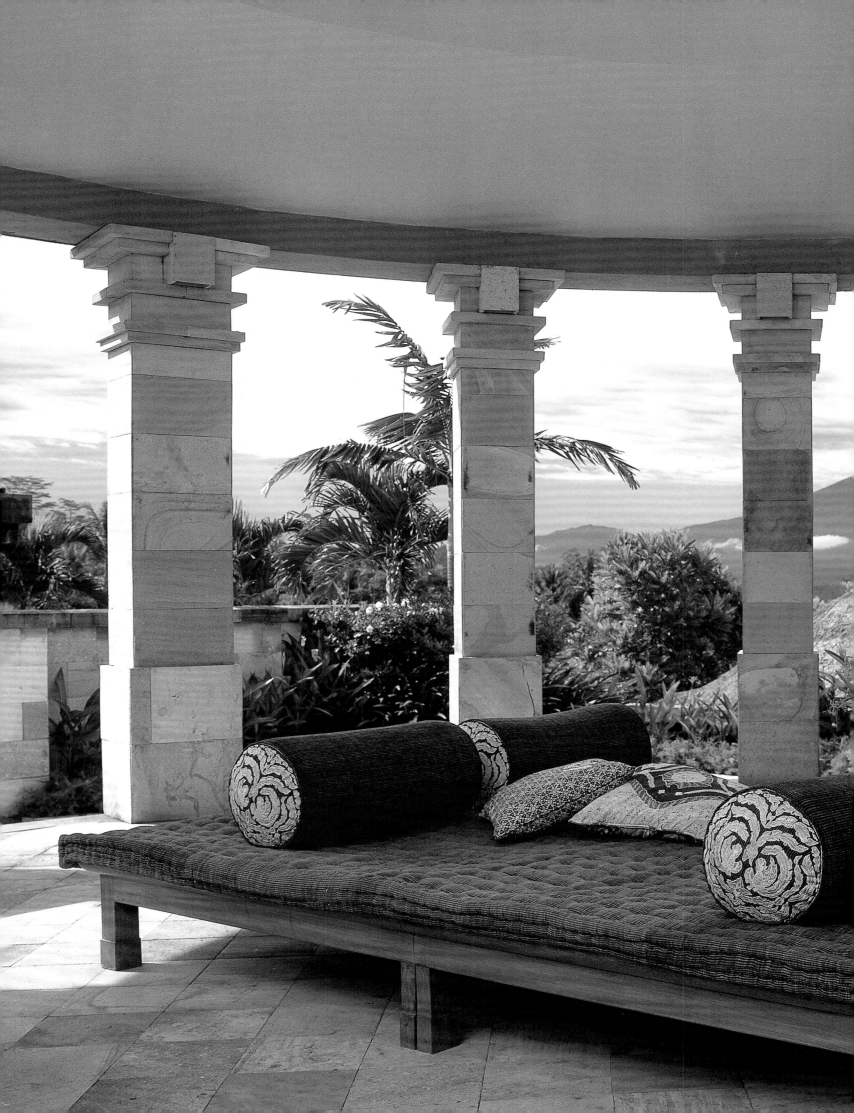

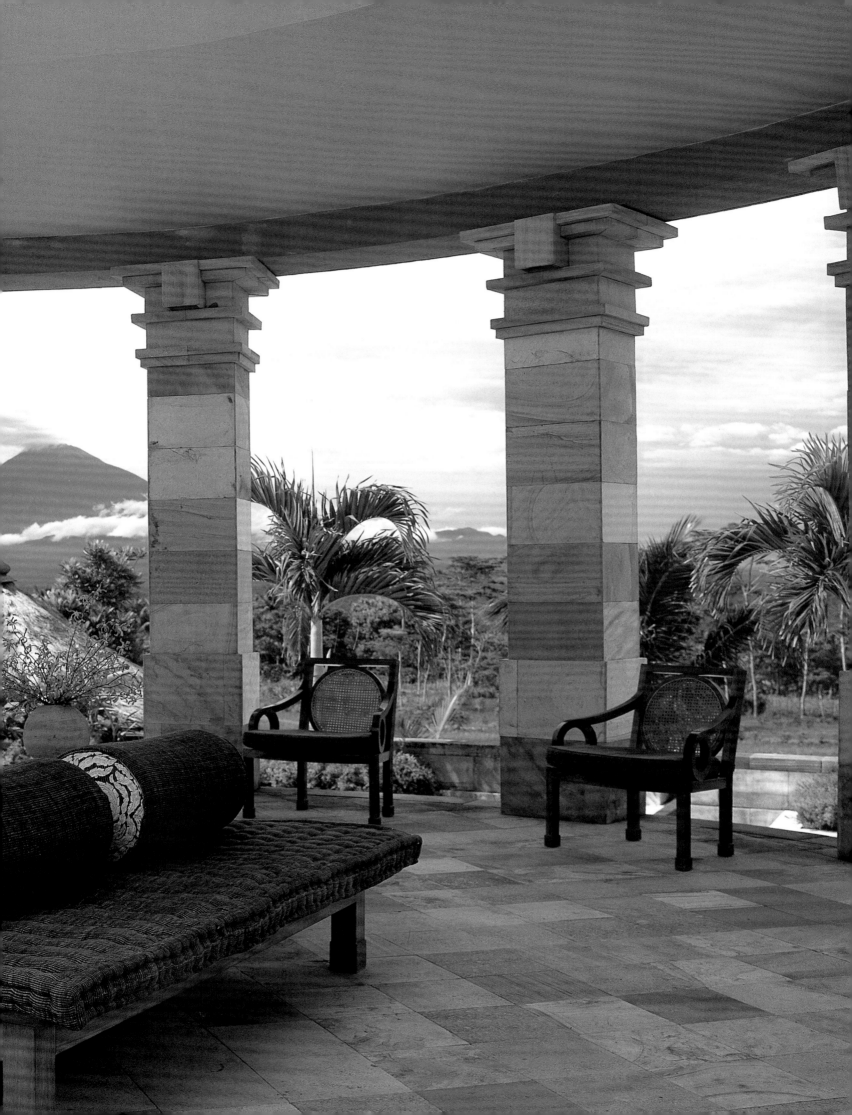

island ethnic

India's best-known architect Charles Correa once said: "It is not possible to build in Asia without acknowledging, in one way or another, the presence of the traditional— and the potent ideograms that underlie these traditions." Nowhere is this more apparent than in Indonesia, where there is such a rich and diverse vernacular architectural style on which to draw.

The houses featured in this Island Ethnic chapter mimic traditional dwellings. They make use of indigenous materials and the skills of local craftsmen, often reinterpreting ethnic styles to create homes suitable for modern living. Many have contemporary spatial organizations and interior design, but they succeed in combining traditional features with today's needs and tastes.

All are designed for life in the tropics, with its bright sunlight, high humidity and monsoon rains. They merge with their natural surroundings—as many who have succumbed will know, life in this region is all about living out of doors. Anthropologist and film maker Lawrence Blair recognized this when he said: "Successful living in Los

Angeles requires controlling the environment, whereas in Bali (and Indonesia generally) it requires a total surrender."

Easy-to-source materials like bamboo and *alang-alang* grass thatching, wood, stone and slate are employed to create spaces that are cool and don't absorb the intense heat. Houses often have open areas and high roof spaces to maximize natural ventilation. For the most part, they are light and breezy homes.

There are houses influenced by Bali's pavilion-style architecture, where a simple thatched roof is supported by tall wooden beams, blurring the distinction between inside and out. The structure of the Balinese *wantilan*, a two- or three-tiered pavilion used traditionally as a village meeting hall, has been adapted to create contemporary villas through the addition of spacious verandahs and sliding doors.

Simple Javanese village houses have been turned into laid-back homes in the urge to return to a rural idyll, free of the hassles of city life. The architectural styles of Indonesia's disparate island cultures—from Sumba and Sumatra, Java and Lombok—have been assimilated into homes that are full of character. All have a strong sense of place, reflecting the culture within which they exist, merging with their surroundings, bringing the beauty of nature into the home.

It is important to stress that these homes are not mere copies of traditional dwellings. The architects of these ethnic-inspired homes have absorbed the principles and traditions of vernacular house design and applied them in a contemporary context. As American architect Frank Lloyd Wright said: "The true basis for the more serious study of the art of architecture lies with those more humble indigenous buildings everywhere…. Functions are truthfully conceived and rendered invariably with natural feeling. Results are often beautiful and always instinctive."

Whether it is a luxurious pool villa inspired by the design and materials of Sumba, or a hotel that utilizes unusual Sasak-style roof forms, this chapter contains a visual feast of Indonesian-inspired architectural forms. There's a collection of village houses transformed into a fine home, two artist's retreats and a wonderful array or artefacts and materials from all corners of the archipelago.

Hendra Hadiprana house

an indonesian home

Hendra Hadiprana could be considered Indonesia's founding father of European-influenced interior design. In 1958, after returning from studying interior design at Groningen University in the Netherlands, he established his own practice and was called upon to design luxurious houses for the Jakarta elite. Although he built his own contemporary home in the capital city's leafy residential area of Kabayoran Baru in 1968, he opted to rent the house out to the chief executive of Bank of America. Eleven years later he took the house back and, after a renovation programme, moved in with his family. He was determined not to decorate his home in the elaborate French-inspired style popular with his contemporaries. Instead he looked to his impressive collection of Indonesian art and antiques for inspiration. He wanted, he says, to create a truly Indonesian home.

Hadiprana's passion for collecting unique pieces from Indonesia's diverse cultural heritage is evident the moment you enter his five-bedroom house. The capacious reception room (right and overleaf) incorporates arrangements of artworks from the various islands that make up the archipelago. A raised area is lined with the intricately carved panels and stepped ceiling timbers from an old Kudus house that is dated 1890. An elegant Javanese table (overleaf), used to display part of his impressive collection of silver objects, is placed in front of a finely carved day-bed on which lies a *tapi* from Sumatra's Lampung province. On top of the panels sits a collection of Javanese *wayang* puppets. An unusual screen from central Java that features painted panels that mimic ikat fabric is set behind a Thai Buddha and a Madurese chest. Sliding glass doors lead on to a pool-facing terrace home to ethnic statues from Irian and wooden *loro blonyo* figures from Java.

Like all serious collectors, Hadiprana is keen to know the stories behind the pieces he collects and, as they are generally from Indonesia, there is often a spiritual element to the tales. A gilded chair covered in sky blue velvet (right), believed to possess magical powers, was formerly owned by Sunan Pakubuwono II of Solo. According to Hadiprana the chair must face the entrance and have nothing placed in front of it. One Christmas, when this was not observed, all the electrics in the house failed for no apparent reason and a large crack appeared in the marble floor beneath the chair.

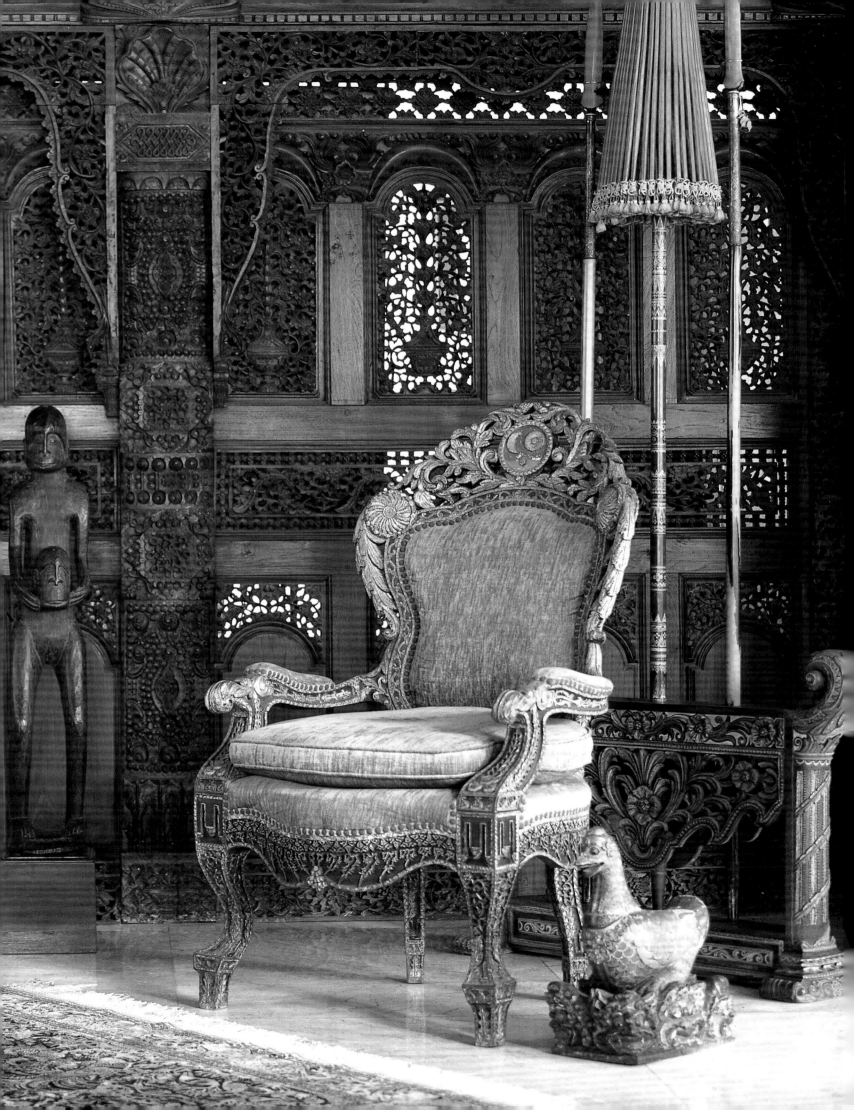

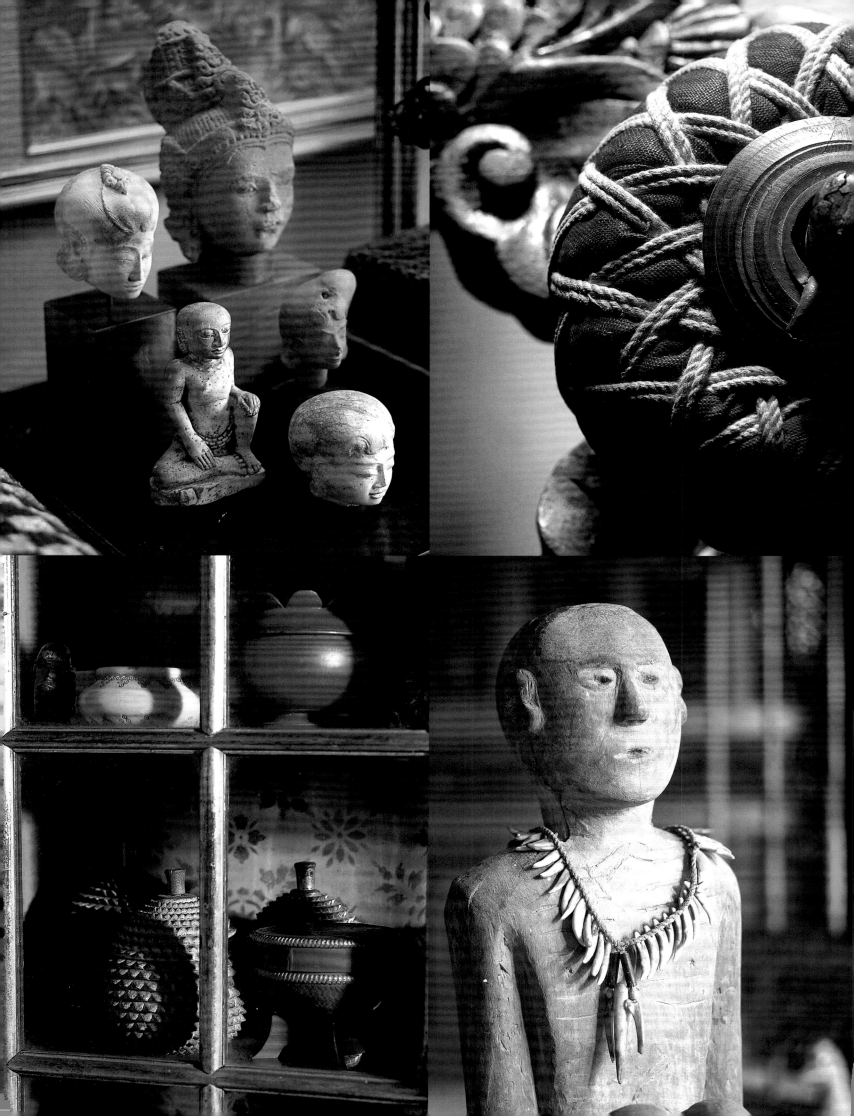

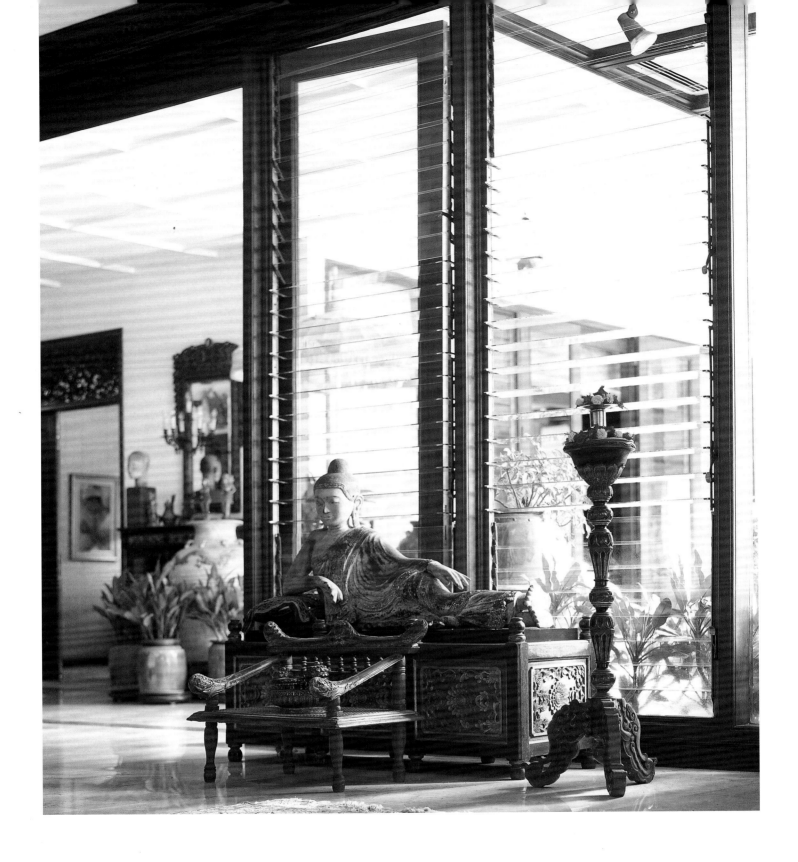

Hadiprana is not just an antique collector. Over the past 40 years he has been amassing the works of some of Indonesia's finest artists. Part of his impressive collection of more than 200 paintings is displayed beautifully throughout the house. Contemporary and abstract works by artists such as Budiyana and Srihardi do not look out of place beside his formal arrangements of antiquities. In the large dining room that can host magnificent dinners for up to 24 hang two fine portraits by Rudolph Bonnet, the Dutch painter who lived and worked on Bali in the 1930s. In a private sitting room the walls are covered with sensual works by some of Bali's leading artists, contributing to the room's intimate appeal.

Hadiprana's decorating style is all about mixing things up, taking the old and the new, the traditional and the modern, the mythic and the corporeal, and creating spaces that are of today but are imbued with the flavour of Indonesia's past. His house is just one of many projects that communicate this ability. His architectural and interior design practice, now one of Indonesia's largest and most prestigious and run by his son Sindhu Hadiprana, continues his legacy, most notably with the Bali Intercontinental Resort in Jimbaran. This impressive resort blends the cultural traditions of Java and Bali in a contemporary manner, a design concept that is the cornerstone of Hendra Hadiprana's philosophy.

high style primitive

Begawan Giri, a private estate located high in the hills above Bali's cultural centre of Ubud, is the realization of English couple Bradley and Deborah Gardner's dream. They first came to this remarkable five-hectare (12-acre) site on a promontory between two rivers in the mountain village of Begawan in 1989. While living on the land in a simple Balinese-style house, they developed a vision: to create a retreat where guests felt as if they were staying in a private home. Enlisting the help of Malaysian architect Cheong Yew Kuan, they built five grand residences each with its own architectural style, reflecting different areas of Indonesia. Tejasuara—which means Sound of Fire—is inspired by Sumba, one of the most fascinating islands in the Nusa Tenggara chain which runs from Lombok to Timor.

Monolithic, raw and massive, Tejasuara incorporates ethnic elements of the Sumba Island culture but is at the same time modern. It is what Yew Kwan calls "high-style primitive" and represents the owners' and architect's homage to the island. Much of the raw materials for the construction of the residence were imported directly from the relatively remote island. Twelve hundred tons (1,219 tonnes) of *batu kuning* stone and large tombstones slabs were brought to Bali, and are used to great effect at the entrance (above). The main interior structures are supported by wooden poles from a traditional Sumba *adat* thatched house (see pages 28–29). Elsewhere recycled telegraph poles (right), rough-hewn logs and *merbau* wood are used.

At the entrance (above) is a totem of buffalo skulls, a common sight within a culture that still practices ritual animal sacrifices at religious and funeral rites. The steps lead down to a huge circle of fire that casts a dramatic dark orange glow over the pool when it is lit at night (right).

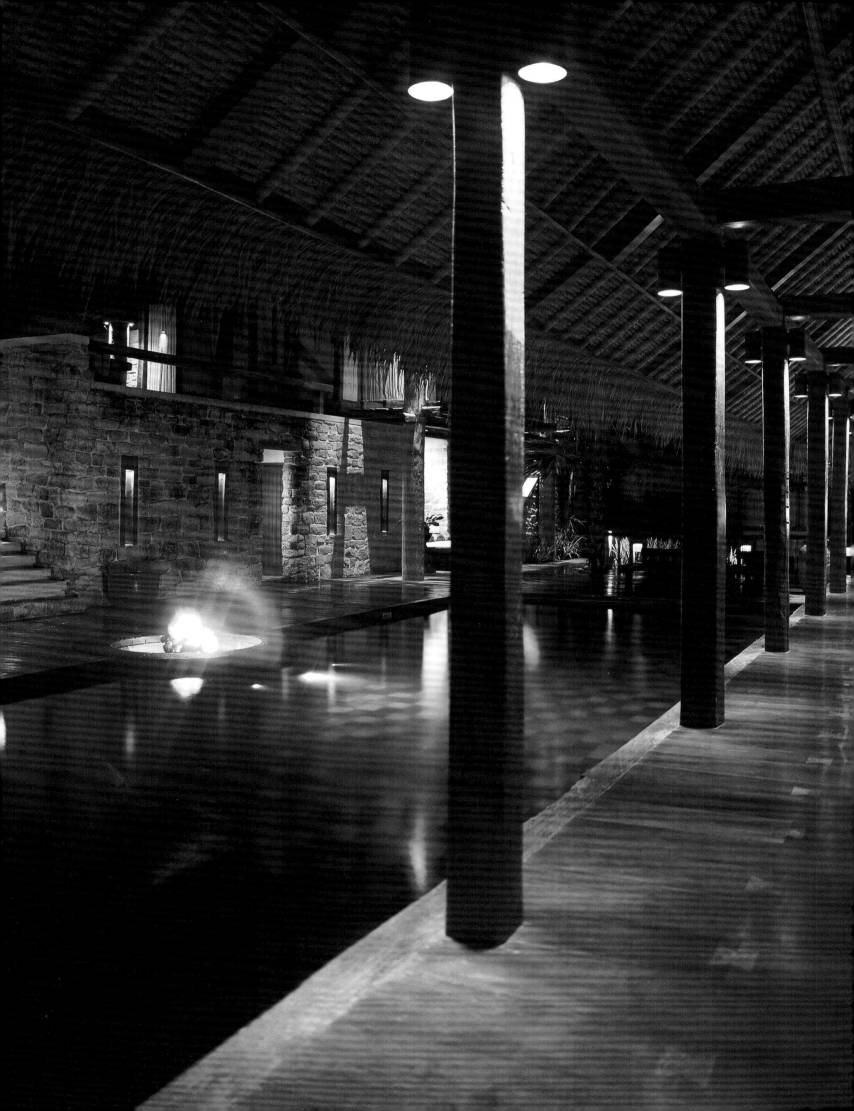

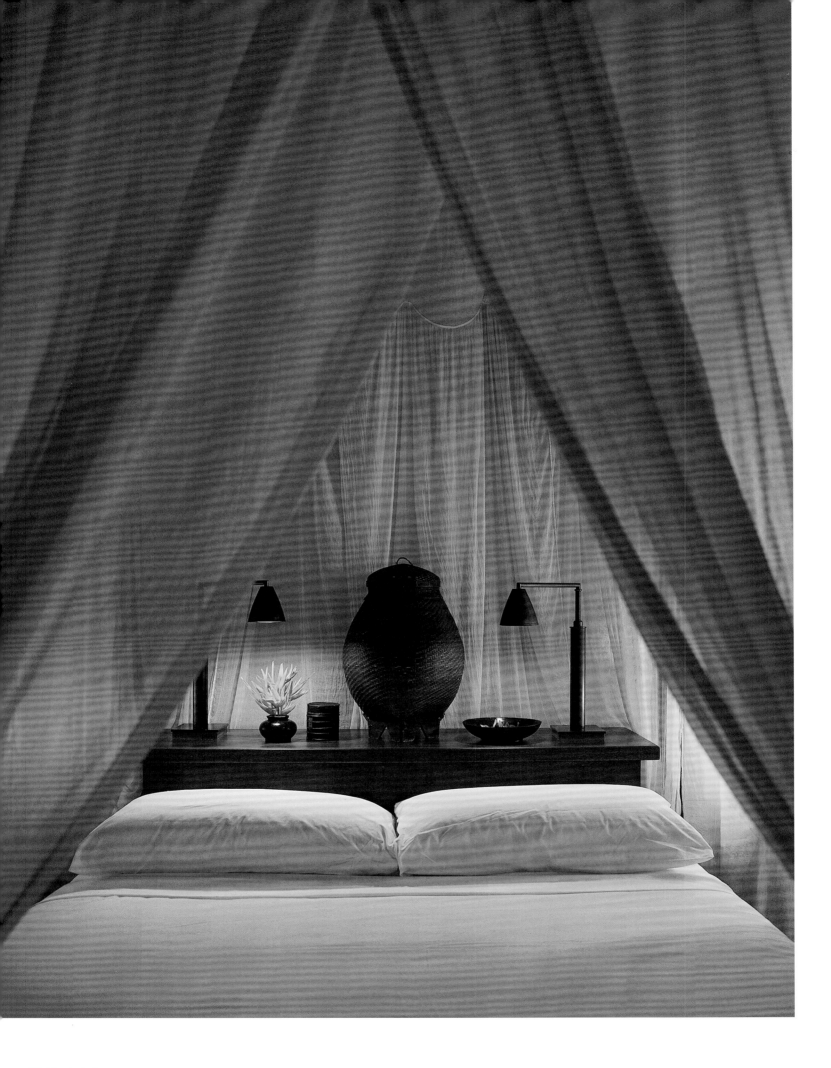

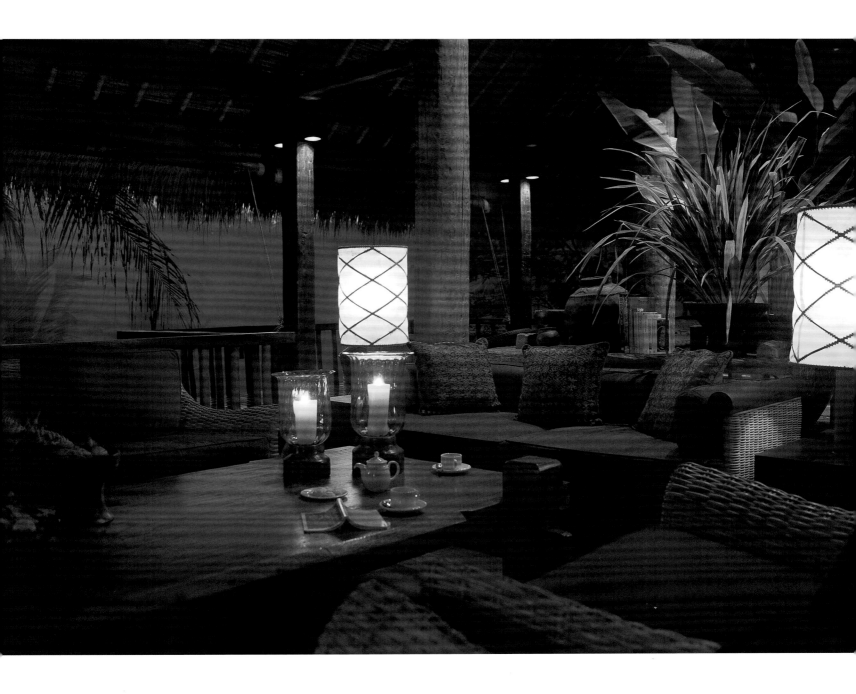

Both the interiors and exterior at Tejasuara successfully combine the primitive and the modern, the old and the new, the raw and the finished. The spacious living area (above) mixes oversized cane armchairs from the Philippines with traditional Sumba ikat cushions. An eclectic mix of tribal statues, ethnic wooden bowls and old terracotta pots add interest.

The luxurious four-poster bed in the master suite is made out of an unusual black bamboo. Billowing mosquito nets add to the highly romantic ambience. In the bathroom, a hollowed-out log serves as a vanity unit within the contemporary terrazzo sinks while woven slats of *merbau* wood (right) provide an unusual wall finishing reminiscent of traditional Sumba houses.

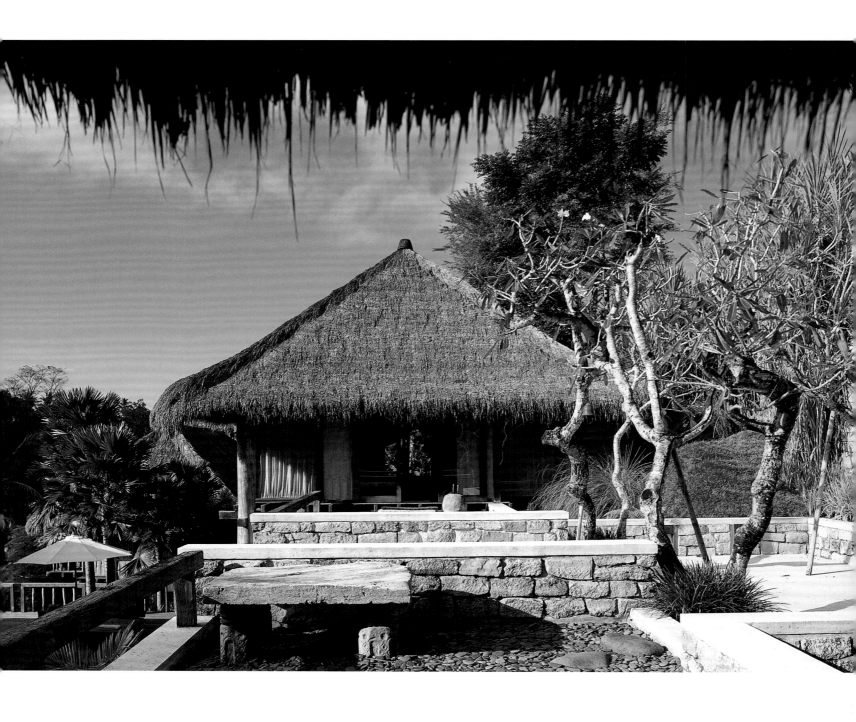

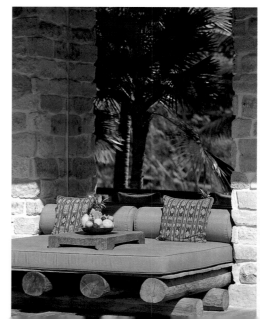

The challenge of Tejasuara, according to Yew Kuan, was building a structure that could stand up to the power and beauty of the nature that surrounded the property's most exposed and linear site. The solution was to build a massive horizontal structure that drops down the side of the hill. Throughout the property, he has created "view points that bring nature in and out, that create a dialogue with nature". A good example is a large piece of frameless glass set behind the day bed on the terrace (left). Reflecting the view of sculpted terraces and palm trees, its incredible depth creates the feeling of being able to step through into another world.

The close interaction with nature is apparent from the terraces and walkways of the residence (above). Looking out over the top of the trees, they appear suspended over the steep terraces below. The gardens have been planted with Sumba grasses and lemon grass by the landscape gardeners John Pettigrew and Thorston d'Heureuse in an effort to recall the open grasslands of the island. Sumba is also renowned for its fine handwoven ikat textiles, made with natural dyes in hues of rust, indigo and red. On the large day bed made from rough hewn ironwood logs (left) the cushions are covered in a traditional Sumba design.

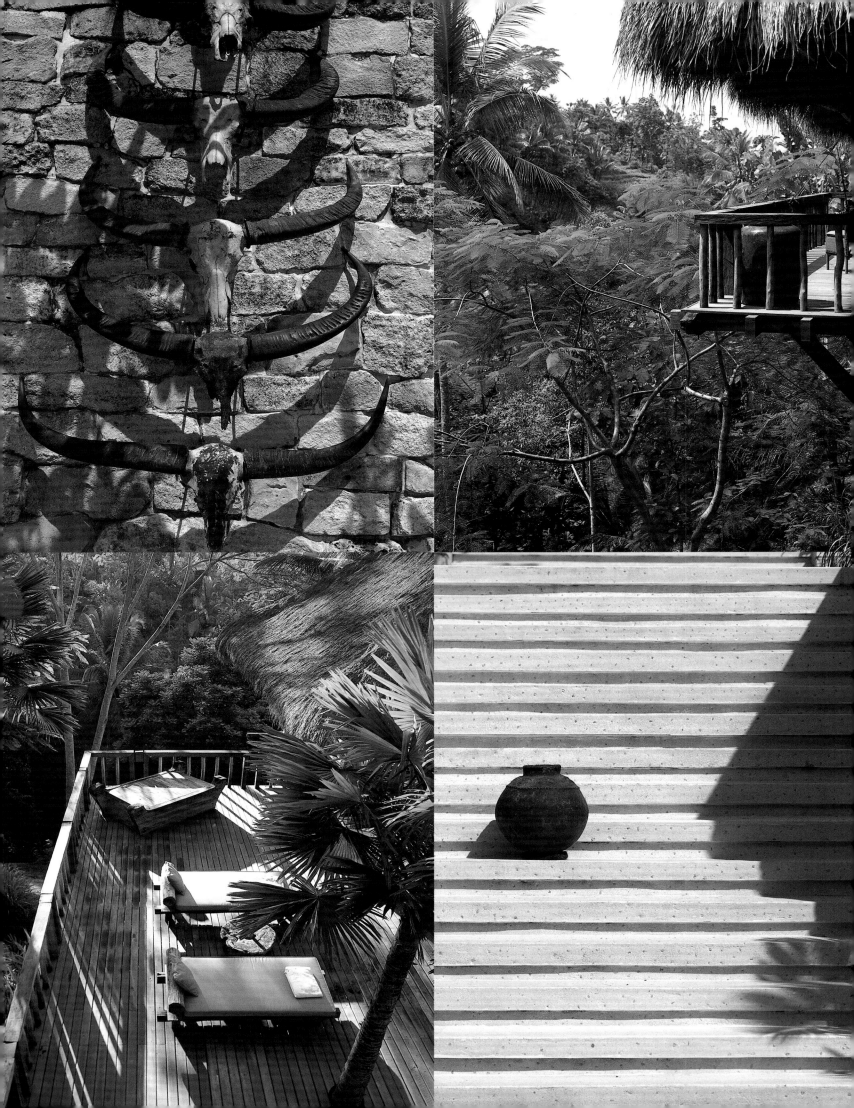

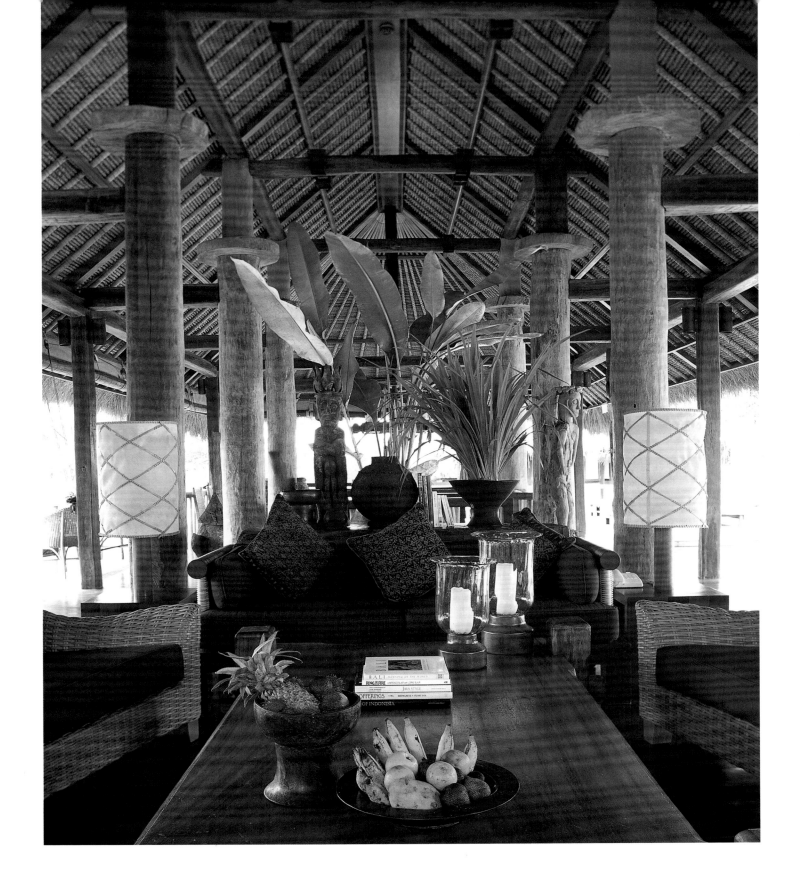

Before building the mysterious Tejasuara, Bradley and Yew Kwan spent time on Sumba to absorb the island's unique culture. The residence is essentially an ode to their passion for the architecture and design they discovered there. In deference to the traditional houses of Sumba, the *alang-alang* thatched roofs are untrimmed, while the central pillars of the spacious dining/living pavilion (above) have circles of wood at the top. In village houses, valuables such as ceremonial textiles and sacred objects are stored high up within the rafters, the circles preventing rodents getting to them.

In contrast to the other houses in Begawan Giri, Tejasuara is more rugged, its beauty lying in its strength and primeval appeal. The furnishings reflect this primitive theme, with the use of ironwood, stone and large pieces of furniture. But what it has in common with the other residences is the incredible attention to detail and how the property sits perfectly within its extraordinary location. According to Yew Kwan, when designing the estate, a lot of invention was done on the site. "We had the luxury of time to evolve our designs," he says, "taking influences and inspirations from our travels."

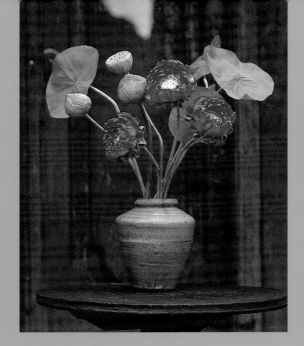

an artist's spiritual retreat

Stepping into Frenchman Jean-Francois's home is like entering the realms of a magical kingdom. A designer of fantastical jewellery and objets d'art, his home is a reflection of his passion for the ancient Hindu Buddhist empires of Southeast Asia. Littered with an eclectic collection of art and artefacts from his travels around the region, this is a very individual home. Seven pavilions that owe their primary design influence to traditional Balinese palace architecture are set within the spacious grounds. The gardens are a tropical wonderland, their theatricality enhanced with a series of secret walkways and elaborate water features.

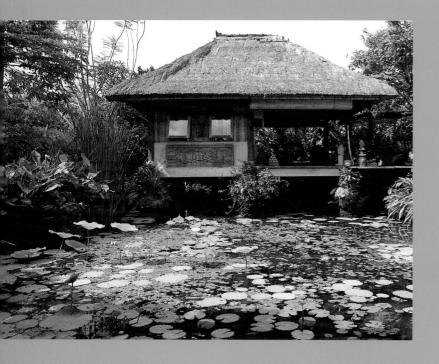

Jean-Francois built his home across a deep ravine in the artistic centre of Ubud nine years ago, although he has lived on the island since 1978. He knew the owners of the land and, after having decided this was the prefect location for his dream home, he started by transforming the fields into a ravishingly lush tropical paradise. New buildings have been added over the years, the latest a showroom for his extraordinary work. Entry to the house is via a small gated wooden bridge over the ravine. A series of stone steps takes the visitor past a spectacular lotus and lily pond (left) to the main house with its welcoming spacious terrace (overleaf).

Jean-Francois's fascination with the spiritual and mystical is apparent in his work and throughout the interiors of his home. The walls of the relaxing room (see page 36) are painted deep saffron, reflecting the colour of Buddhist monks' robes. An extensive collection of paintings by both Balinese artists and foreign artists who live in Bali line the walls, while a treasure-trove of artefacts are placed throughout the room. A meditation pavilion (left), overlooking the beautiful lotus pond, is home to an impressive collection of crystals, silver figurines and statues of Buddha; all combine to help achieve a serene environment.

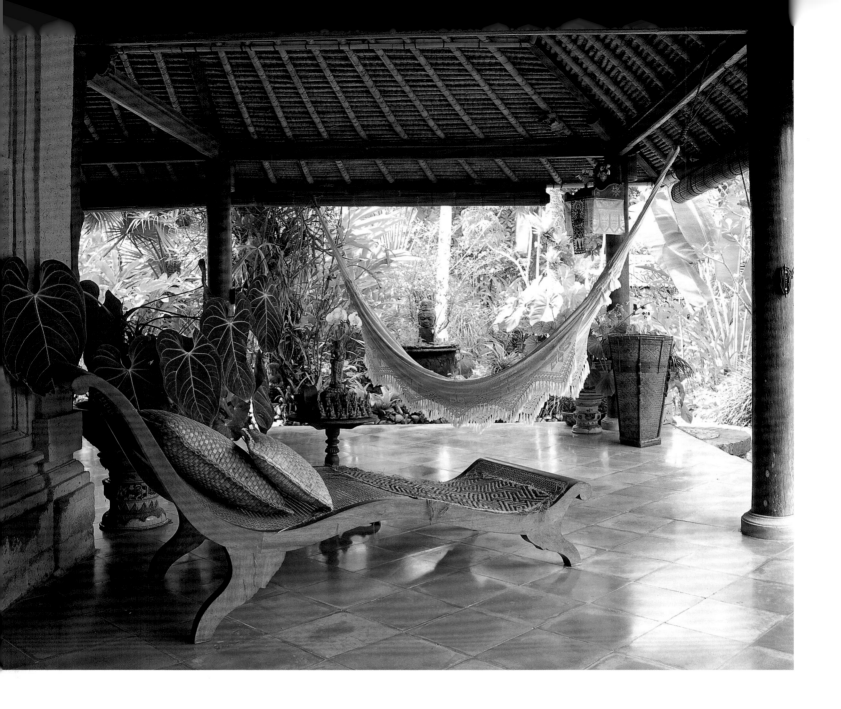

The heart of Jean-Francois's home is the large welcoming terrace (above and right), where the influence of Balinese architecture and design is most evident. "I am an auto-didact," declares Jean-Francois with intensity. "I have a feeling for local design and I have incorporated it into my home." Materials were sourced locally, including the sweeping *alang-alang* grass roofs that are supported by thick coconut palm pillars. The local stone walls were carved around an ornate wooden door from Singaraja in North Bali. Two stone Buddha heads sit either side of the door frame, while the terrace, which looks across the lotus pond and is linked to the meditation pavilion by wooden decking, is furnished in Indonesian colonial style. An ample day bed, wood and rattan recliners, a chaise-longue and a hammock provide a choice of places for lounging while large Vietnamese planters add flashes of colour.

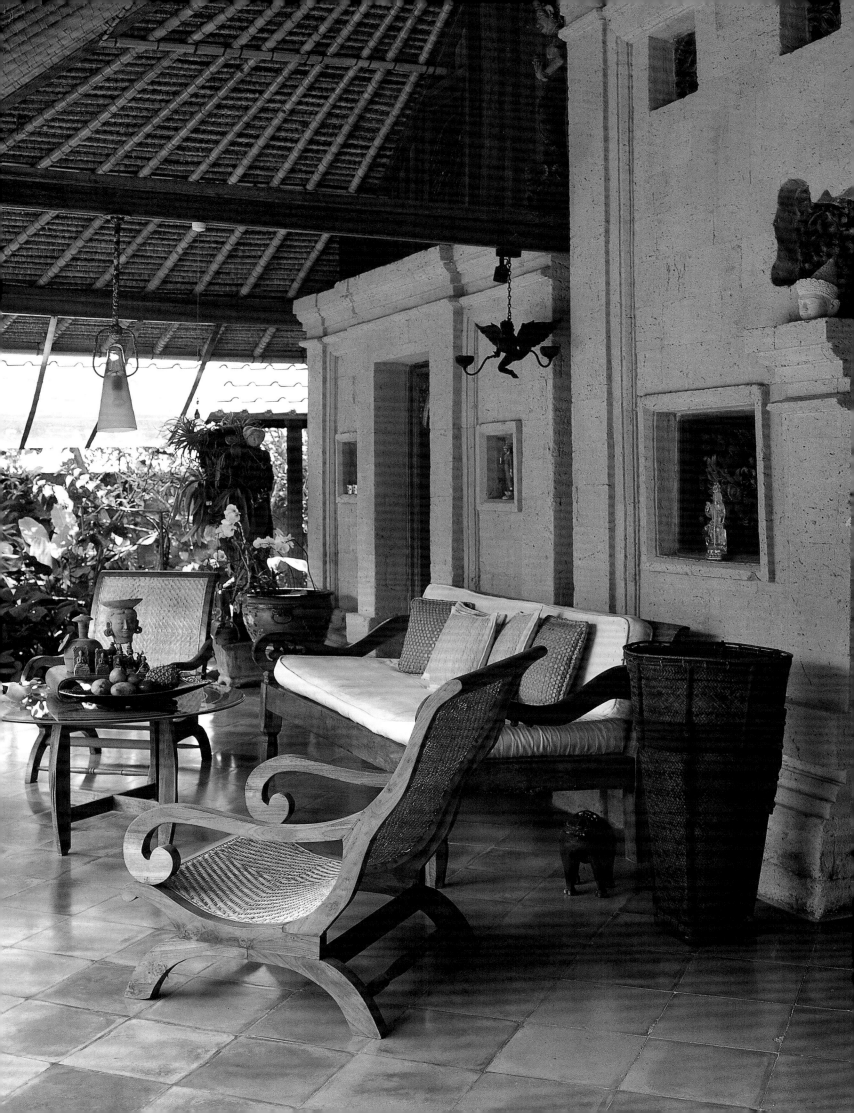

The jewel colours, rich silks and ornately carved furnishings in the bedrooms create a mood of romantic sensuality. The master bedroom (right), which is reached by a spiral staircase, features a soaring Balinese thatched roof. Quiet views across rice paddy fields make it hard to believe the house is situated in the busy mountain village of Ubud. The focal point of the guest bedroom (below) is a Shan Buddha from Thailand, placed between two antique Balinese *balé* beds from Klungkung. The ethnic bedcovers are from Sumba, while the canopies above are saris from India; the carpet is from Pakistan, and all work together in this strongly Asian-themed room.

Antique stained-glass windows from Indonesia's Dutch colonial period provide a warm glow to the relaxing room (left). The rich textiles of the throw cushions include a Japanese kimono belt, Tibetan designs and a Burmese sarong.

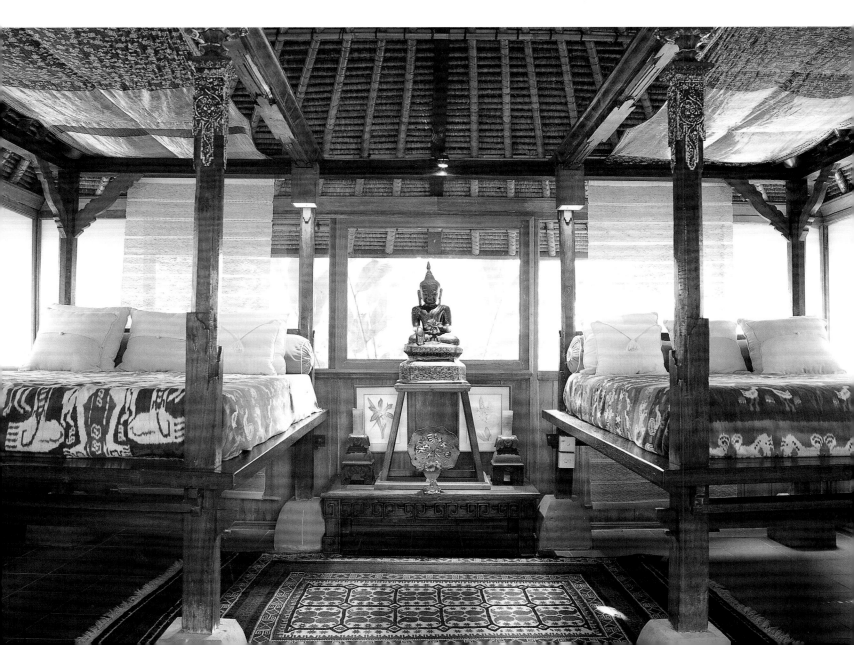

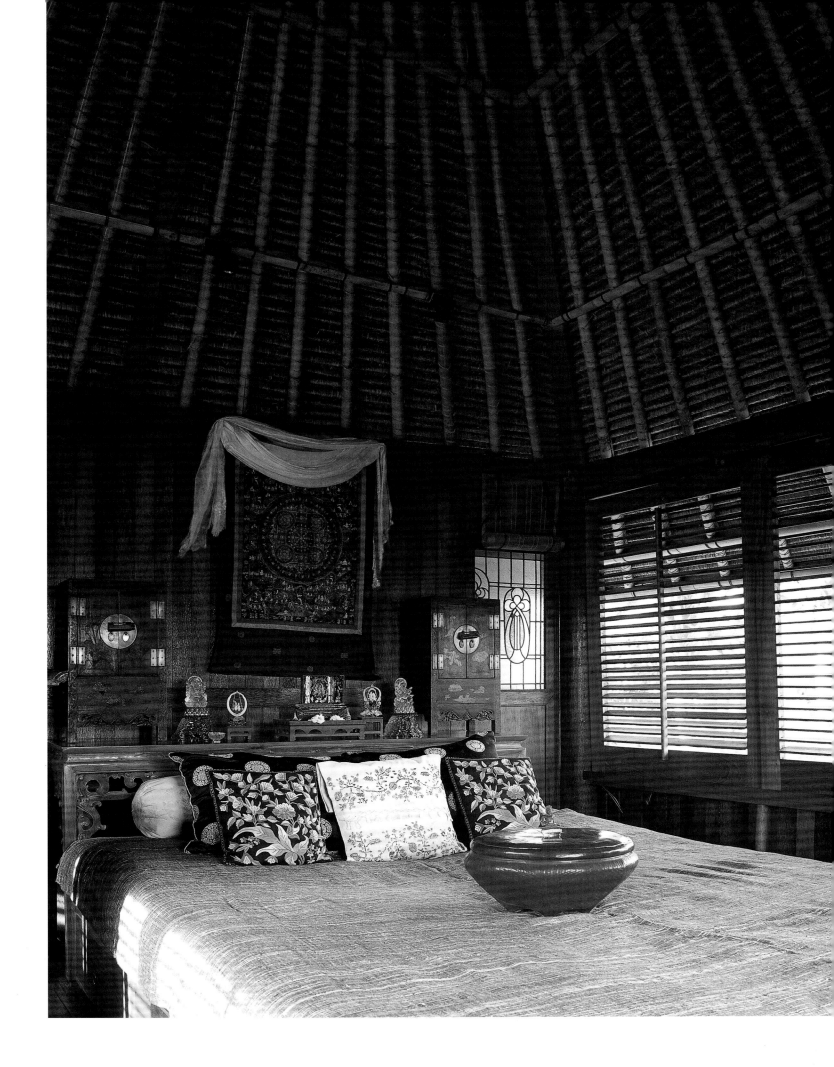

Outside, a maze of meandering paths and stepping stones lead through the gardens to the pool (above), which features a tiled pattern of the Fichot logo, an inlaid sunburst. Many elements in Jean-Francois' home have a strong Hindu Buddhist theme, such as (opposite, from top left) statues dotted around the grounds, like these made-in-Bali Khmer copies; with time they have become covered in moss, giving the impression of great age. The windows of the meditation pavilion lift out over a terracotta carving of a scene from the Majapahit era. A statue of Tara, the Buddhist goddess of knowledge, is adorned with daily offerings. A simple wooden bowl is transformed by Jean-Francois into a precious object with the addition of intricately worked silver.

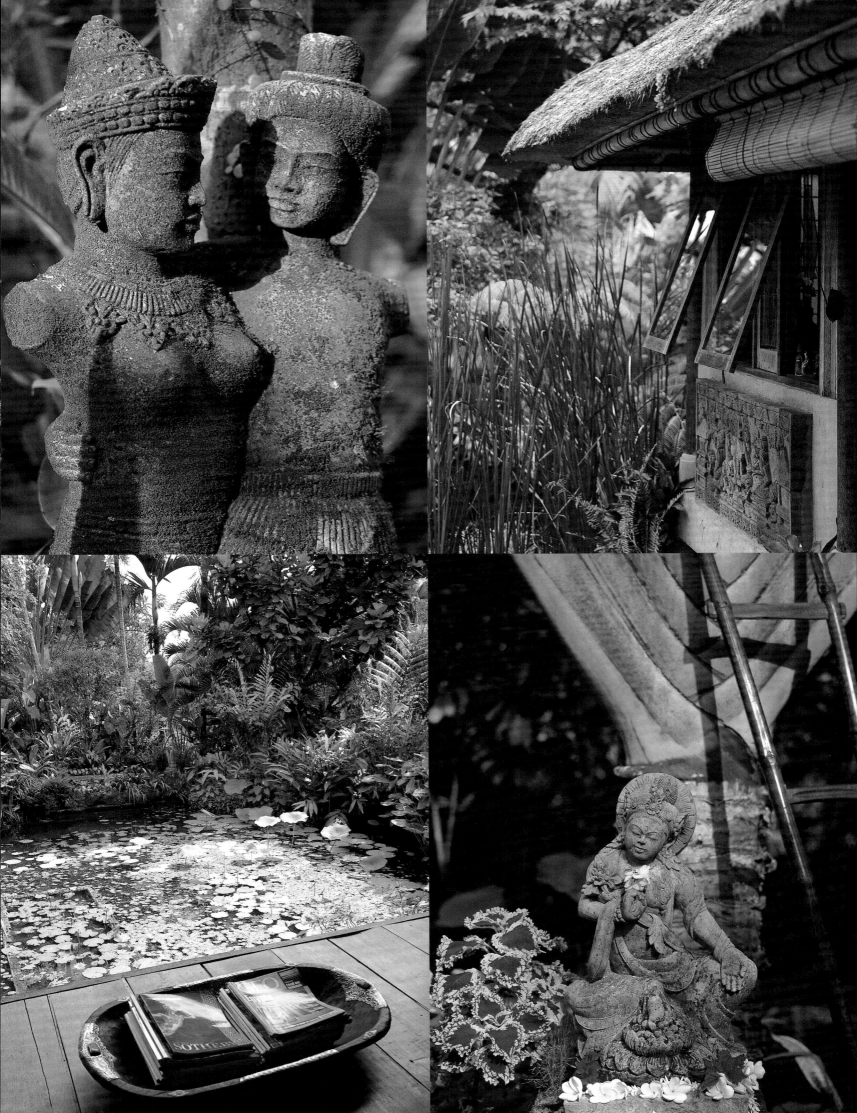

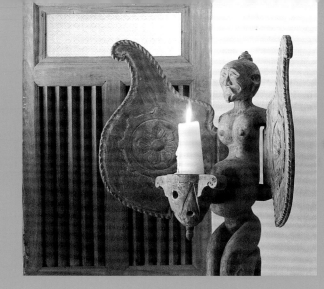

village life

Warwick Purser—founder of Out Of Asia, Indonesia's largest exporter of handmade homewares —has done an enormous amount to promote the extraordinary talents of Indonesia's craftsmen. Working closely with masons, carvers, weavers and a host of other artisans who live in simple communities scattered around the countryside, he came to appreciate the architecture and atmosphere of the traditional Javanese village. Although he has a grander showcase house in one of Yogyakarta's main streets (see pages 122–125), he has chosen to make his home in the nearby village of Tembi. Here he lives in a 150-year-old renovated wooden house set within a compound of similar buildings that accommodate guests and his company's offices, showrooms and workshops.

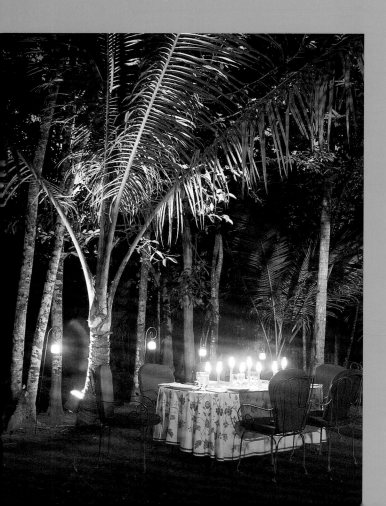

"My heart is in the village," says Warwick. "I work with village people —it's where it all began for me. I wanted to start a trend by focusing attention on old Javanese village houses that were in the main part collapsed and falling down." Six years ago he bought three houses— including the village chief or Lurah's house that was practically in the ground—and restored them. He resurrected the original teak pillars and windows and he looked for old tiles. If any feature was unusable, he searched the antique shops and found a replacement that was appropriate to the style and time of the original house.

Warwick's greatest talent is his ability to adapt to the surroundings in which he lives. His village houses reflect that philosophy—they are unobtrusive, they blend. The simple garden lined with coconut palms is turned into an atmospheric out-door dining area with the ample use of candles (left). An old painted Javanese door is adapted into a two-panel screen in the guest house main living room (right). Its unusual terracotta-red colour is not often seen in modern Java. A 1.3-metre (4-ft) tall wooden statue (above) makes an attractive candle holder.

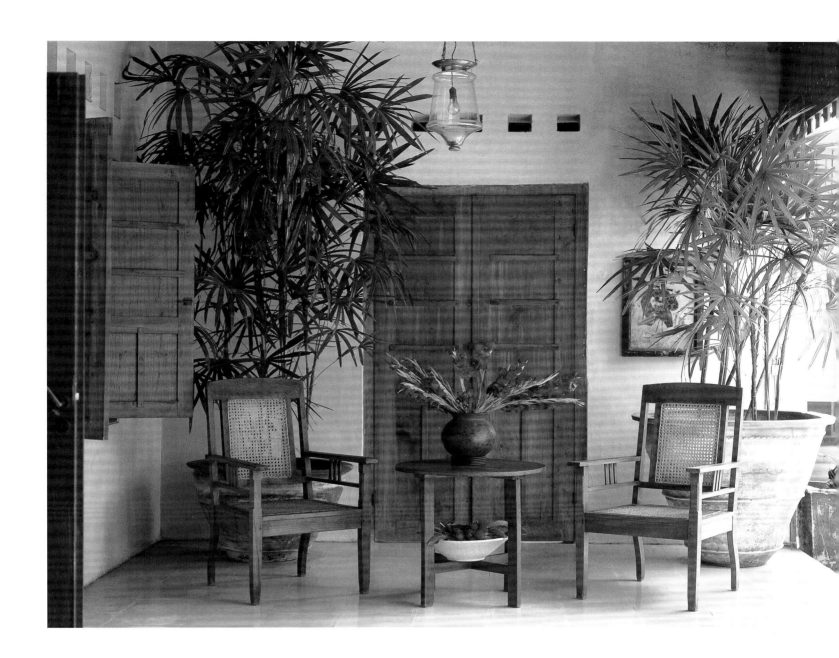

Warwick's main house is set within a tranquil walled courtyard that contains a traditional Javanese *pendopo* or open-sided meeting area with large sofas, a wrap-around pond with stepping stones, and a pavilion. At the front of the house is a large terrace and sitting area (opposite and above) where furniture and antiques are grouped together in an informal manner. 1920s art-deco style arm-chairs are set next to a small wooden coffee table. A palm is planted within a huge terracotta dye pot, formerly used in the making of batik textiles, an art form that Yogyakarta is famous for. In his approach to interior design, Warwick believes that "good houses tell you when you go wrong—they say what is right and wrong in an instant." It is clear when you walk into the house that he was listening well, as everything is what the Indonesian's call *cocok*, or a perfect match.

Warwick's crusade to promote the simplicity and easy-living of traditional village houses has clearly been successful as a number of his Jakarta friends have followed suit, and now rent houses in Tembi.

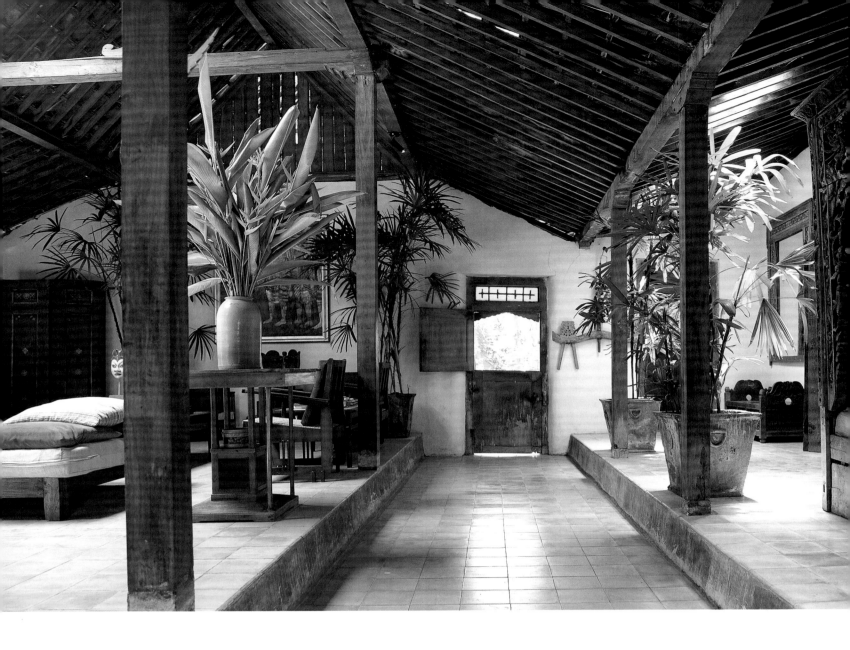

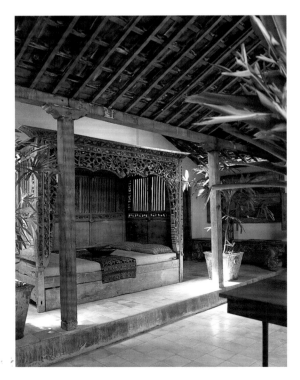

In keeping with Warwick's design philosophy of blending with the environment, the style of the village houses is minimalist and relaxed. "I live in Indonesia where there is an abundance of natural materials," he says, "so I make use of them." In the guest house, the palette is pale sage green and light terracotta. The furniture, with a strong 'European-in-Asia' feel, is a mix of antique and reproduction that works well. The polished cement tiles, made in Yogyakarta, are laid throughout the house. Within the main living room (above and left) two sides of the room are raised. The lower central part is where servants would traditionally walk, ensuring that their heads were lower than the master and mistress of the house.

The enclosed design of village houses means they are often dark. Warwick has compensated for this by placing traditional glass tiles within the roofs rather than putting in windows that are not part of the original architecture. A carved wooden bed from Madura that is over 100 years old (left) provides a restful place for settling down with a good book, and listening only to the whirring of the overhead ceiling fans and the clucking of the village hens. Traditional reverse paintings on glass hang on the wall in a study area (right).

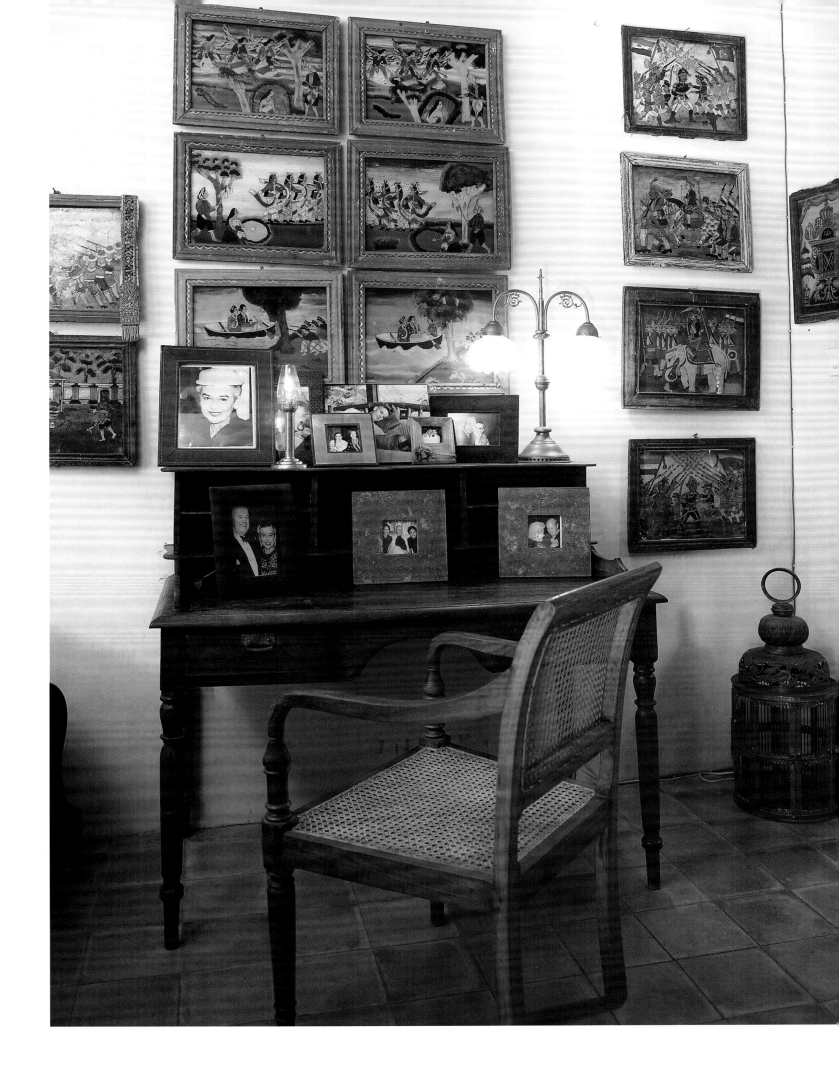

Morley house

tribal modern

When New York-based couple Nicholas and Clare Morley decided to build a get-away-from-it-all home on Bali, they chose a 1,600 sq-m (17,216 sq-ft) site in Kerobokan that provided uninterrupted views of terraced rice fields. Their design brief to New Zealand architect Ross Franklin was what you might expect of people from the world of high fashion—a sophisticated property that was spare and clean, like a piece of haute couture. "We took ideas from all the top hotels we've stayed in to create our own personal Aman retreat," says Nick. However, Puri Shanti also incorporates design influences from Indonesia, with the overall result being modern and sleek, yet with a strong ethnic feeling.

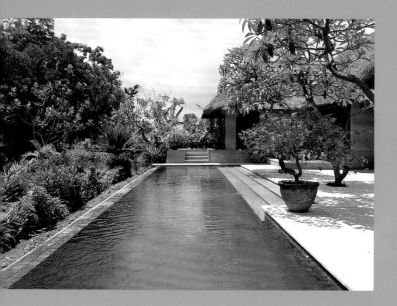

The main house, built around a rice-terrace shaped tension edge swimming pool (left), is open-air with an ample *alang-alang* roof —in the best Balinese tradition. The poolside *balé* and the entrance *porte cochère* (above) look to the Toba Batak people of Sumatra for inspiration with a saddle-back roof and outward leaning gables. "What we were trying to achieve was a 'tribal modern' design concept," says Nick.

One of the most striking features of the house is the saffron-coloured exterior walls (right). "I wanted to recreate the flashes of colour of traditional monk's robes that so impressed me in Thailand," says Nick, clearly a man with a strong sense of the visual. Antique Javanese wooden doors are used throughout the house to provide atmosphere and warmth. The example here is 350 years old and leads through to a separate bathroom from the guest bedroom. On its other side are unusual carvings of Buddha.

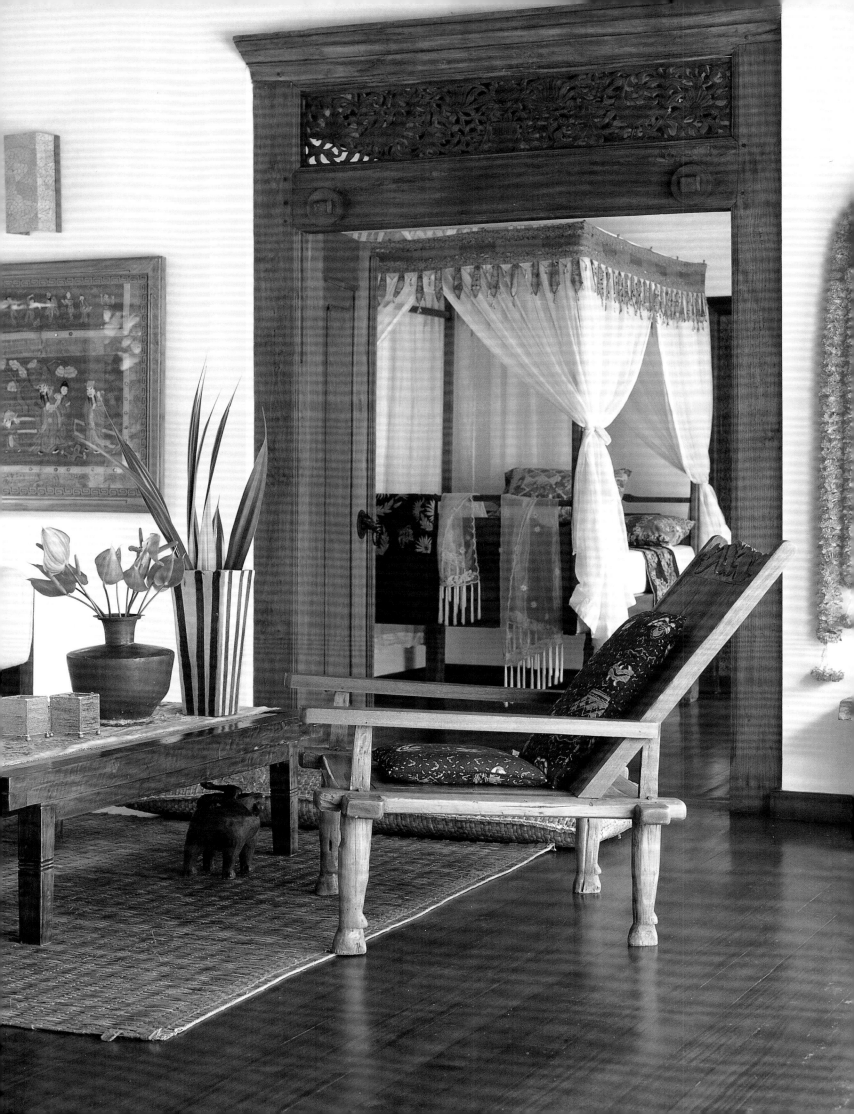

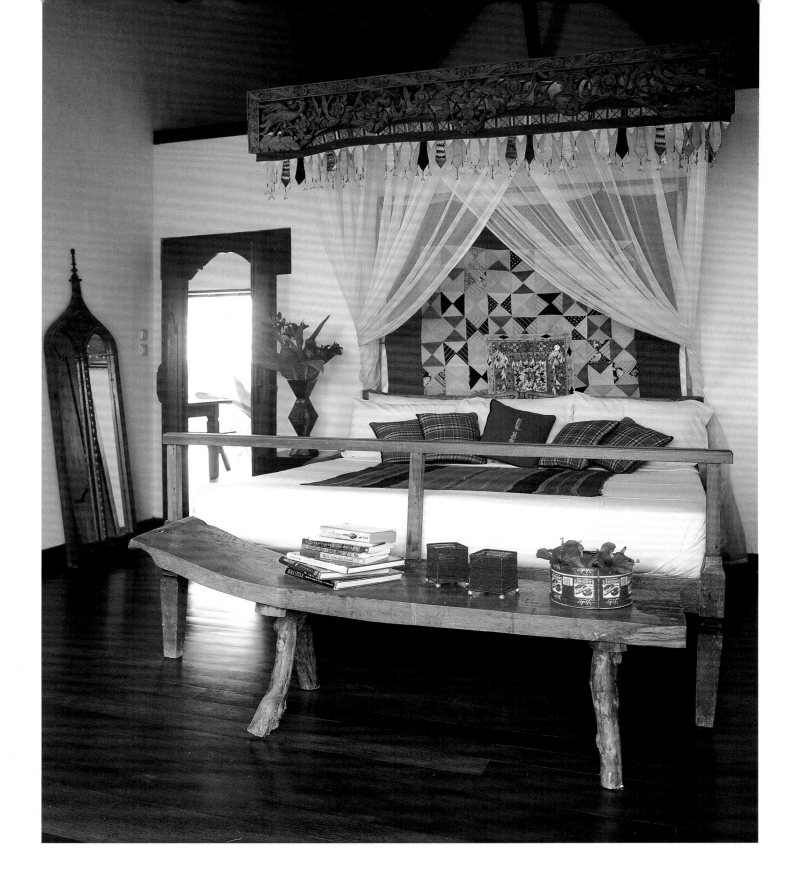

The centre of the house is a spacious open-air living room with a set of steps down to the poolside terrace paved in cream *palimanan* stone. From here the eye is drawn down across the pool, past the manicured lawns to the green fields in the distance. To one side is a raised dining area and kitchen, to the other a comfortable sitting room (left). A majestic carved wooden doorway (above) leads through to one of the guest bedrooms. The wooden furniture— some of it antique, the rest newly made in Bali from old teak wood— is complemented by beautiful framed fabrics. A framed piece of

Chinese embroidery hangs above the ample sofas. The cushions on the rustic armchair are covered in traditional blue and white batik from Solo in Java. Around the canopied beds hang unusual antique temple decorations that were traditionally used in Balinese wedding ceremonies. The centrepiece on the wall behind the bed in the second guestroom (above) is a Balinese patchwork quilt with beads at its centre, sourced from an antique dealer in Sukawati near Ubud. Wooden *bengkerai* floors throughout complement the clean white interior walls.

Like a well-tailored suit, Puri Shanti fits the couple that designed it perfectly. Their aim was to create a home with a level of comfort and sophistication that would entice their friends from New York to make the long flight to Bali. In this they have succeeded as their house has played host to many a guest impressed with its laid-back tropical style. Even in the bathrooms their attention to detail is meticulous. They have the rustic, indoor-outdoor feel that Bali allows, but are still luxurious. The master bathroom (right) is painted in the same warm saffron as the main house. The vanity unit is made of black terrazzo inlaid with mother-of-pearl. A large hand-made teak mirror reflects the rural view. The shoulder-height walls are open below the *alang-alang* roof to provide that all-important tropical outdoor feel.

The master bedroom has louvred windows (above) that lead on to a private terrace with views across to the local village or *banjar*. This is the place to catch the morning sunrise while watching the Balinese start their work day in the fields. It also looks out to the manicured lawn that takes up an entire rice-field. Sown with fine grass seed, it is springy underfoot and is lined with tall coconut palm trees. An old brass copper vase sits on top of a simple table, filled with heliconias.

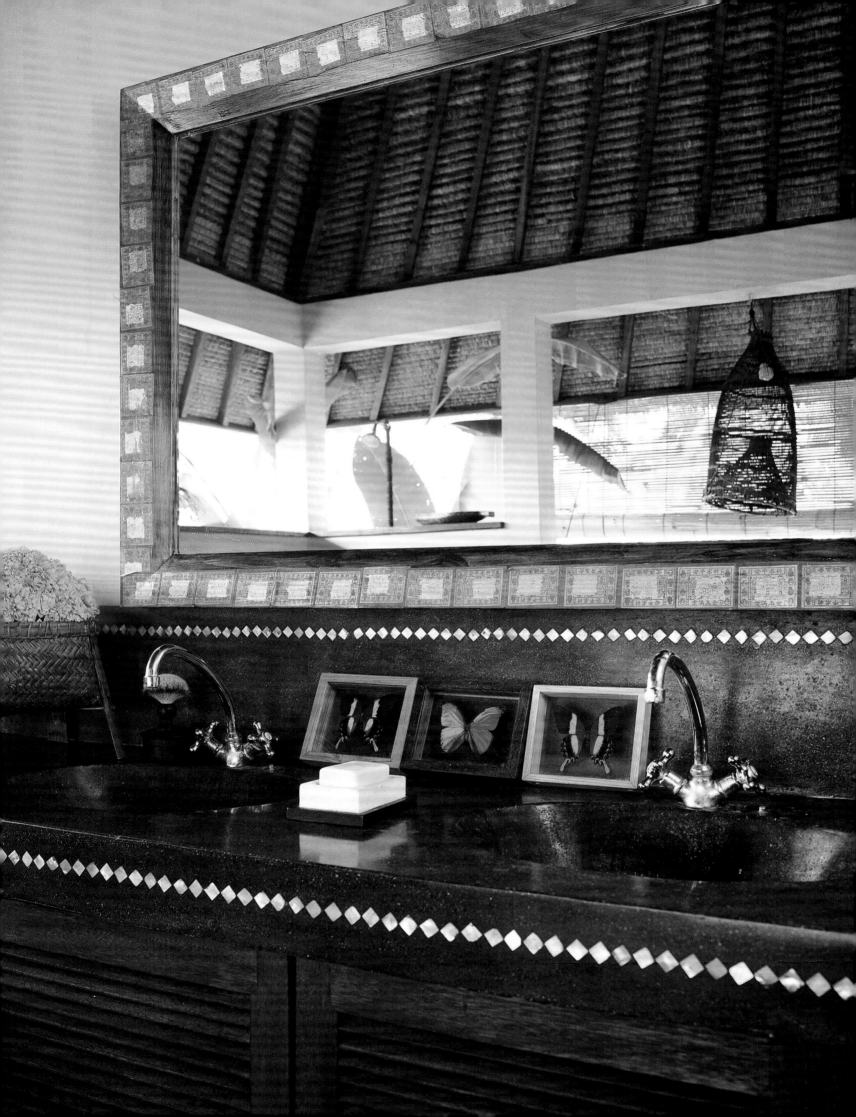

sasak style

The Coralia Novotel is a 108-room resort located on an isolated and beautiful beach on Lombok's southern shores. A collaborative effort between architect and interior designer Lek Bunnag and landscape architect Bill Bensley, the resort's design is inspired by traditional Sasak villages prevalent on the island. According to Bill, the pair wanted to build a hotel with a "new and fresh image" that made use of the vernacular architecture, used local materials and craftsmen in its construction, that would "capture the imagination" and draw people to what is essentially one of the world's most faraway places.

Inspiring the work of Bunnag and Bensley is the belief that "people leave their places of work to enjoy a break in extraordinary places with unusual encounters". As such their aim with Coralia Lombok was "to bring whimsy and humour into everything that we designed, as resorts are not, or shouldn't be, serious places". This light touch can be seen throughout the resort, from a climbing gecko carved into the *batu klaten* stone walls of one of the swimming pools (left), to the carved and polished coloured cement columns in the arcade of the meeting rooms (right).

A variety of roof forms have been used throughout the resort including the "upside down ice-cream cones" that cap the Café Chilli restaurant; roofs with long finials made of *alang-alang* grass and *ijuk*, a black-palm fibre; and the steep sloping thatched grass roofs of a traditional Sasak village house as used in the restrooms adjacent the pool club (above). According to Bill, Lek has taught him that "a steeper roof is more dramatic than a shallow roof, and a group of roofs looks more dramatic than a single roof, especially when trying to emulate a village of the Sasak people."

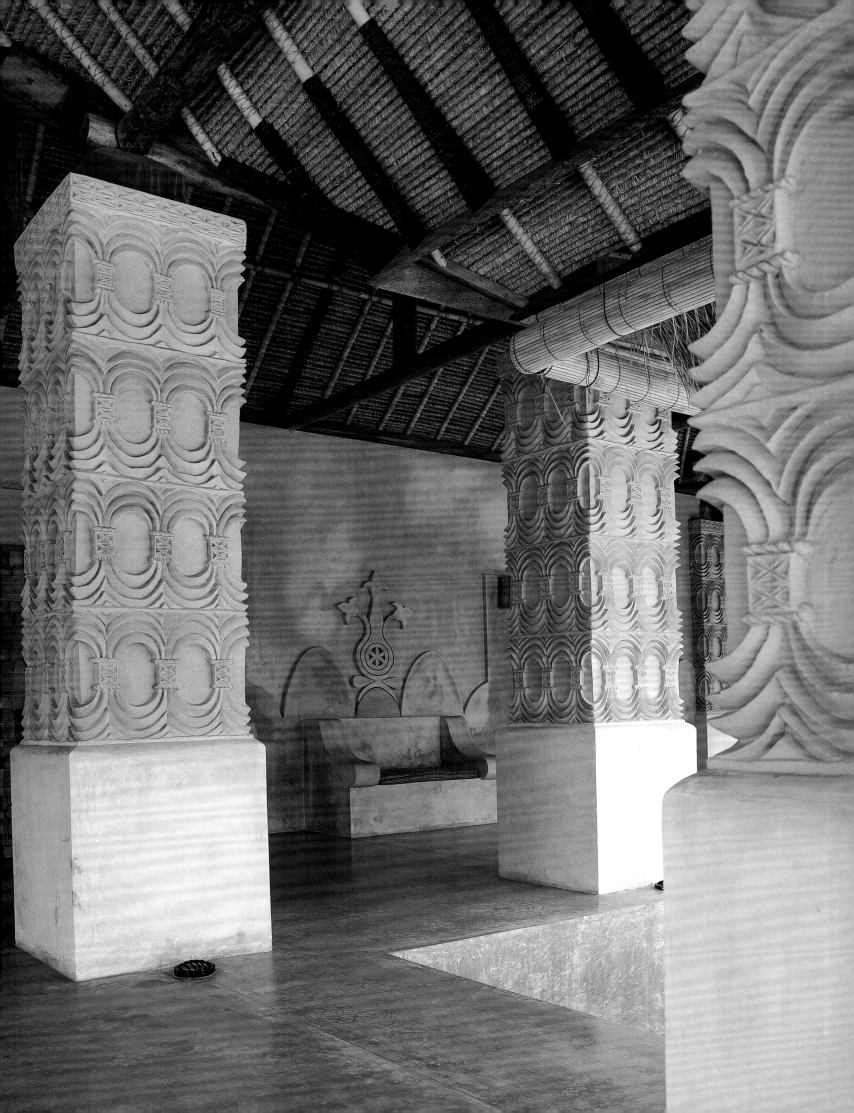

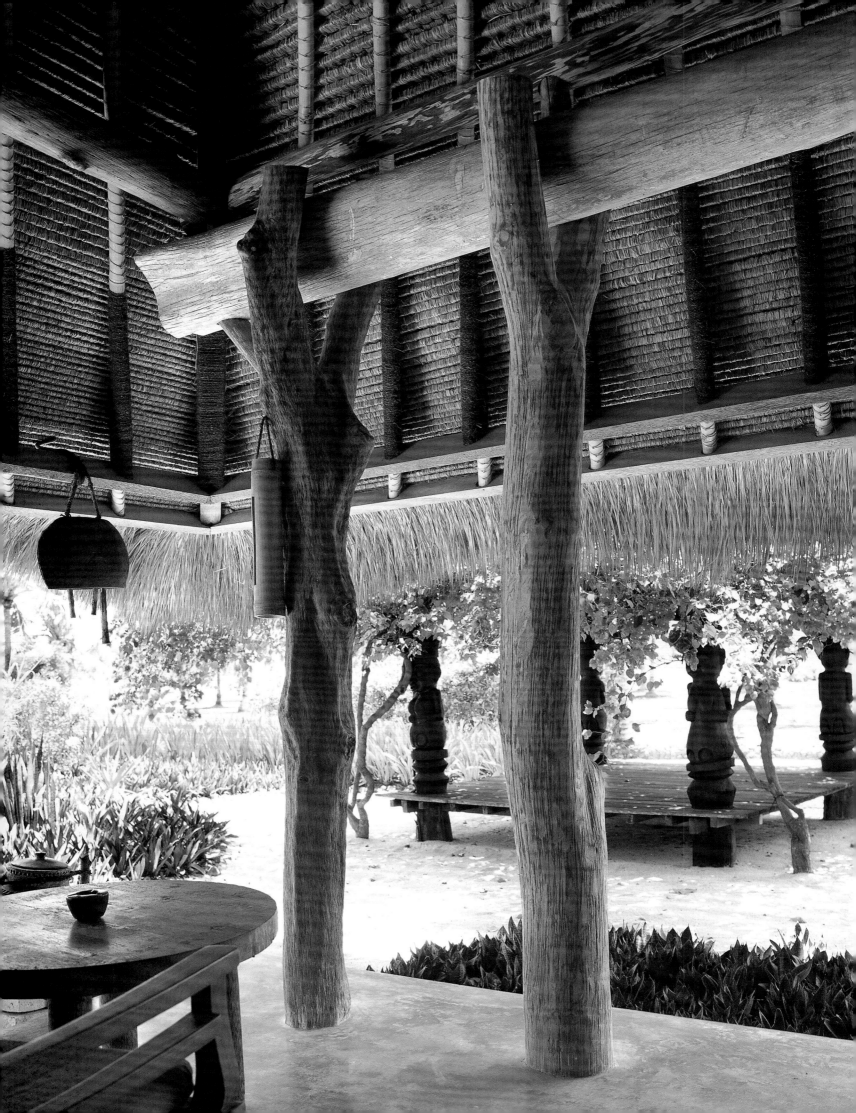

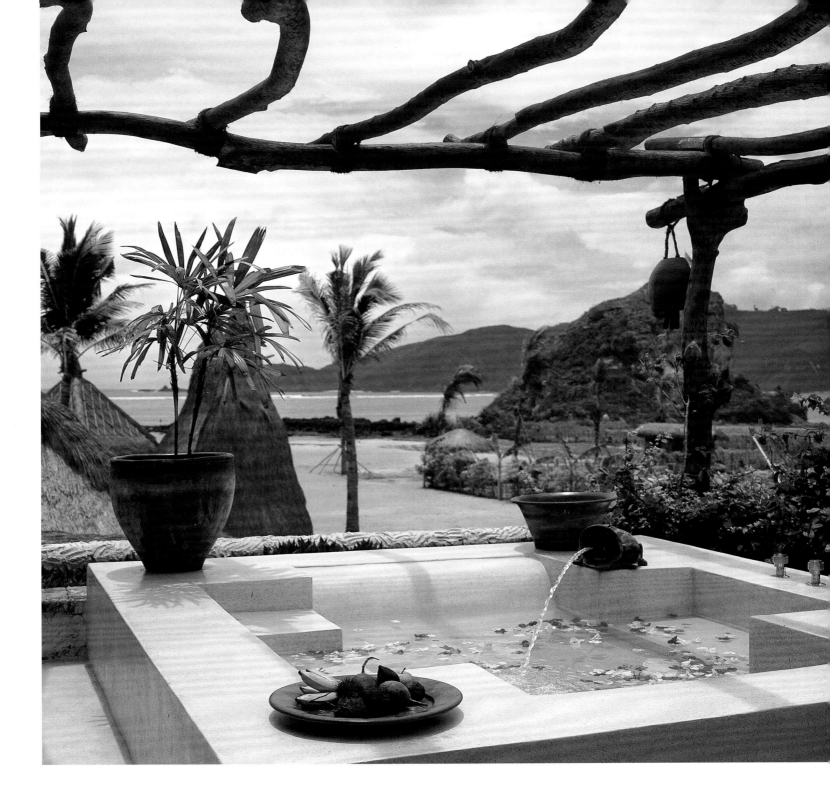

The resort has 23 individual bungalows featuring steep *alang-alang* grass roofs, the edges of which have been left untrimmed in keeping with the 'primitive' look of the resort. The bungalows are grouped within three separate 'villages', each with their own theme: duck, alligator and gecko. Mimicking the tradition of the Sasak people of decorating their roofs with geometric designs, Bill and Lek have added animal figures to differentiate the villages. On right, we see wooden ducks grouped on the roof.

As southern Lombok is generally very dry, Bill planted a garden that would adapt easily to the harsh climate. "As the resort was within an existing coconut grove, I intentionally planted very few additional trees so that the gardens would remain sunny and therefore produce a lot of flowers." He experimented with many varieties of sedums and cacti, and used bougainvillea for colour. Bougainvillea leaves float in one of the villa's private outside bathtubs, with stunning views out across the deserted white sand beach to the sea (above).

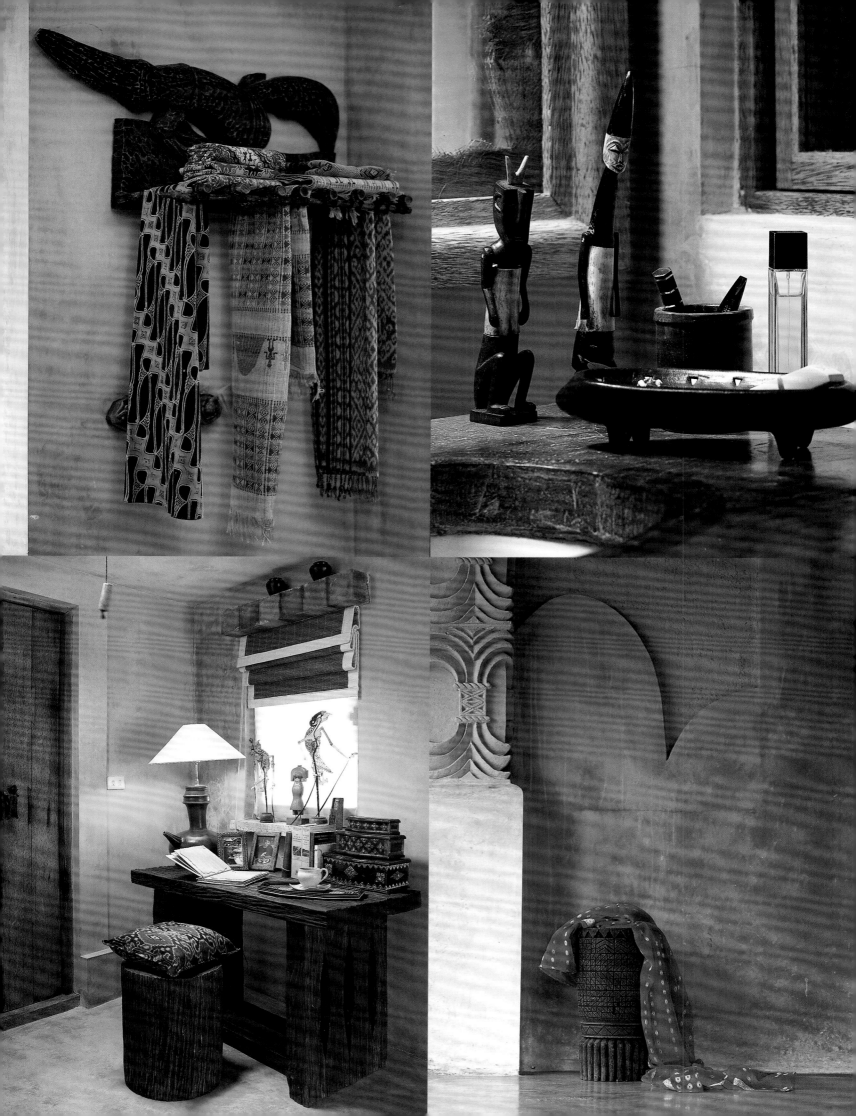

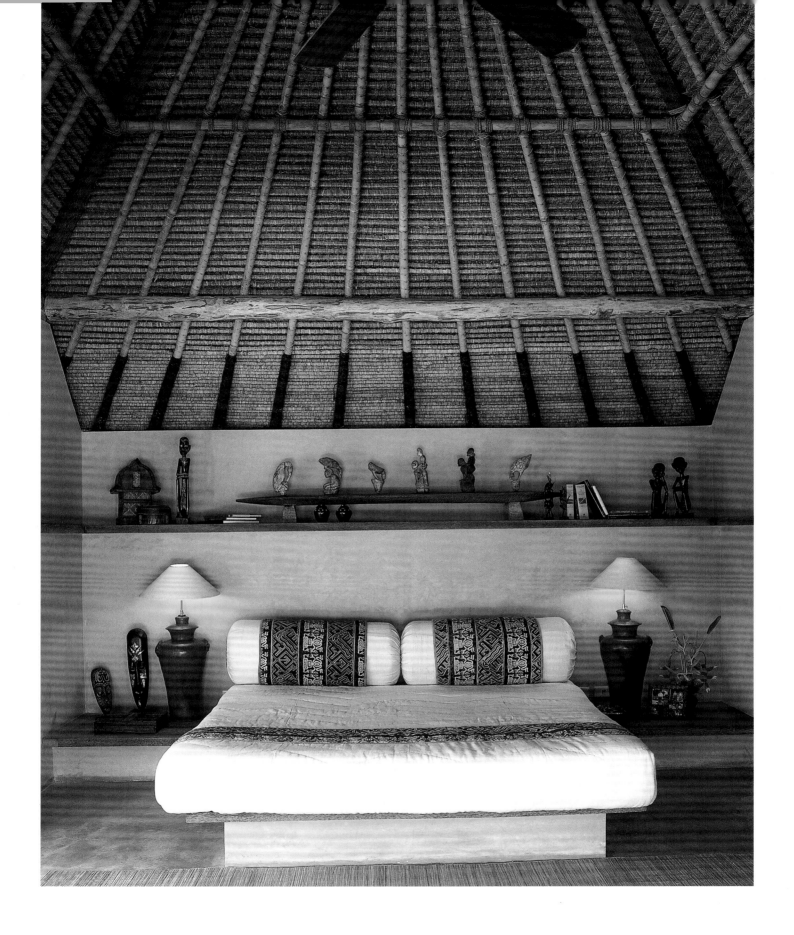

The colour palette used by Lek for the interiors is a warm ochre for the polished cement floors and a deep brown for the coconut wood furniture. Bill and Lek deliberately used local materials and enlisted the help of talented local craftsmen. The bedroom furnishings (above) reflect the distinctly ethnic style. Everything has been designed in a relaxed and simple way in keeping with a beach resort. But there is also an effusive element to the design that celebrates the stunning culture and natural environment of this spectacular tropical island. Lombok is famous for its hand woven textiles, traditional baskets and pottery. Fine examples of these local handicrafts (opposite) have been placed throughout the Coralia giving the resort a character that is quintessentially Lombok.

remembrance of things past

Anhar Setjadibrata's Tugu Hotel in Bali is part museum, part tropical retreat and part homage to the island's—and the country's—artistic and cultural past. Having started collecting in the '70s, he has amassed a wealth of antiques and artefacts that record Indonesia's eclectic history, from its pre-colonial roots through to the influence felt by Chinese immigrants and its celebration by foreign artists. Rather than hide them away in dusty storerooms, Anhar has made it his personal mission to share the beauty and history of these magnificent pieces by placing them throughout his 26 suite-hotel, recreating what he sees as the romance of an era now gone.

The ten thatched pavilions of Tugu Bali are set amid rice paddies and lotus ponds in the ancient village of Canggu on Bali's west coast. The resort, designed by Anhar and built with a team of master craftsmen, blends traditional Balinese architecture with elements taken from old Javanese houses. His rare collection is displayed in thematic arrangements throughout the property, each telling a different story. Two suites pay homage to the European artists Walter Spies and Le Mayeur, both of whom lived and worked on Bali; the dining room is a reconstructed Chinese Kang Xi temple that is over 300 years old; and the Bale Puputan, a small meeting room, commemorates a dark moment in Balinese history—the ritual mass suicide 90 years ago of noblemen and their families before the guns of the Dutch colonialists.

The hotel's buildings are separated by a maze of narrow, meandering pathways with low doorways that serve as discreet entrances to the suites. A wooden walkway (left) connects the Le Mayeur Suite to its private dining pavilion (see pages 62–63). The Balinese door beside the private pool of the Dedari Suite (right) leads through to the gardens and the beach. Over 100 years old, it is unusual in that it features painted *wayang* puppet figures instead of the more typical elaborate carvings. Sitting either side of the old-style table and chair are *loro blonyo*, the inseparable pair of statues representing Dewi Sri, the goddess of rice and fertility, and her consort Raden Sadono, that are traditionally placed before the family altar in Javanese houses.

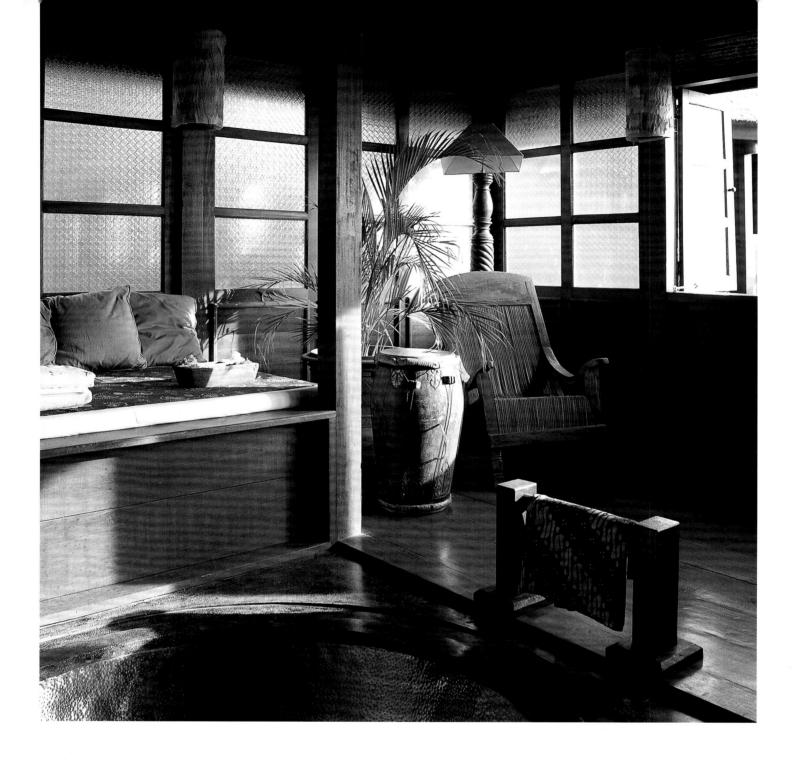

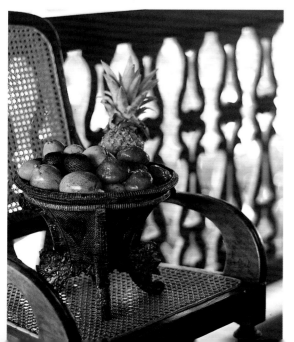

Anhar's interior design is all about creating atmosphere, about recreating "a romantic feeling of the exotic east, a feeling of the past". Eclectic pieces of furniture, artefacts, paintings and textiles all tell a story. Even the fruit baskets are antique at the Tugu Bali (left): this rare example was traditionally used by high-ranking people in Java and Madura. A striking feature of the resort's bathrooms (above) is a big-enough-for-two circular stainless steel bath, made locally and beaten by hand. Beside the bath is a Javanese day bed, traditionally used for safe keeping of valuables or rice, but now used as a massage bed. The walls are made of wooden panels from a Javanese village house, that sit well under the traditional Balinese *alang-alang* roof.

The large four-poster bed (right) has cotton fishing-net curtains that can be drawn for that all important feeling of old-world romance. Lying across the bed and ample armchair are strips of batik fabric from Tuban, East Java. Each room has original artwork—there are no Impressionists' prints here. This painting is by Nyoman La Nusa, from Peliatan, near Bali's artistic centre of Ubud.

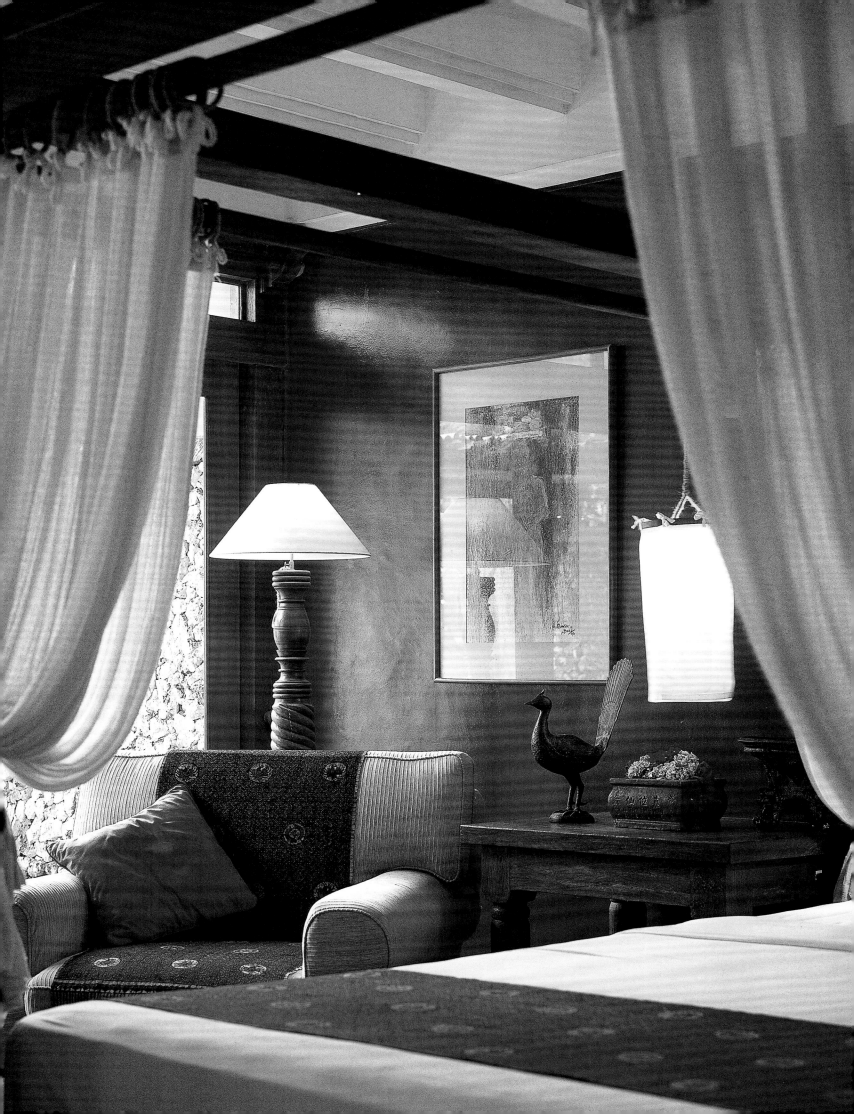

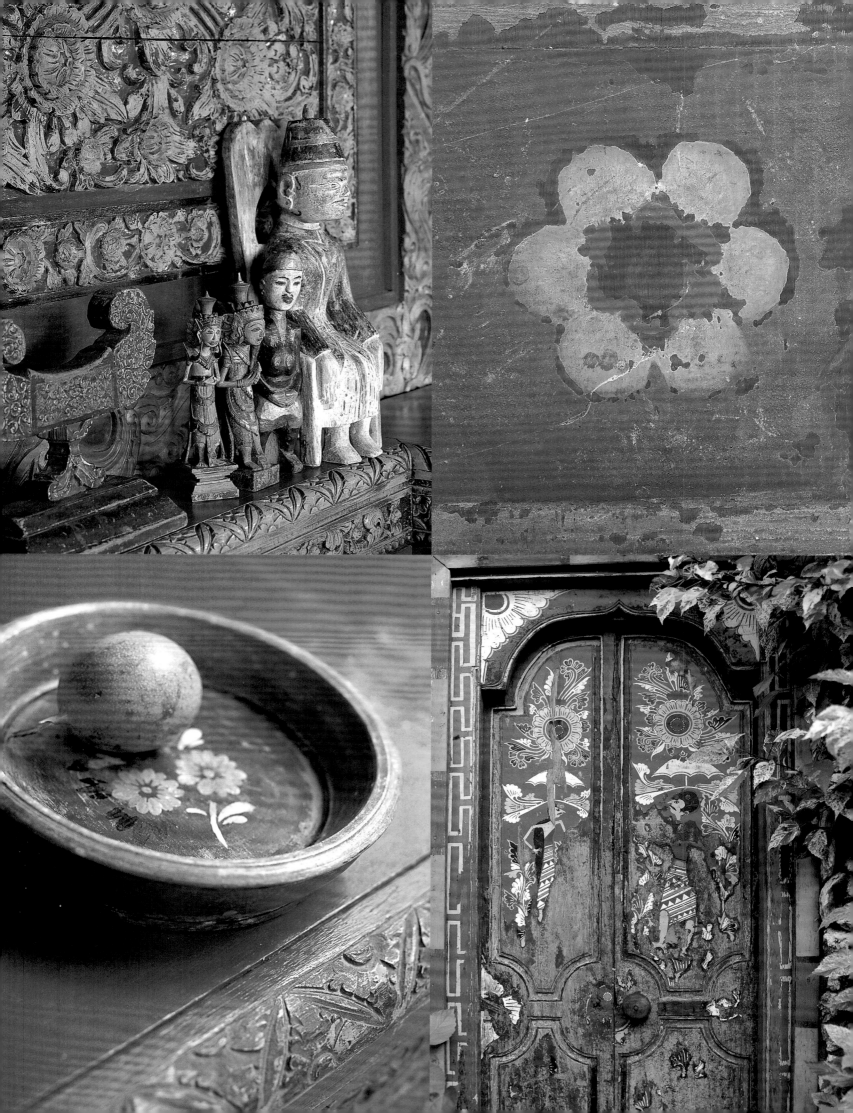

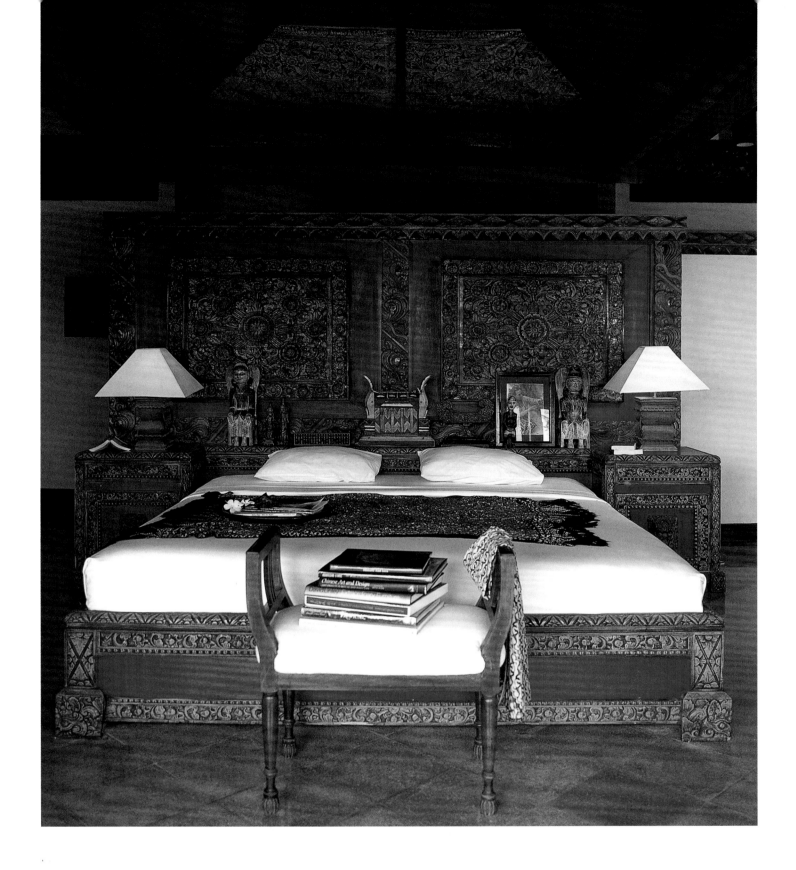

In the 1970s, when it was fashionable in Indonesia to be 'modern', many people discarded the old and the traditional. Anhar looked on in horror as what he saw as his country's heritage was thrown away without so much as a backward glance. So Anhar bought in a bid to preserve his country's rich and interesting past. His Bali property was built to house his impressive collection of art and artefacts related to the island.

This suite (above) is a tribute to the Belgian artist Adrien Jean Le Mayeur de Merprès who lived in Sanur from 1932 until his death in 1958. It is filled with crimson and gold furnishings and other memorabilia from the artist's estate, bought from his widow and muse, *legong* dancer Ni Polok, before she died in 1986. Anhar prefers to buy his antiques from the original owners: "I want to know the history, the story behind them."

island contemporary

The contemporary architecture featured in this section is all about creating buildings that are ethnic in spirit, yet have been reinterpreted in an innovative and modern way. It's about extracting the essence of traditional design principles and forms and reworking them in a modern idiom to suit today's living environments.

Western architectural influences were introduced to the archipelago largely by the Dutch (the Portuguese and Spanish arrived earlier but their impact, in architectural terms, did not extend beyond the confines of the trading compound or 'factory'). The earliest Dutch merchant-adventurers tended to build more or less the same type of houses that they lived in back in Europe but over time they increasingly began to incorporate local architectural features better suited to the tropical environment. This resulted in the so-called 'Indies Style' of the late 18th and early 19th centuries—a hybrid of indigenous and European forms, exemplified by the magnificent country houses, or *landhuizen*, of Batavia. Sadly, these great mansions of the colonial era, with their exaggerated eaves and spacious

verandahs, have all but disappeared. However, in recent years, there has been a revival of interest in this style of architecture and new examples have risen to take their place. Jaya Ibrahim's splendid villa at Cipicong, near the provincial city of Bogor, is a fine example of a revival of the Indies Style in a contemporary manner.

In the years immediately following World War 1, a new generation of Dutch architects, trained in the Netherlands, sought to introduce a modernist agenda to the architecture of the Indies. Modernism advocated a rationalist approach to architectural design, which meant flat roofs and sheer facades—design features that were spectacularly unsuited to the tropical climate. Clearly some rethinking was in order and again it was the indigenous architecture of the region that provided solutions to the problems of designing for a tropical environment.

Traditional forms were reinterpreted in a modern way, but this time using modern materials. The result was homes of the 'New Indies Style'—a kind of 1930s' tropical art-deco incorporating local design elements. This unique

architectural tradition has been reworked in a contemporary way at the Chedi Hotel in Bandung; although new, it reflects the style of many of the old Dutch-designed buildings of this city in the hills.

The region's rich architectural heritage has also sparked the imagination of many of today's architects working in Indonesia. The vernacular style of the remote island of Sumba, for example, was the inspiration behind Uma Bona, one of the villas that make up Begawan Giri Estate near Ubud in Bali. Similarly, the super-deluxe Amanjiwo resort draws its inspiration from Java's classical past and in particular the nearby Buddhist monument of Borobudur. This is reflected not only in terms of materials and overall forms, but in also in the sensitive response of the buildings to their surroundings. The resort nevertheless still manages to achieve maximum levels of comfort and luxury.

As architectural historian William Curtistalks commented when talking about authentic regionalism: "The hope is to produce buildings of a certain timeless character which fuse old and new, regional and universal."

in the shadow of borobudur

At the foot of the mystical Menorah Hills in Central Java, within the shadow of the world's largest Buddhist monument, Borobudur, sits the 36-suite super-deluxe resort Amanjiwo. Part of the famed Aman chain, Amanjiwo was created by Paris-based American architect and interior designer Edward Tuttle and represents what many consider to be his masterpiece. His challenge was to build a resort on a site surrounded by towering volcanoes that was influenced by and sensitive to Borobudur, yet was innovative, contemporary and designed for modern living.

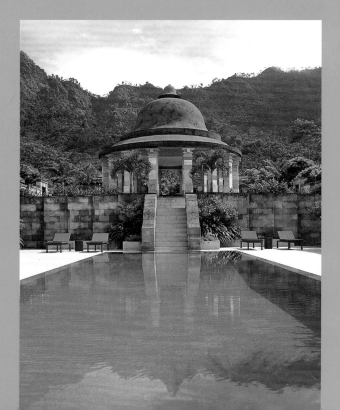

The inspiration behind the hotel's layout comes from the top three levels of Borobudur's mandala, and is almost Zen-like in its simplicity. At its heart is a monumental rotunda shaped like a wide, round Burmese bell (see pages 74–75) that sits on top of a circular sandstone monolith. Descending the steep driveway leading to the hotel, views of Borobudur are framed through the building's centre. At the front are the reception, gallery, library (right) and offices, while facing north is the imposing elevated dining room. To the west is the amphitheatre-like pool and restaurant embraced by columns, to the east the Dalam Jiwo suite (left). The suite's two free-standing bedroom pavilions share a rotunda *pendopo* overlooking a 15-m (50-ft) pool from which views of the active volcanoes pierce the horizon.

The major architectural motifs of circles, squares, diamonds and crescents pay homage to Borobudur, and are echoed in the interiors—from the carved wooden panels to the chairs (right). The resort was built with indigenous materials while the furniture and furnishings were made locally. The integrity of the design means that everything merges into a complete whole, conforming to the Javanese concept of *halus*, in which everything is refined, elegant and subtle.

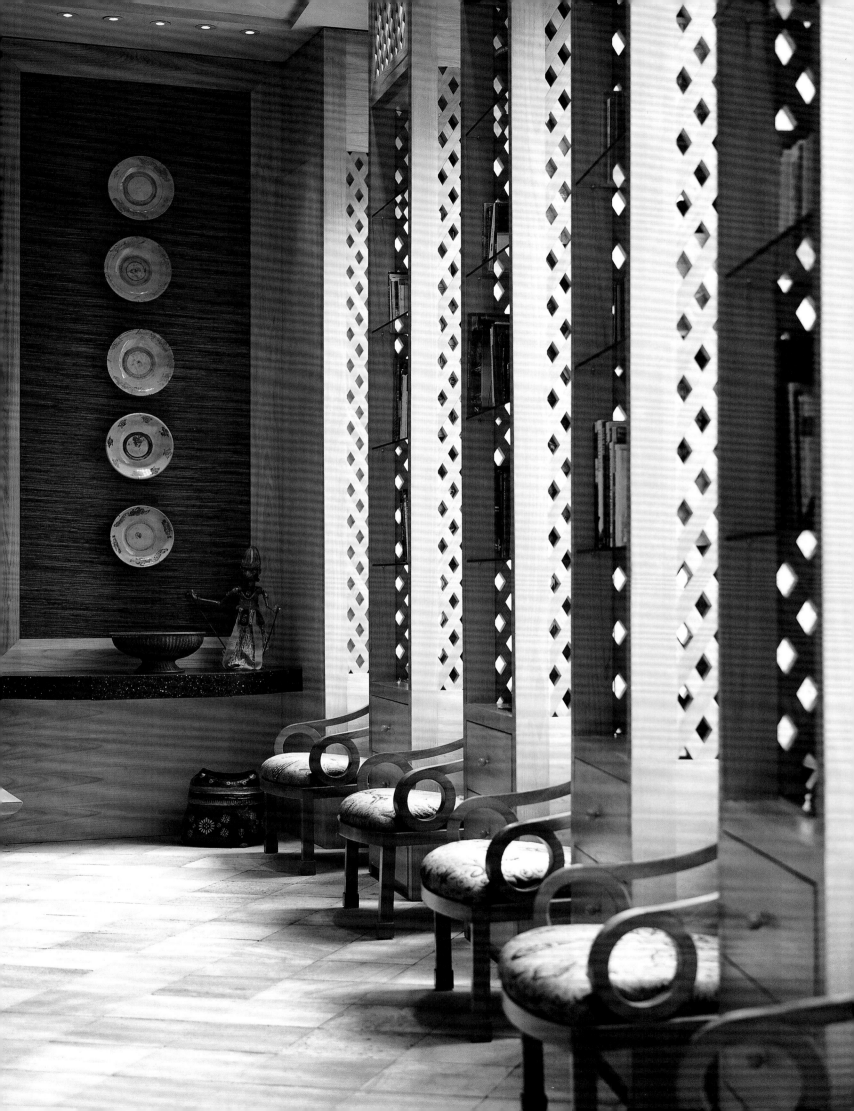

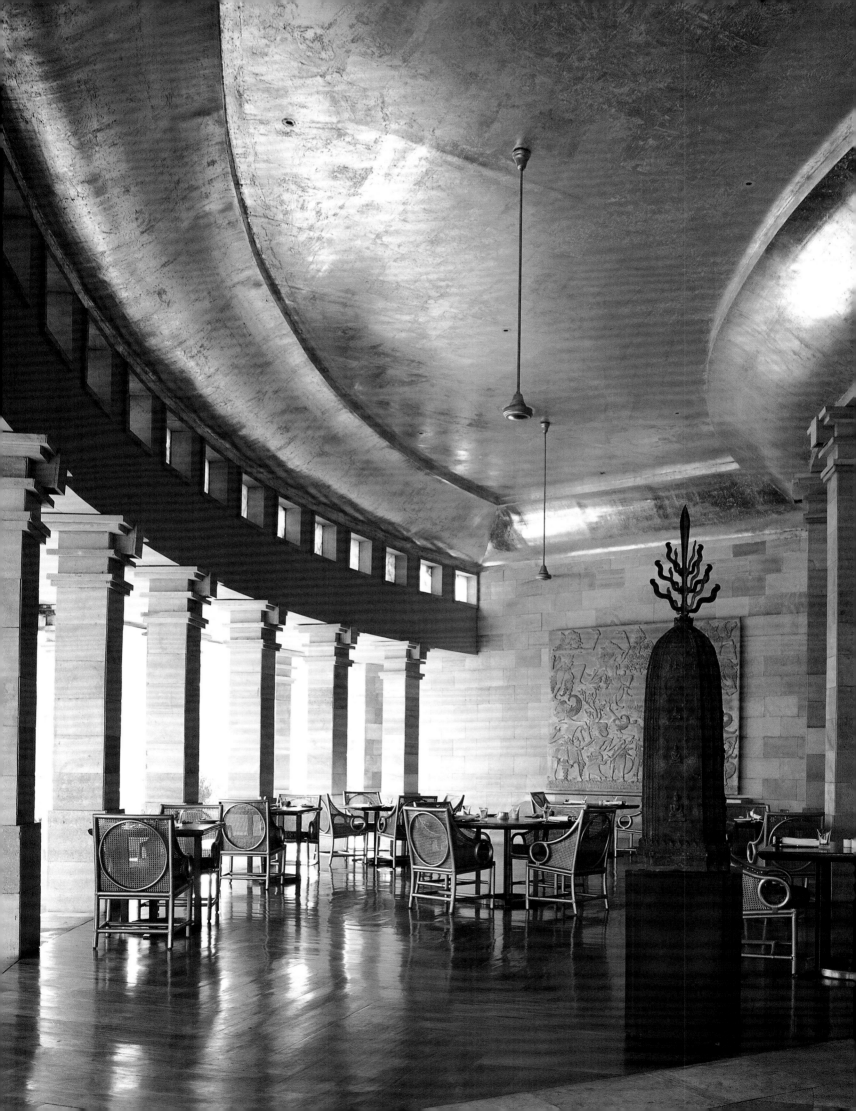

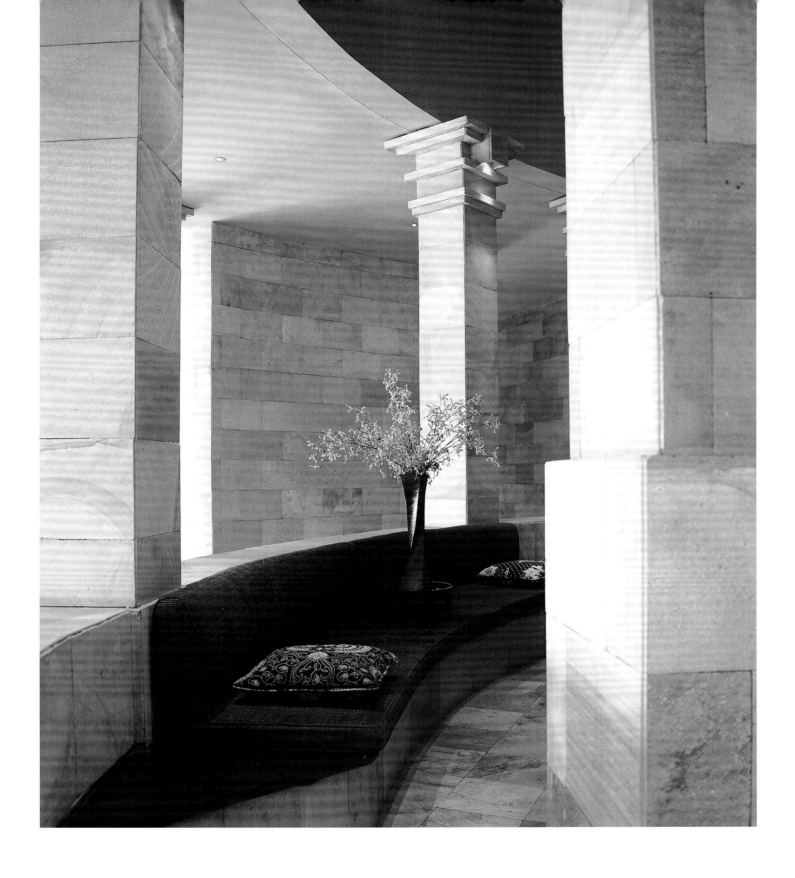

Tuttle has successfully infused a calm, temple-like quality into a modern building. This is particularly evident in the sweeping curves of the central rotunda's interiors. From the hotel's entrance, five steps (see overleaf) lead to the circular rotunda bar (above) which in turn leads to the imposing arcing dining room (left) with its impressive 6-metre (18-ft) high amber-washed silver leaf ceiling and *paras yogya* stone walls. Pale light is reflected through high rectangular windows lined with wafer-thin alabaster. The dining room looks out onto the crescent-shaped stone terrrace, its shape mirrored by the 36 suites laid out around it.

From here there are impressive views across the Kedu plain to Borobudur and four volcanoes—Sumbing and Sundaro to the west, Merbabu and Merapi to the east. The restrained palette of antique and faded gold echoes the predominant colour of the Buddhist monument. There is an openness and simplicity to the resort's design which, when placed within the breathtaking environment, creates a feeling of humbling silence. Fittingly, Amanjiwo translates from the Indonesian as 'peaceful soul'.

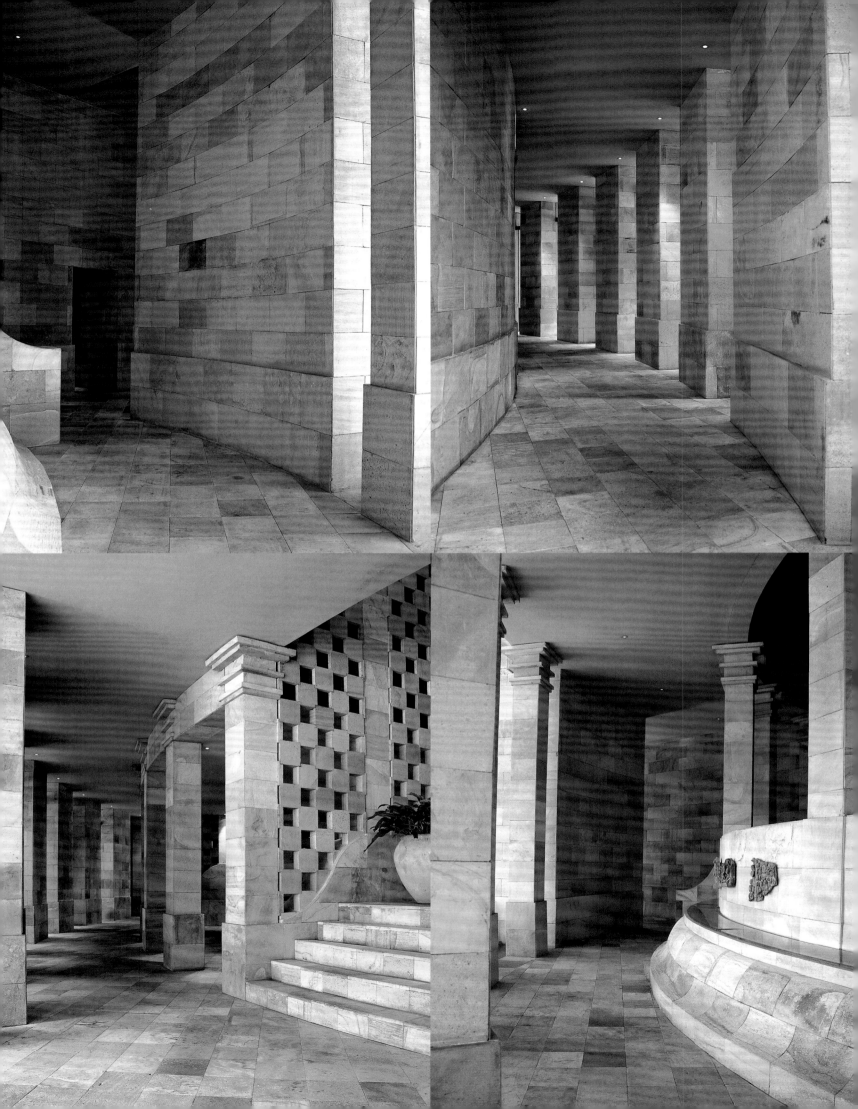

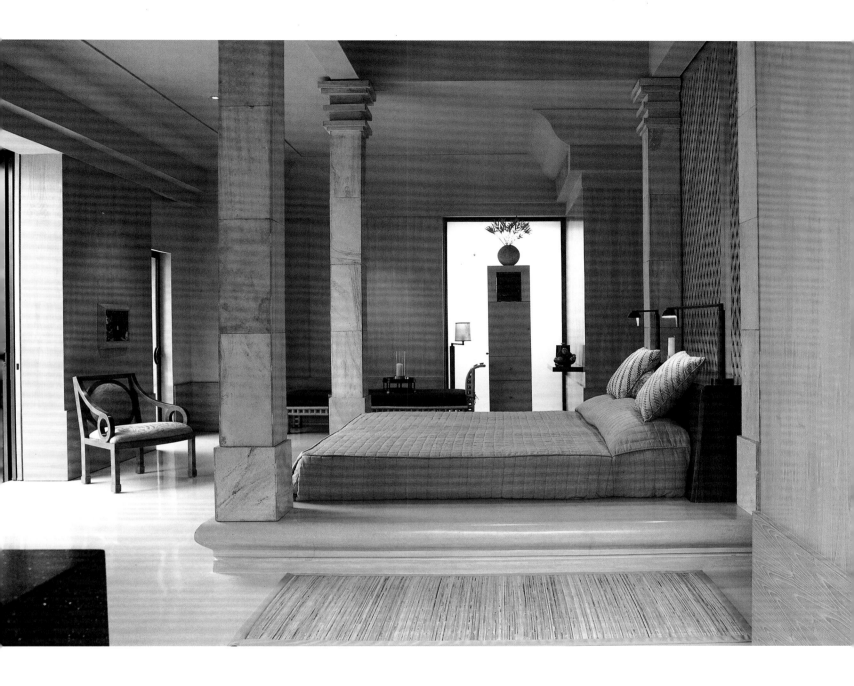

Tuttle has successfully combined the comfort level that is synonymous with an Aman resort with indigenous architectural traditions and materials. The resort's central sweeping circular monolith (opposite, left) is crafted out of *paras yogya*, a limestone found in the Yogjakarta area, and is all but entirely open to the Javanese country air. The walled suites (above), decorated in shades of sand, feature domed roofs edged by stone walkways with high walls. Behind the four-poster bed on a raised terrazzo platform is a diamond lattice *sungkai* wood screen. Other design features include coconut wood and rattan furniture, cushions made from old batik fabrics in classic Yogjakarta style and traditional reverse paintings on glass. Over the luxurious sunken bathtub, hidden behind the sliding screen, hangs an impressive brass *gamelan* gong.

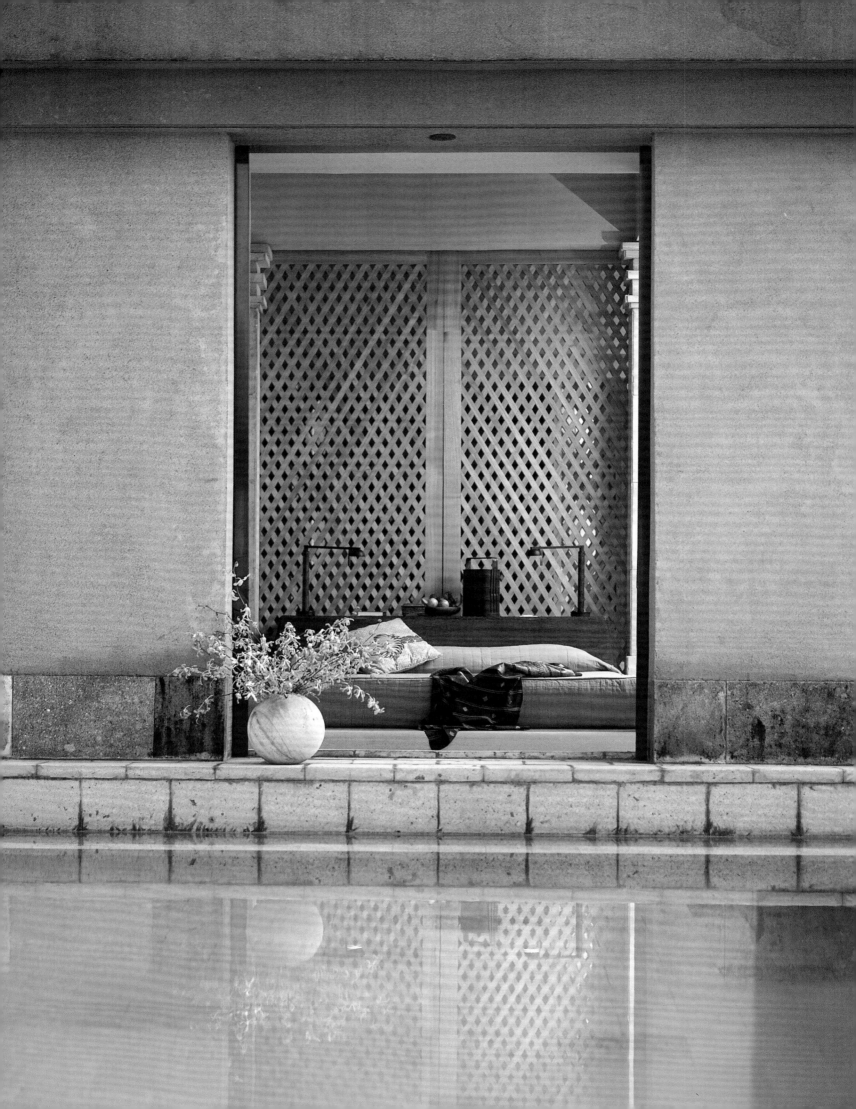

The resort's impressive 46-metre (151-ft) *batu hijau* swimming pool with its green tones (below) sits well within the picturesque Javanese landscape. Bill Dalton's sensitive landscaping makes use of mango, rambutan and banyan trees, and bushes that mimic the lines of rice terraces. He creates the feeling of travelling through the island's countryside. The colonnaded pool club and restaurant—built out of *paras yogya* stone—takes the form of an ancient amphitheatre, its columns giving it a classical air.

Fifteen of the suites feature private pools (above and left) within their garden terraces. Each has a thatched roof *kubuk* pavilion with a large day bed. Guests are often to be found sitting here, mesmerized by the view, making use of the water-colours supplied within the room, an unmistakable Aman touch.

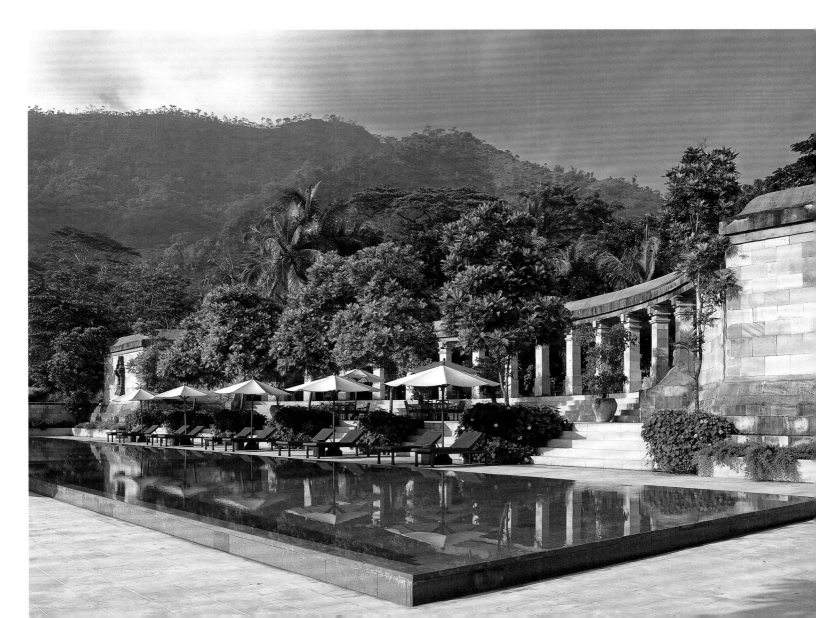

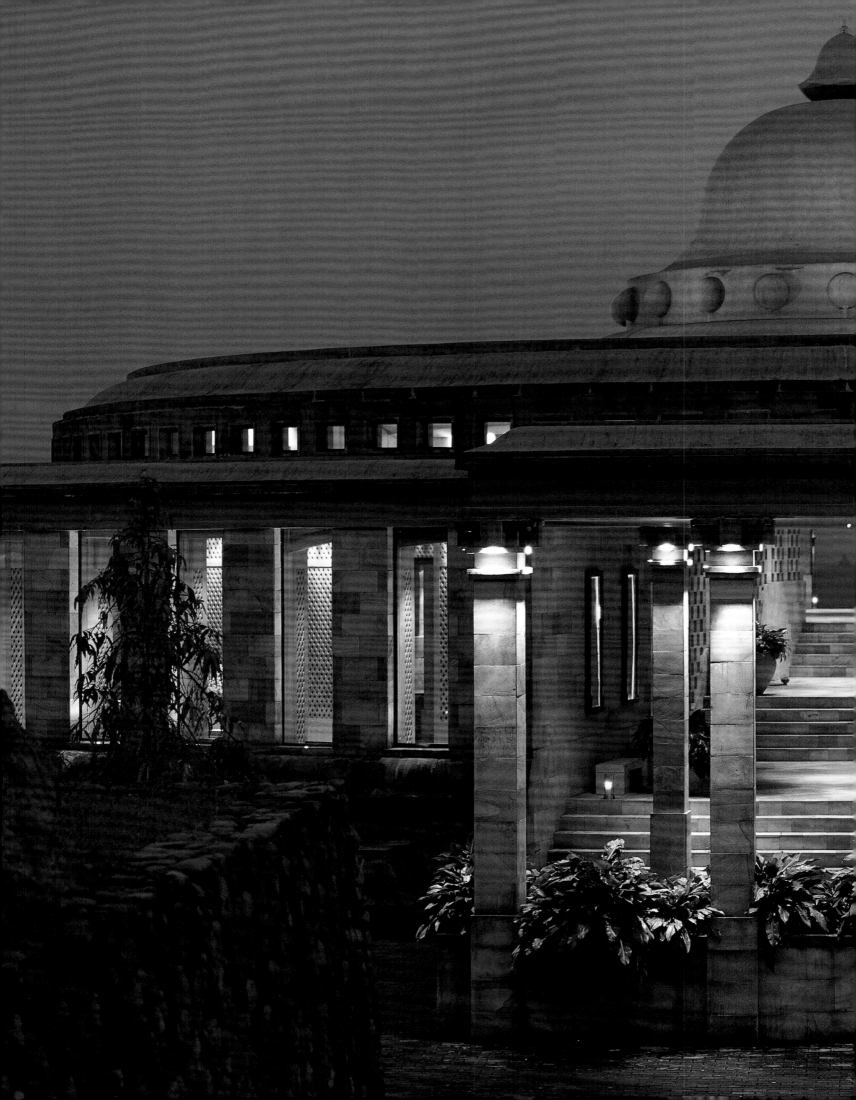

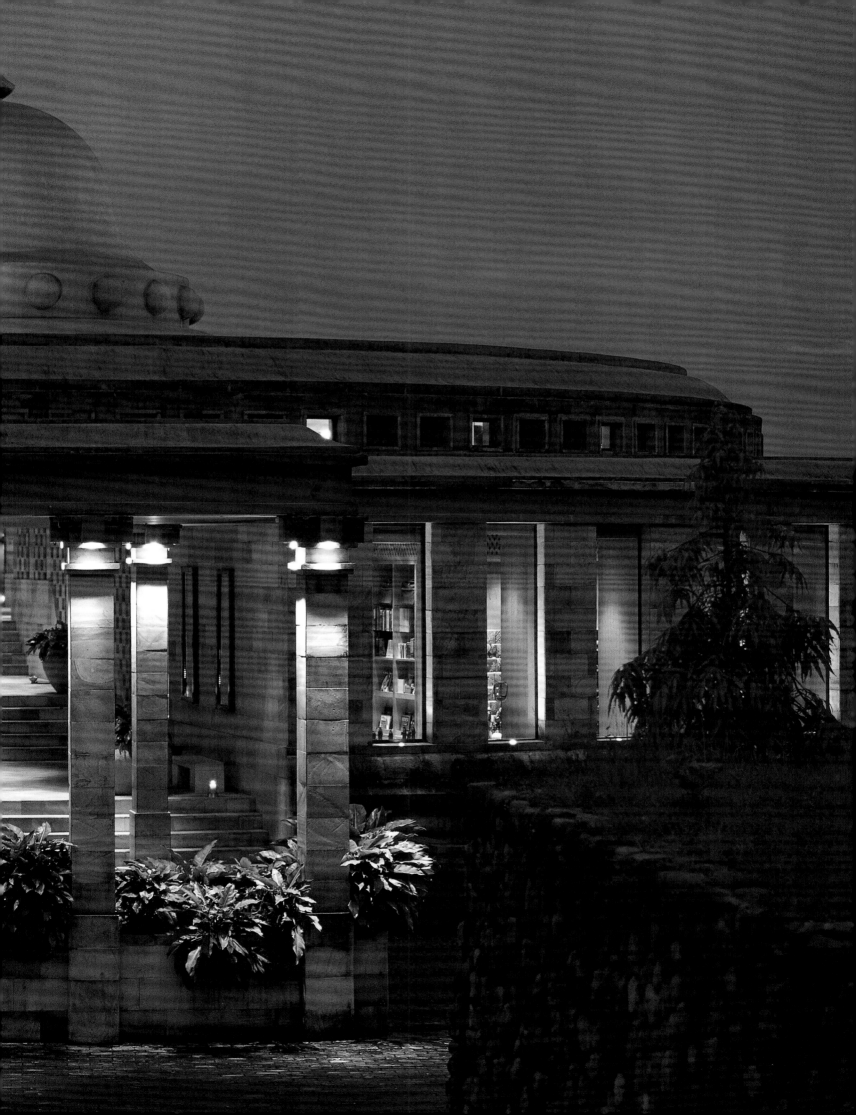

Uma Bona, Begawan Giri Estate

house of the earth son

Uma Bona, or House of the Earth Son, is one of five grand residences that make up Begawan Giri Estate perched high above Bali's dramatic Ayung River valley north of Ubud. All the residences have their own unique architectural style (see pages 24–31), reflecting different aspects of Indonesia's rich cultural heritage. This classic home, with its extravagant elegance befitting royalty, owes its origin to the Majapahit palaces of Indonesia's past. Nestled between two river valleys, it is perhaps the development's most spectacular site. It was here that owners Bradley and Debbie Gardner originally built a bamboo *wantilan* where they used to "sit and dream" and "listen to what the land wanted from us". Begawan Giri is their dream realized.

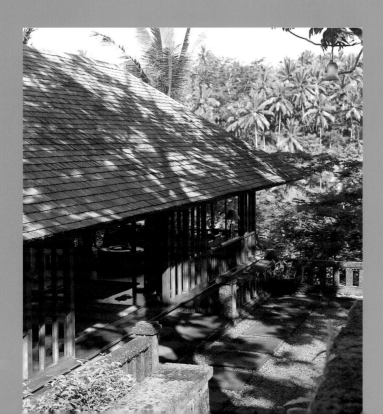

Uma Bona represents building on a grand scale. Taking the Majaphait era of the 14th and 15th centuries as inspiration, the architecture reflects the era's classical, rich and formal style. The property consists of a vast 180 sq-m (1940 sq-ft) Royal Suite, three terrace suites and an open dining pavilion complete with a wood-fired oven. Water plays a central role in the luxury of Uma Bona. On the lower level of the two-bedroom Royal Villa, spacious bathrooms lead out to a vast interior pool set within a central courtyard (right). At its centre is a reproduction miniature terracotta *candi* or shrine, reminiscent of a past era. From here, guests can swim out to a 20-metre (66-ft) infinity-edge pool (above) that cascades down to another pool below.

Uma Bona sits beneath roofs of ironwood shingles (left). Ironwood decks, made of recycled telegraph poles, run around the entire residence. An outdoor Jacuzzi provides the perfect place to look out to the stunning views of the river valley below and Mount Batu Karu in the distance.

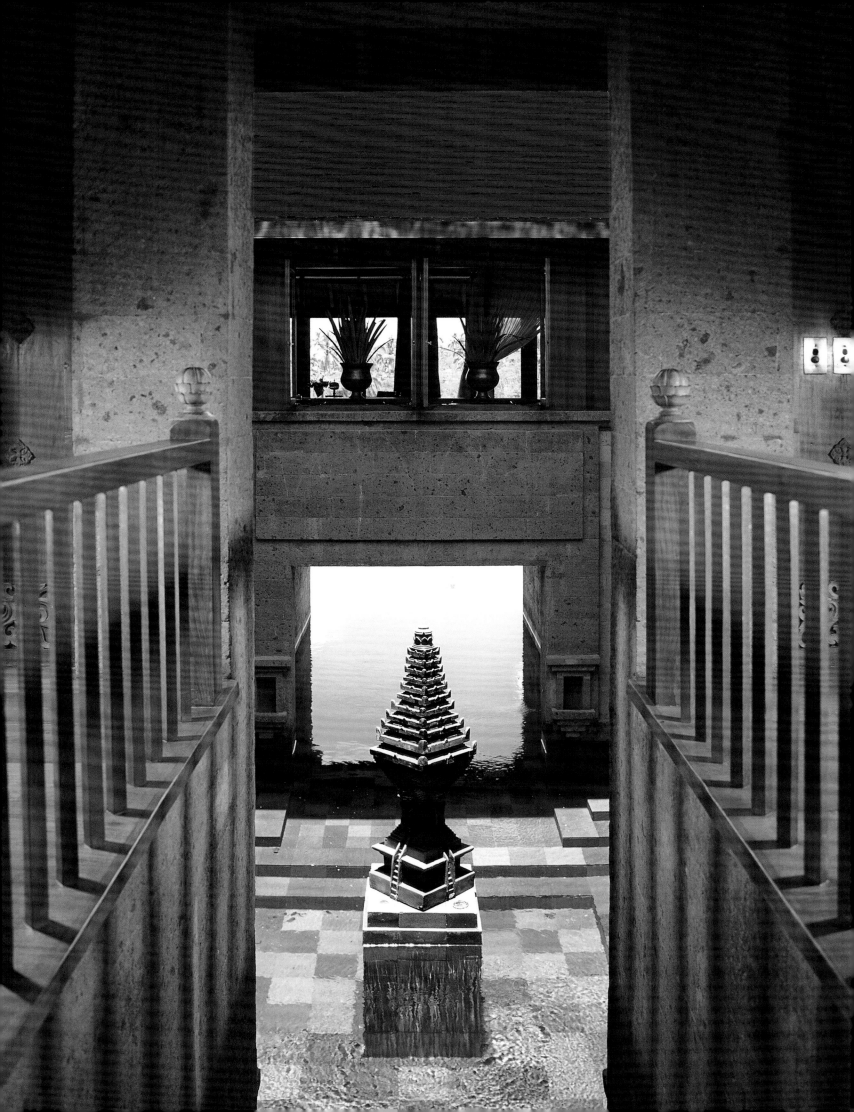

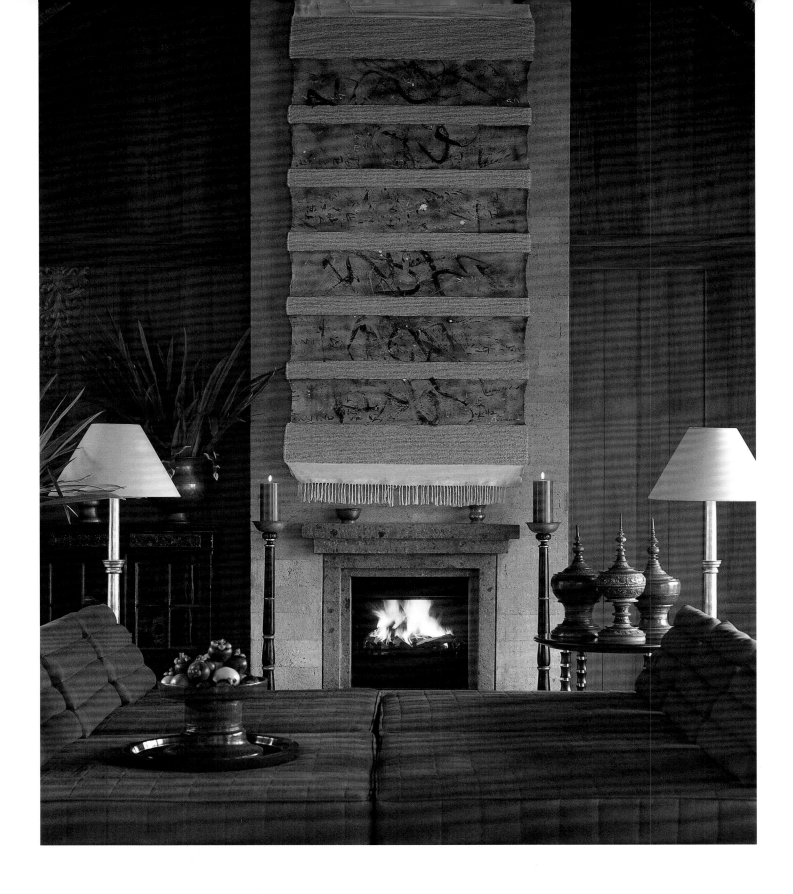

The interiors of Uma Bona are elaborate and rich, befitting its royal inspiration. Oversized day beds with triangular Thai cushions in the Royal Suite's sitting room (above) evoke a feeling of majestic luxury. A roaring fire in the stone fireplace warms the chill night air. An evocative painting by Indonesian artist Made Wijanta hangs above, matching the earth tones of the Balinese *paras taro* stone. A collection of Burmese lacquerware complements the dark green and red palette of the hand-woven Balinese ikat fabrics. Everything in Uma Bona is arranged in a formal, stylized manner.

The Royal Suite's master bedroom (right) is a study in opulence. A voluminous two-tier mosquito net hangs from the high timber rafters. The regal four-poster mahogany bed is set beside floor-to-ceiling windows that look out across the spectacular valley view. Long ikat drapes are arranged in a stylish fan shape. At the foot of the bed is a pedestal table on which a group of artefacts are placed, reflecting the reddish hues of terracotta and lacquer. By placing pieces from their own personal antique collection throughout the residences, the Gardners have created an individualistic, highly personal environment.

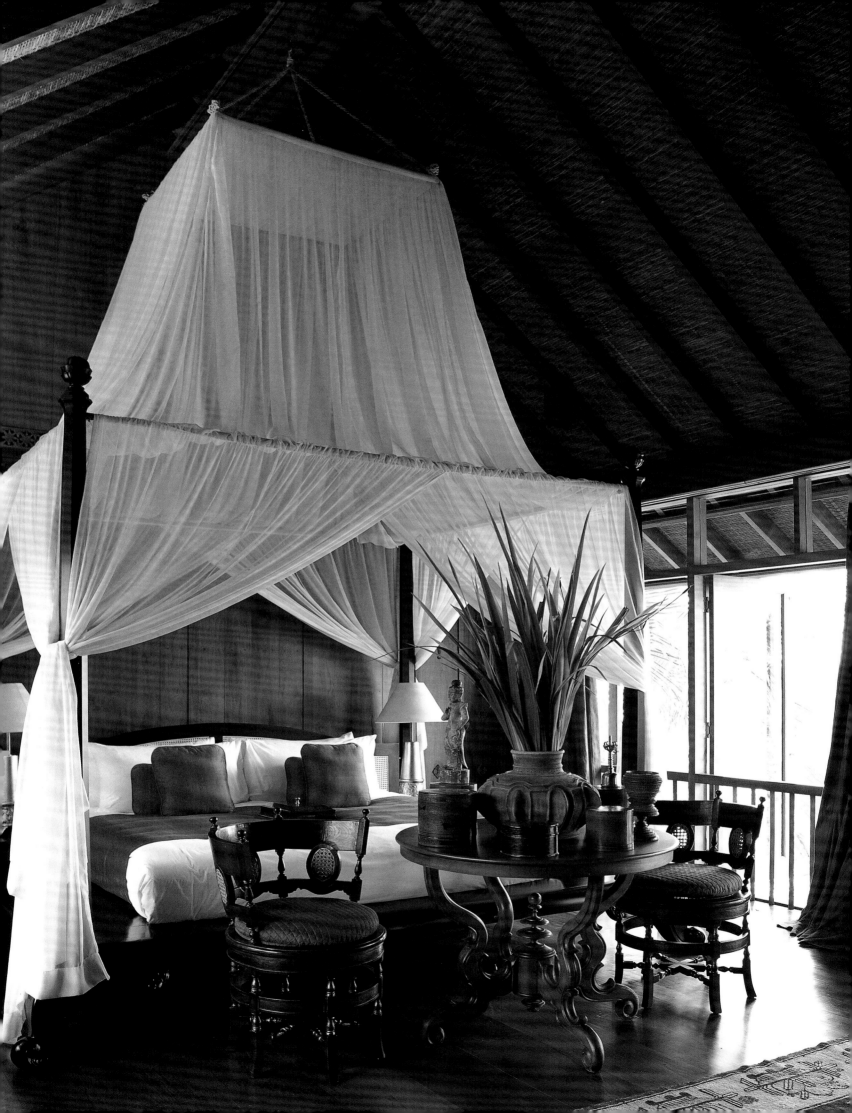

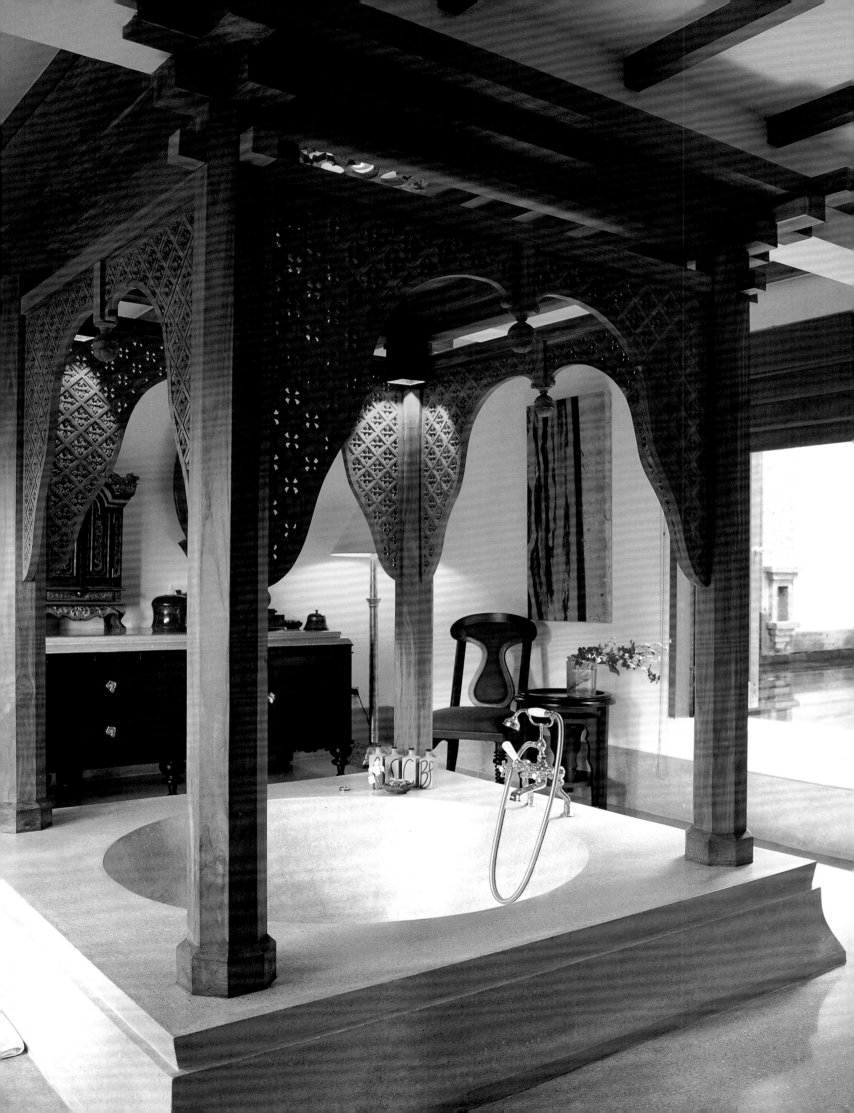

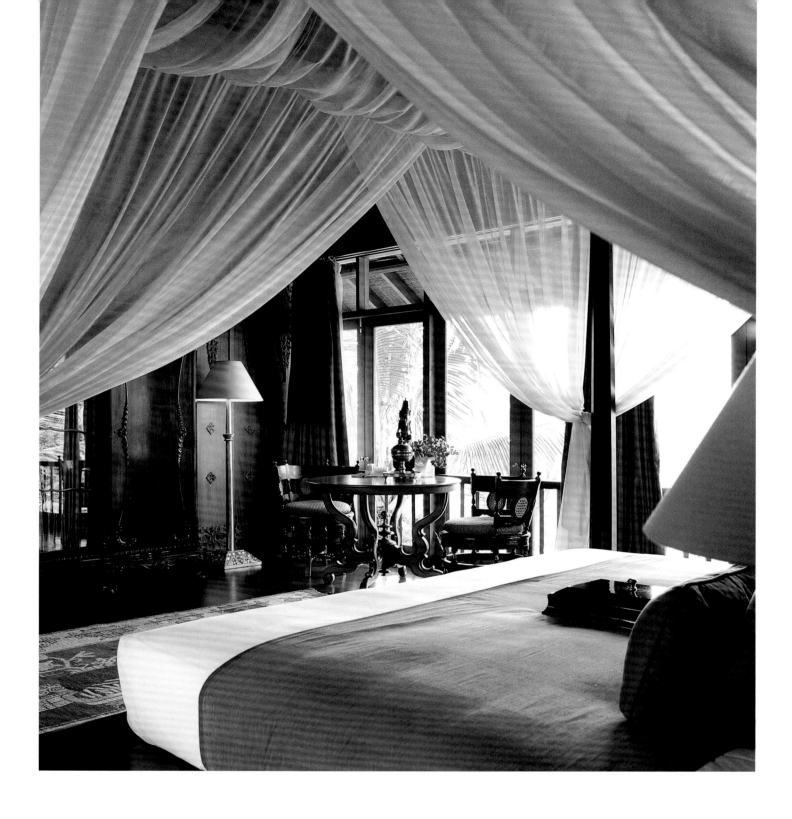

Uma Bona offers guests a seemingly endless choice of places to bathe in, both inside and out. Within the Royal Suite's bathroom is a luxurious circular orange terrazzo tub (opposite) surrounded by a carved wooden structure. Although this gives it a strong Moorish feel, it is actually a copy of a Javanese design. Similarly, the cabinet is a reproduction of a piece from the *kraton* (palace) in Yogjakarta. A doorway leads out to the interior pool area lined with *batu candi* tiles in shades of blue and grey. A sensual shower area is lined with carved stone friezes that are copies of erotic Indian temple carvings.

Also in the Royal Suite is a small bathroom that reveals one of the owners' passions: antique Victorian enamel sanitary ware (right). It is a testament to the Gardners' belief that everything within Begawan Giri "has to be different".

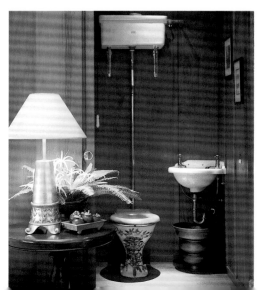

the art of design

Renowned Indonesian interior designer Jaya Ibrahim designed his one-storey Jakarta residence and studio as an extension of his weekend retreat in Bogor (see pages 98–109). Although the one-bedroom property is relatively small, Jaya has organized the interiors in an ordered and well-constructed manner to create the feeling of a much larger property. "I like dealing with spaces," he says, "I like to compose things." As this is where he works, he has filled the modern house with things that inspire him. "I must have a connection with the past," he says, "I can't design in a void."

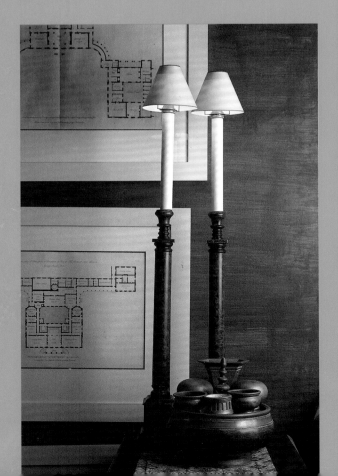

The house, located in a residential area of South Jakarta, consists of a bedroom and bathroom, a large dining room that doubles as a working area, a kitchen, an office and a sitting room. Jaya has used colour both to harmonize and differentiate the spaces. In the sitting room (right) he has painted the walls a dark green to reflect his bronze collection; in the bedroom the red walls mirror the colour of lacquerware, while in the dining room the two colours are joined in a red and green striped fabric.

The trademarks of Jaya's design style are balance, order and arrangement and they are very much in evidence within his studio. Lamps are always to be found in pairs. In the sitting room (left) two reproduction ebony and ivory candlesticks are placed in front of a series of framed 17th-century lithographs of floor plans of English houses that are used, he says, as a "kind of wallpaper". The sofa is a Biedermeier copy. Throughout the room are examples of beautiful Indonesian textiles, one of Jaya's passions.

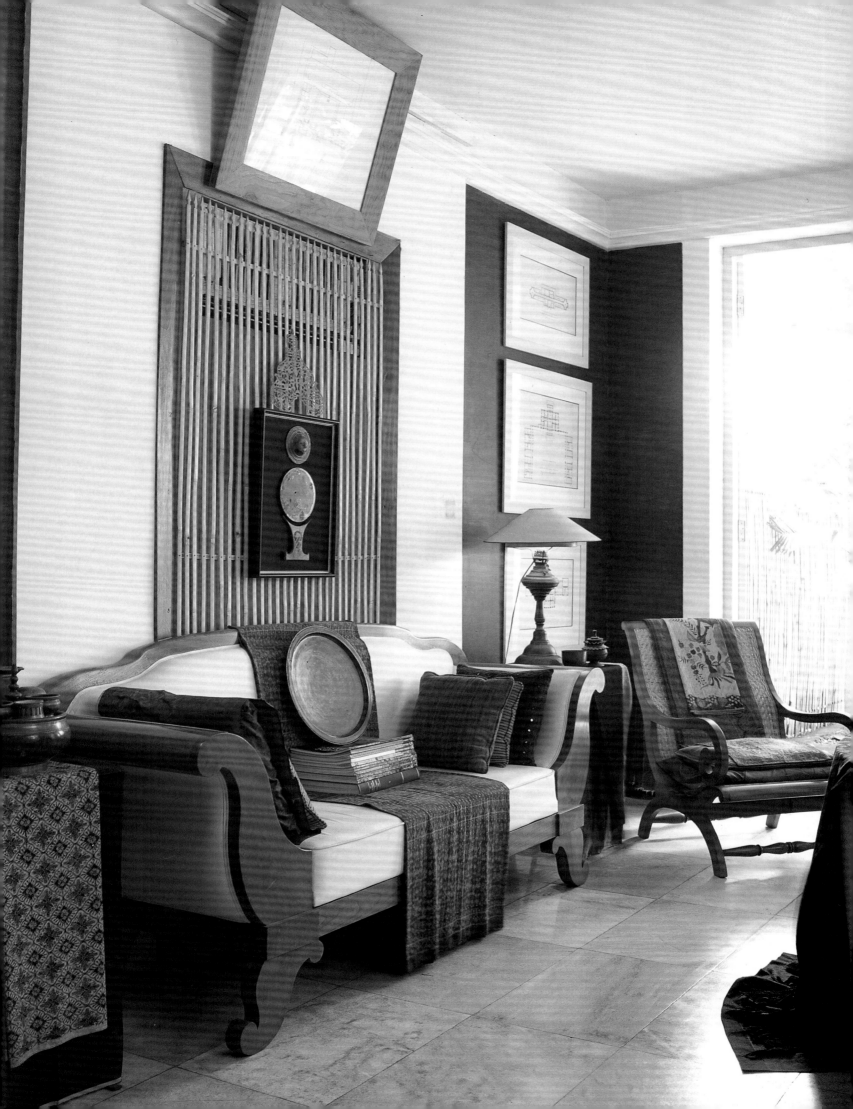

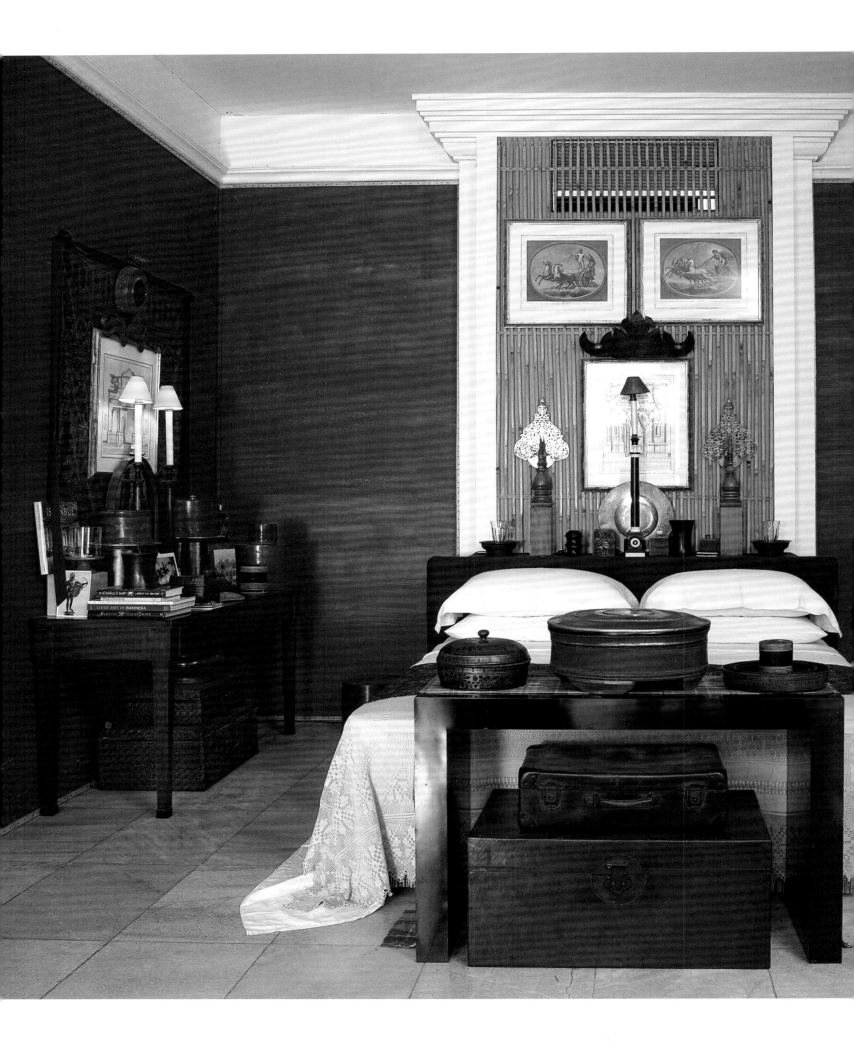

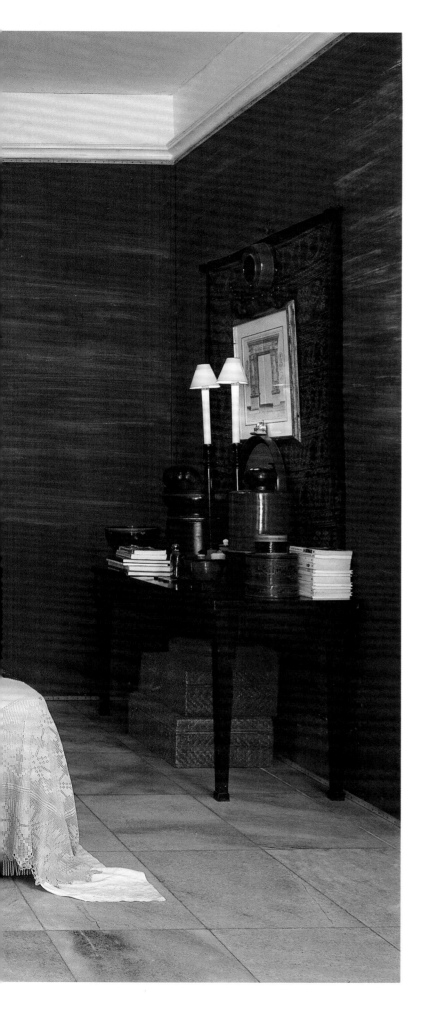

Jaya is a compulsive collector but rather than display pieces statically in glass-fronted cupboards, he uses them as an integral part of his interiors: his style is about blending and layering these elements from the past. Jaya's collection of Southeast Asian lacquerware, for example, is the main feature and design element of the bedroom (left). "My collection of lacquer baskets and boxes is from all over the region," he says. "They are from Burma, Sumatra, China, Thailand, Java—but they all have an affinity. I love the colours—the variations of reds and oranges." These deep, rich colours find an echo on the walls, painted in an imitation of silk. A large Chinese lacquer dim sum box at the foot of the bed is home to just part of Jaya's collection of fine Indonesian fabrics. Here he keeps the first sarong he wore as a child. Above the bed are French engravings of Sol and Mars, and the three arches of Imperial Rome. Above this picture is a bridal crown from South Sumatra, providing touches of green. Under the tables is a collection of old travelling boxes, suitcases and trunks.

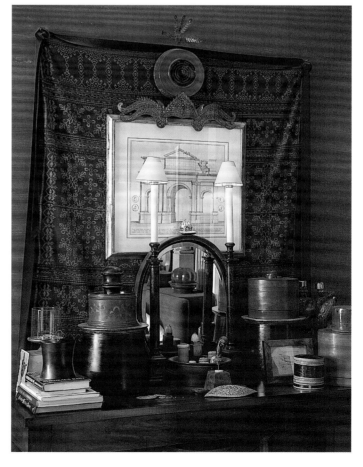

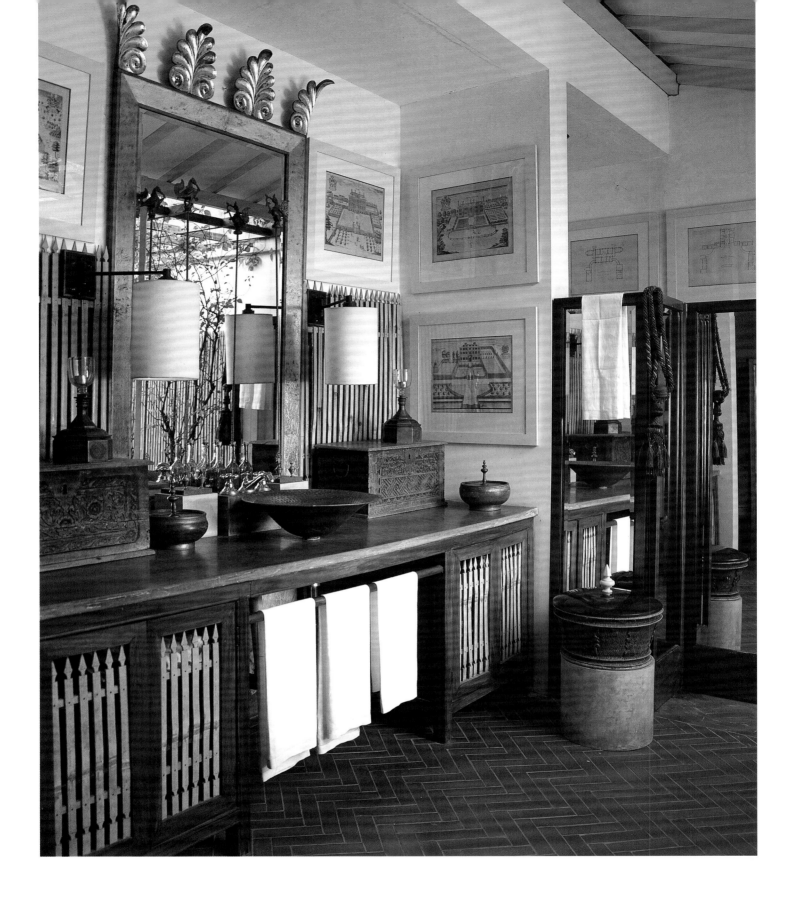

The bathroom (above) that lies off the bedroom is open to the internal courtyard garden. Carved, pointed bamboo slats are used at the front of the cupboards and at either side of the mirror, providing texture. A free-standing wash basin is placed on the marble counter. On top of the gilded mirror is a Javanese revision of a Greek leaf design. At its side sit 80-year-old Madurese dowry boxes. The glazed terracotta floor is a herringbone design. On the walls are prints of English garden designs.

"I like the strictures of English gardens," says Jaya, "where trees and shrubs are planted in a pattern." This love of order and considered placement of objects is fundamental to the Jaya Ibrahim style of design. In front of the tall French doors that lead out to the bathroom and garden is a neo-classical desk (right), a piece designed by Jaya. The art-deco chair is from the 1930s. On the wall are old prints of Indonesian scenes that all have a connection with Sir Stamford Raffles.

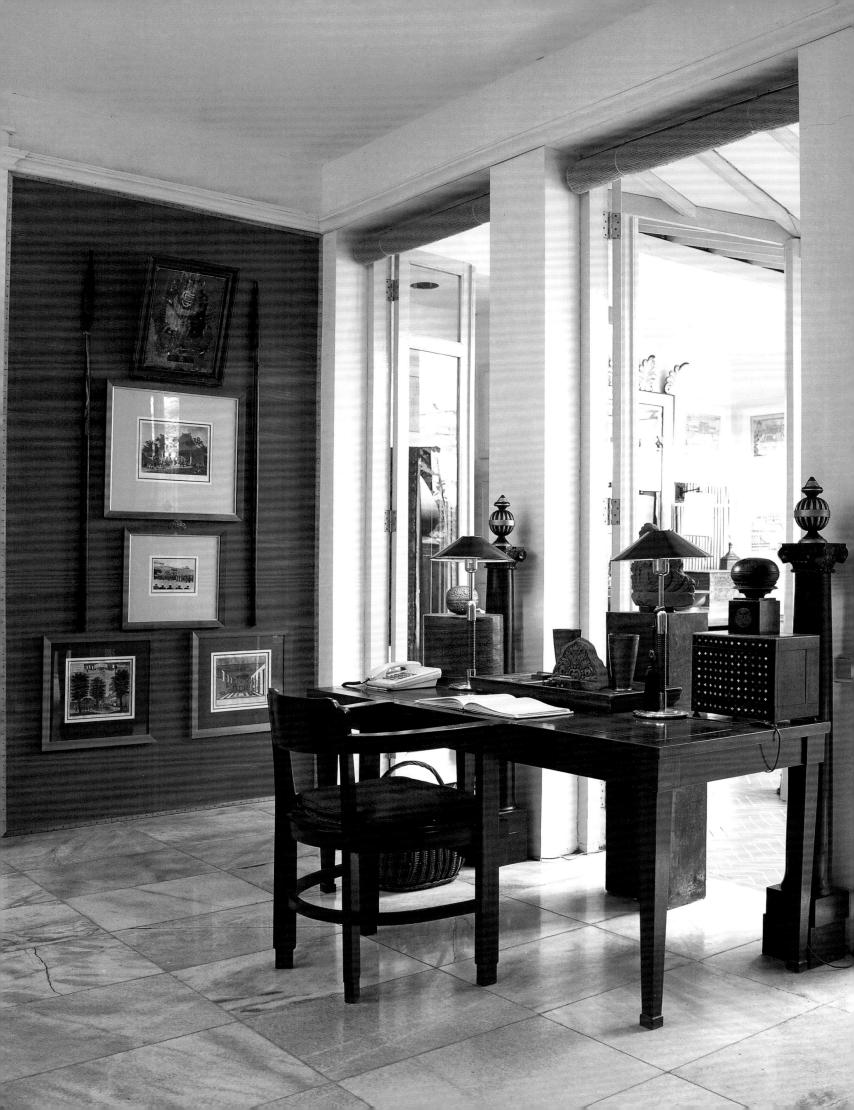

Yusman Siswandi house

contemporary village living

In a small village close to Java's oldest cultural centre of Solo is the house of Yusman Siswandi, a partner in the Indonesian company Bin House, renowned for producing beautiful handmade silk batiks. An anthropologist by training, Yusman has expressed his interest in Indonesia's past by taking antique furniture and artefacts and placing them within a modern setting. Although his home is rooted in the traditional design of Javanese village houses, it is decidedly contemporary. The most defining characteristics of the house, designed by the owner, are the internal brick-work, used to create texture, and the integral use of water features.

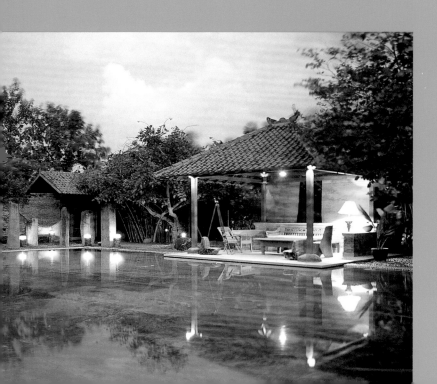

The Yusman house conforms to the ancient Javanese principles of progression, whereby guests move from the formal greeting areas at the front of the house through a series of rooms into the intimate heart of the property, called the *dalem* (right). At its entrance is a large open *pendopo* pavilion, home to *gamelan* musical instruments used by the villagers. Separating the interior of the house from a semi-enclosed exterior verandah is a carved teak divider (overleaf), a copy of an old design reproduced in Yusman's company workshop. A walkway over gleaming pools leads into the main house. Boulders from Bogor add a natural organic feel to the brick walls while blue Flores pebbles contribute a touch of colour. The European-style louvred shutters on the bedroom windows suit the Indonesian climate.

A giant reflecting pool (left), inspired by flooded rice fields, has been constructed in the walled enclosure at the rear of the house. Placed within it are a series of megalithic stones from West Java that are thousands of years old. A tiled pavilion provides an atmospheric sitting-out area.

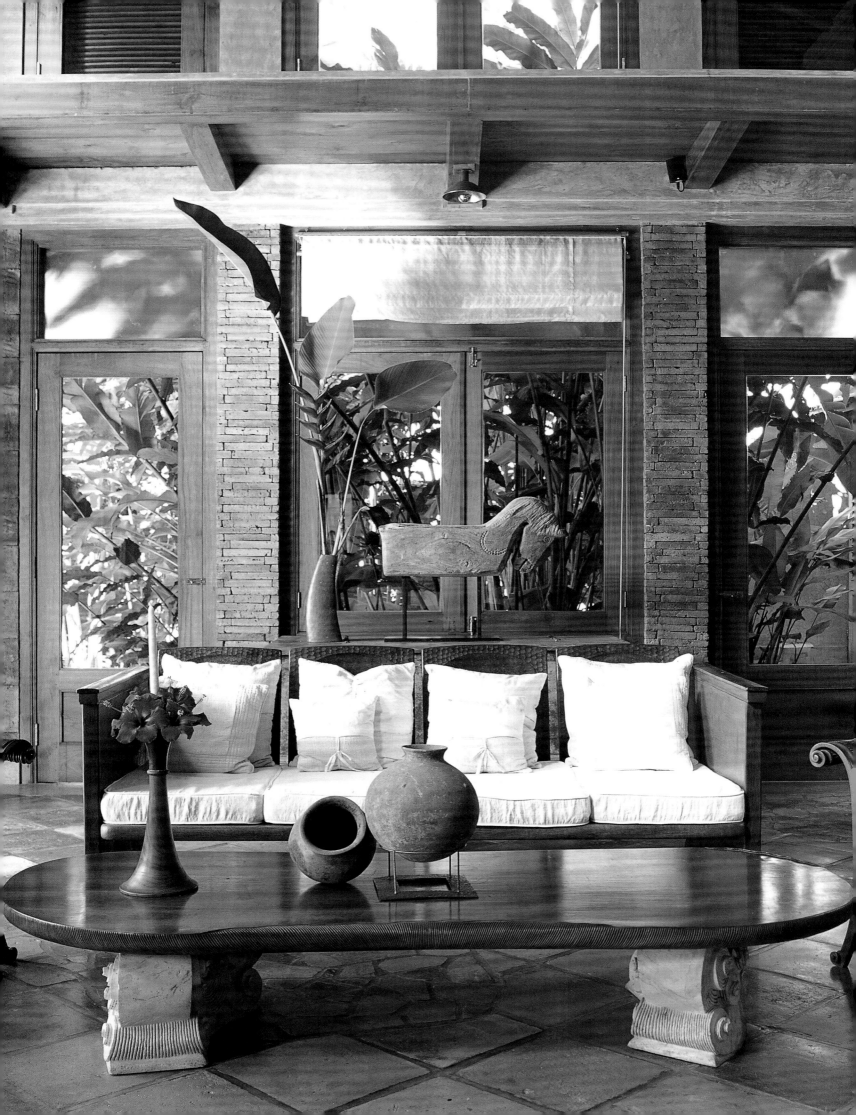

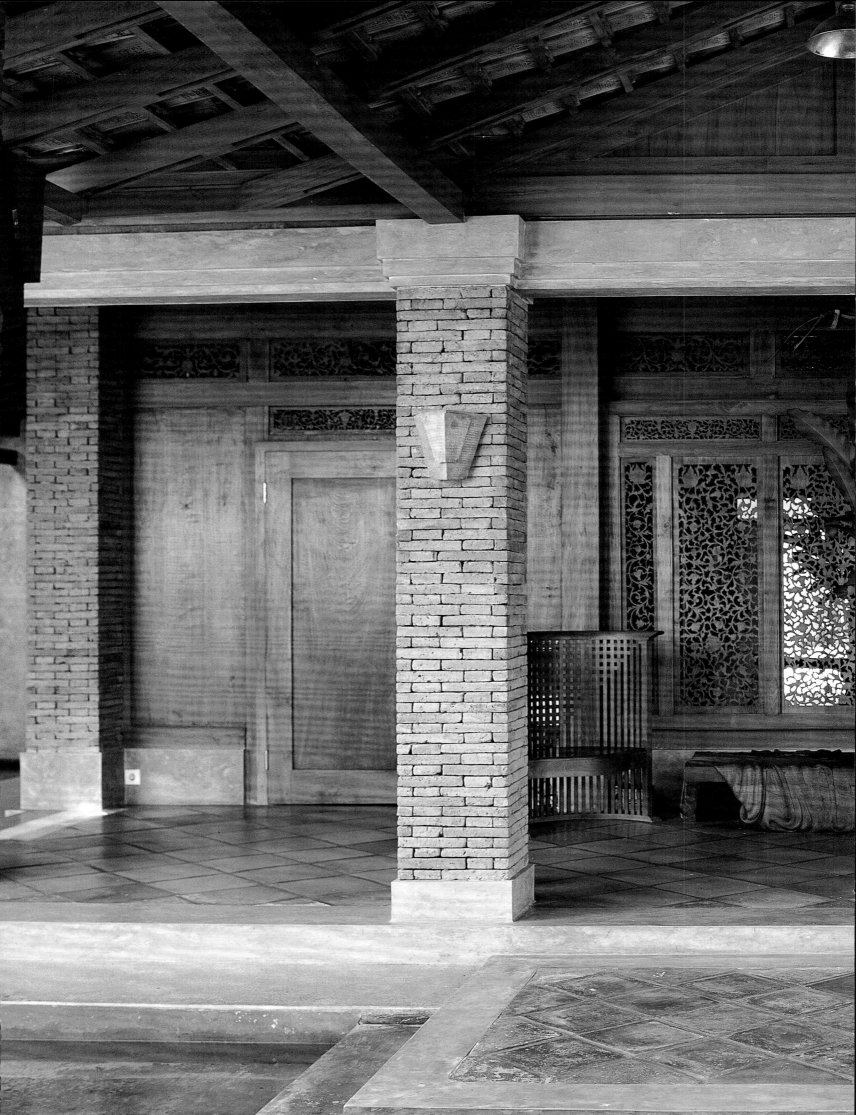

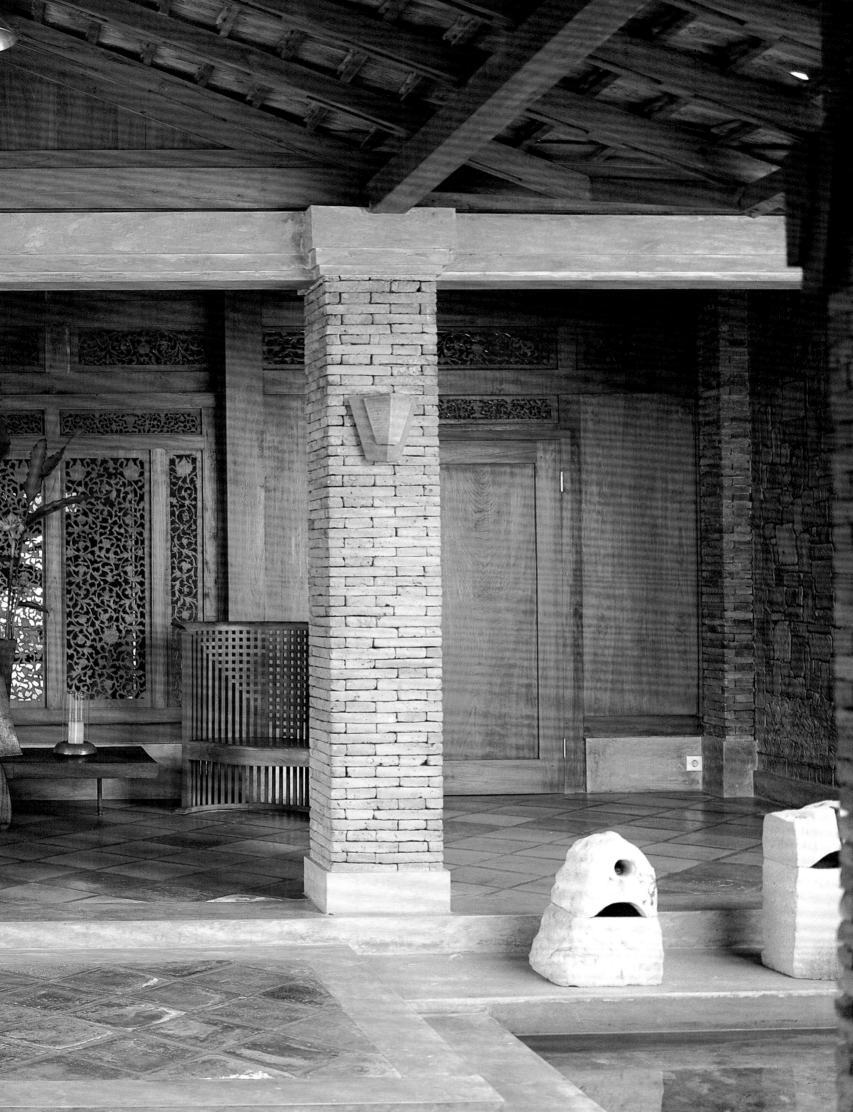

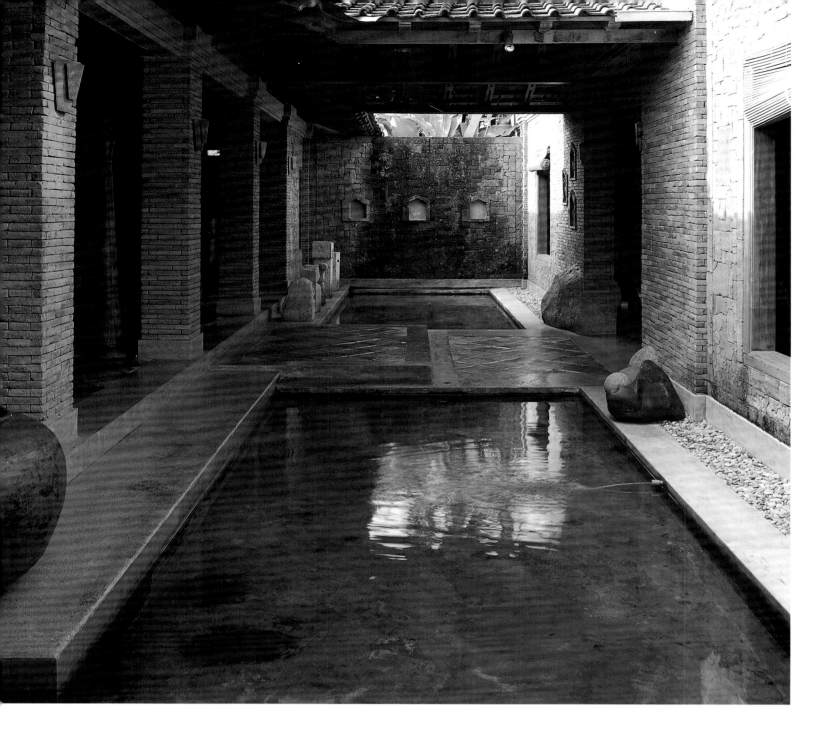

When designing his house, which took four years to complete, Yusman wanted to keep it unobtrusive. "I wanted to keep it close to the style of the other houses in the village," he says. He chose brick for the exterior and interior walls because in Java this signifies "the house is not yet finished" as the final layer of plaster is missing. The interiors are marked by monochromatic, earth tones through the use of brick and teak. Most of the wood is old and had been salvaged from dismantled houses, but it was also sanded back to its natural state to give it a new patina.

The guest bedrooms are reached via a series of granite stepping stones (right) that were previously used at the entrance to an old Chinese house. Giant Javanese copper water pots and a 9th-century statue of a Hindu temple guardian have been placed within the front courtyard. Yusman designed the house to maximize air-flow and natural light. Glass ceiling blocks in the roof of the courtyard and tall windows set high above the main living room allow daylight to stream into the interior. A picture window (opposite) looks out to the courtyard water feature (right), while glass doors open on to the reflecting pool.

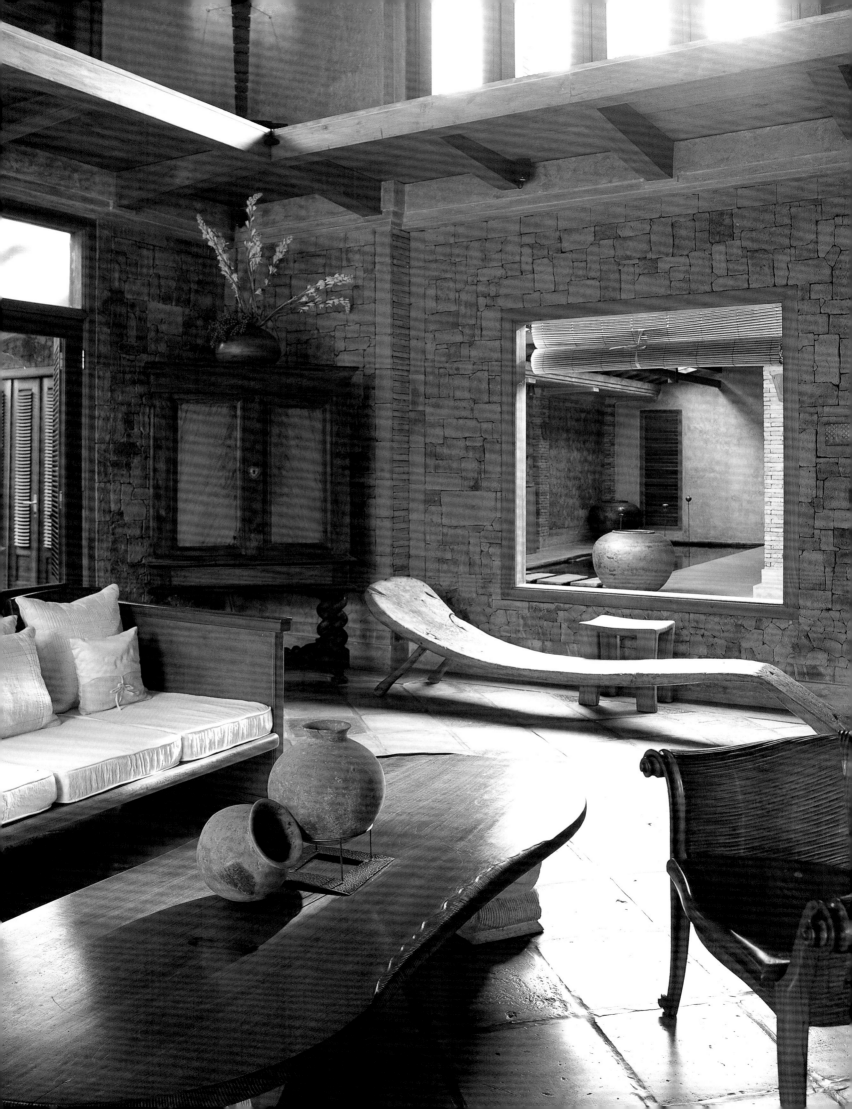

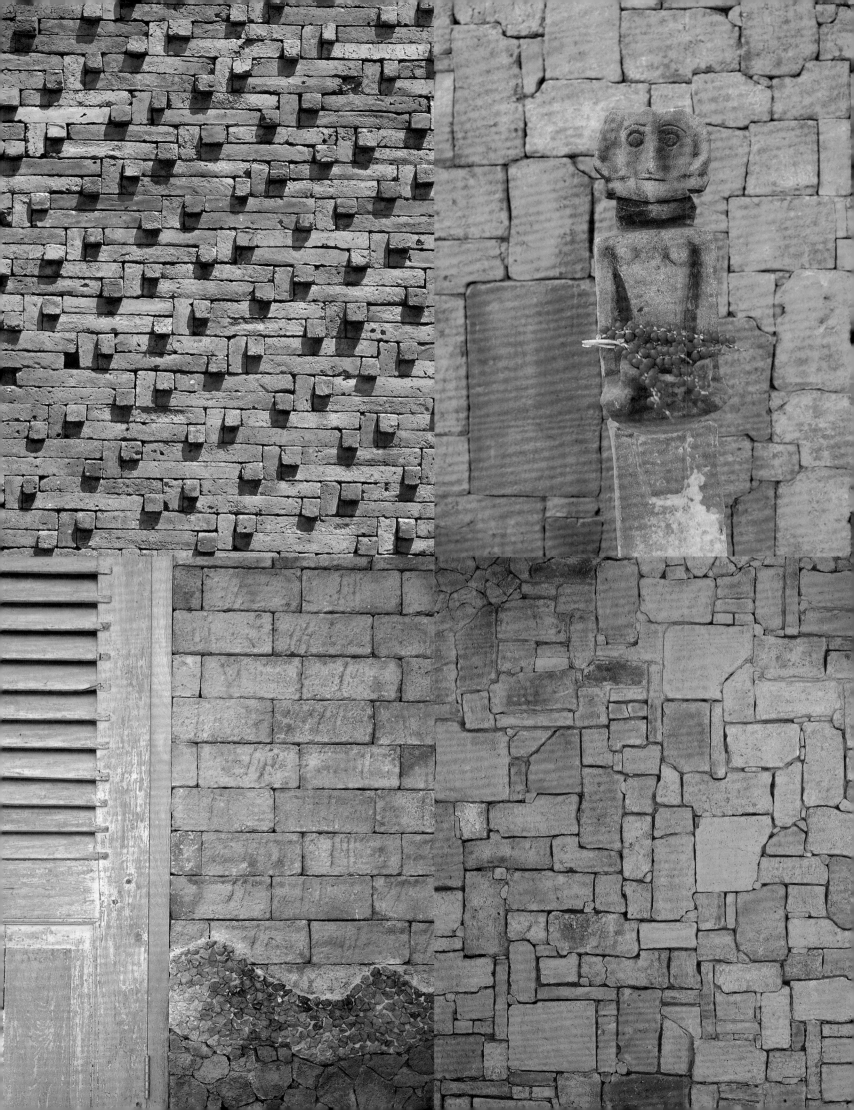

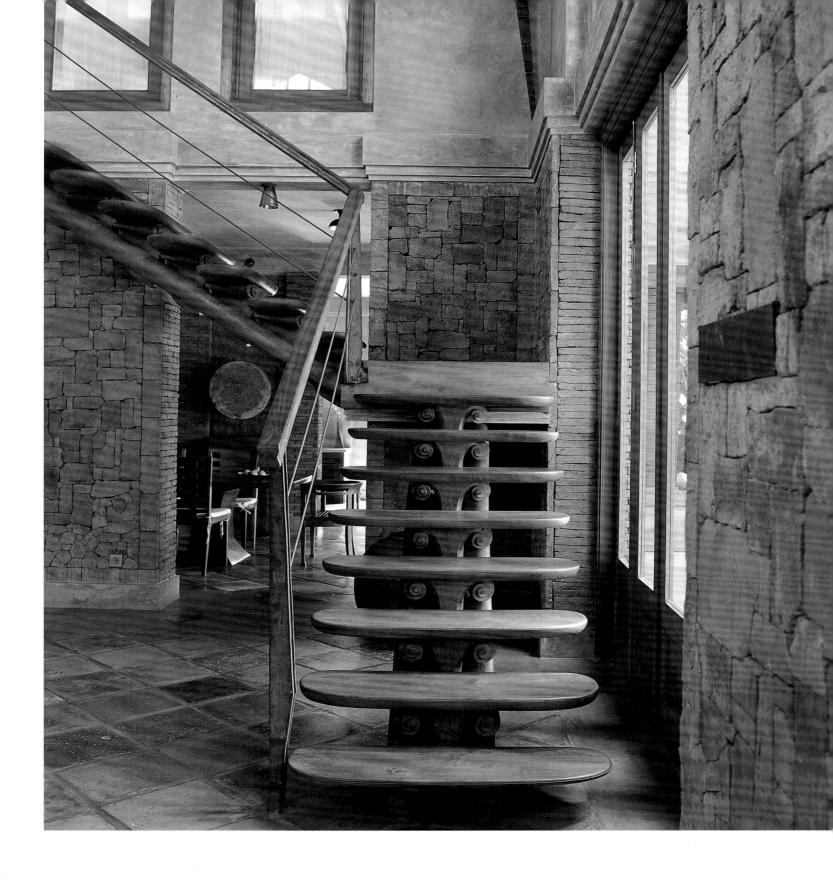

The defining feature of the house is the mosaic-like brickwork that has been used to create texture and pattern. Pillars have been constructed out of simple handmade *kampung* bricks, while the walls have a variety of designs. A strong geometric look (opposite, top left) has been achieved by placing protruding bricks at intervals within a linear design. Large bricks have been cut into various shapes and assembled in an uneven design (opposite, top and bottom right) rather like a jigsaw puzzle. According to Yusman, this was a time-consuming process, undertaken by skilled craftsmen who live and work around Solo. The bricks were all hand made to order by villagers in the area.

Apart from the odd antique piece, most of the furniture in the house was designed and produced by the owner. His company, Bin House, is expanding its range to include furniture and home furnishings, and some of these designs are now being produced for retail. The stairway (above) leading to the master bedroom is a good example of his contemporary style. The steps are fashioned out of rounded slabs of teak, placed on a support with spiral details, carved out of one entire log. He also designed the light fittings that include tall slim copper lights placed in the four corners of the main living area and an unusual flat circular lamp (overleaf).

In keeping with the minimalist interior design of the house, Bin House fabrics have been used sparingly throughout. The cotton covers on the two simple four-poster beds in the guestroom (below) are in a contemporary batik design. Behind the beds are fine silk hangings in a more traditional pattern. The guest bathroom (left) features a Yusman-designed copper sink placed on a vanity unit of buttermilk-coloured Indonesian marble with flashes of red in its grain. Mixing the old and new, a 9th-century stone statue of Vishnu from Central Java and a wooden panel, used for storing a *kris* or ceremonial sword, are placed in the corner.

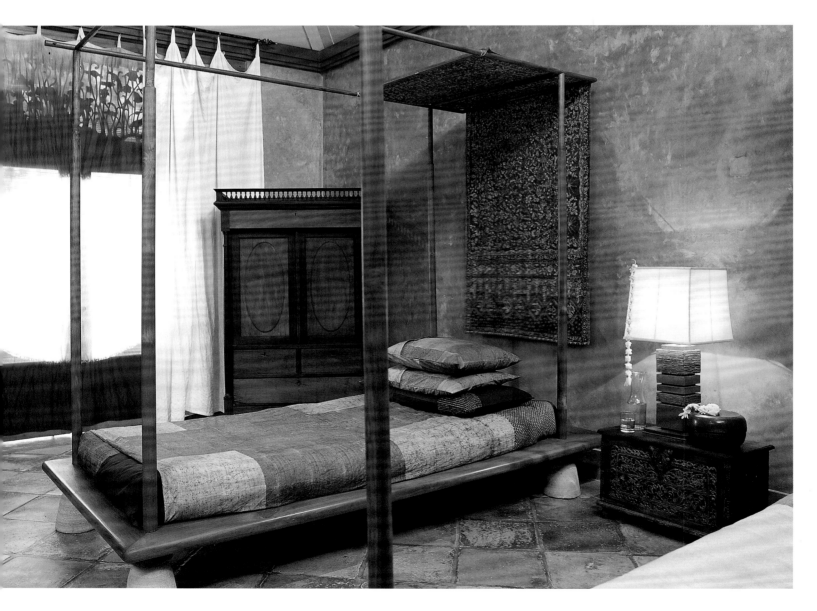

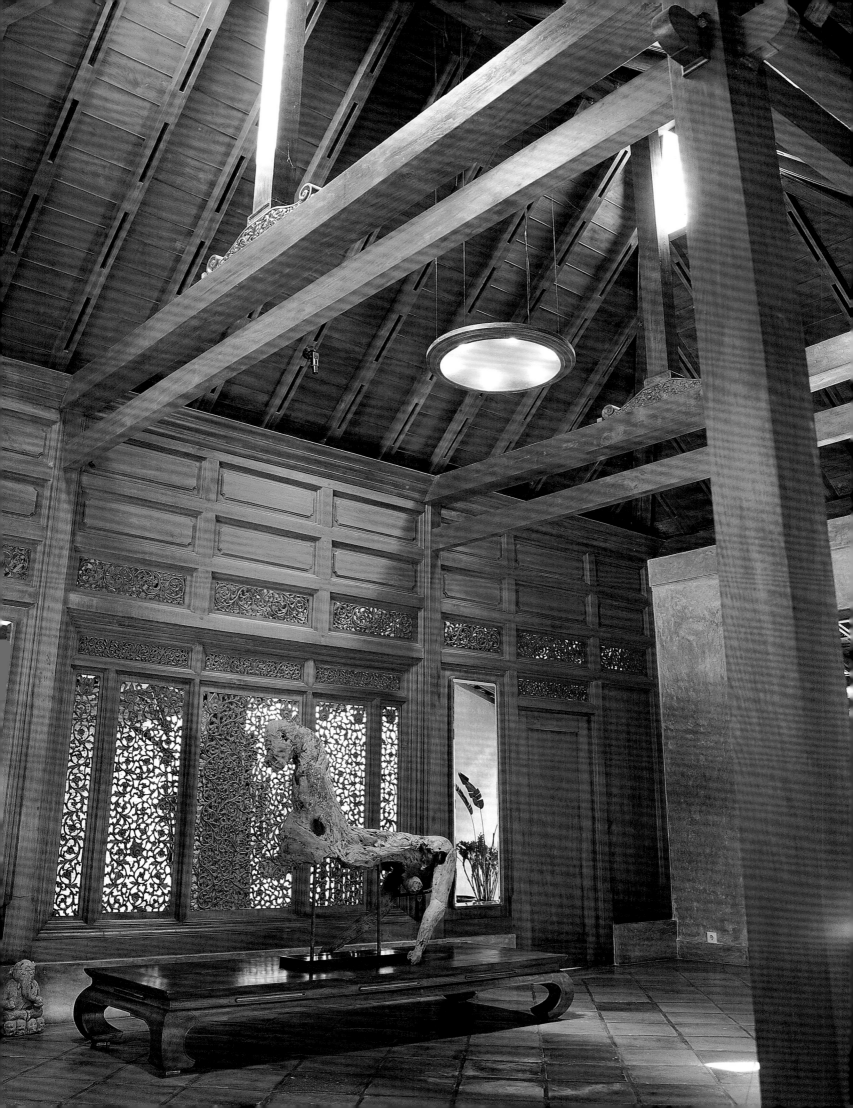

Jaya Ibrahim Bogor house

a house built on memories

When renowned Java-born interior designer Jaya Ibrahim moved back to Indonesia in 1993 after 12 years in London, he decided to build a house in a small rural village near the provincial city of Bogor. It was designed principally as a home for his mother and a weekend retreat for himself, yet it represented his first major project since returning home and he wanted this to be reflected in the design. He resolved to base the house on the concept of *tempo doeloe*, or times past. "To find my footing I needed to look back," says Jaya, whose work can be found in interiors throughout the archipelago. The one-storey Javanese version of a Palladian villa draws on his Indonesian roots, providing a celebration of his family and of local history.

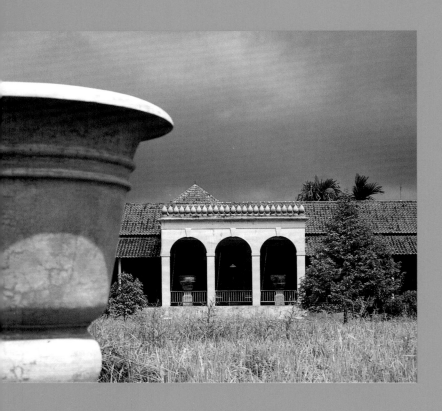

The house, called Cipicong, is surrounded by an expanse of rice fields (left) in the shadow of Gunung Salek, an extinct volcano. "I was conscious that I was building in the countryside," he says, "in front of a mountain, in the middle of nowhere." Adhering to Javanese design principles, Jaya built a one-storey brick and concrete villa that is a hybrid of Javanese, Indo-European and Venetian influences. "I chose these three design elements because out of confrontation comes results," he says. There are no walls around the house to obscure the views. "In Java, what is important is what you see," he says, "how the house sits on the land."

Designed for living in the tropics, the rather grand and unashamedly romantic retreat consists of a long narrow block built around two internal open-to-the-sky courtyards (right). At the front is a large *pendopo* open on three sides and at the rear, facing south, is a continuous verandah culminating in a loggia with three arches (left), with spectacular views of the volcano.

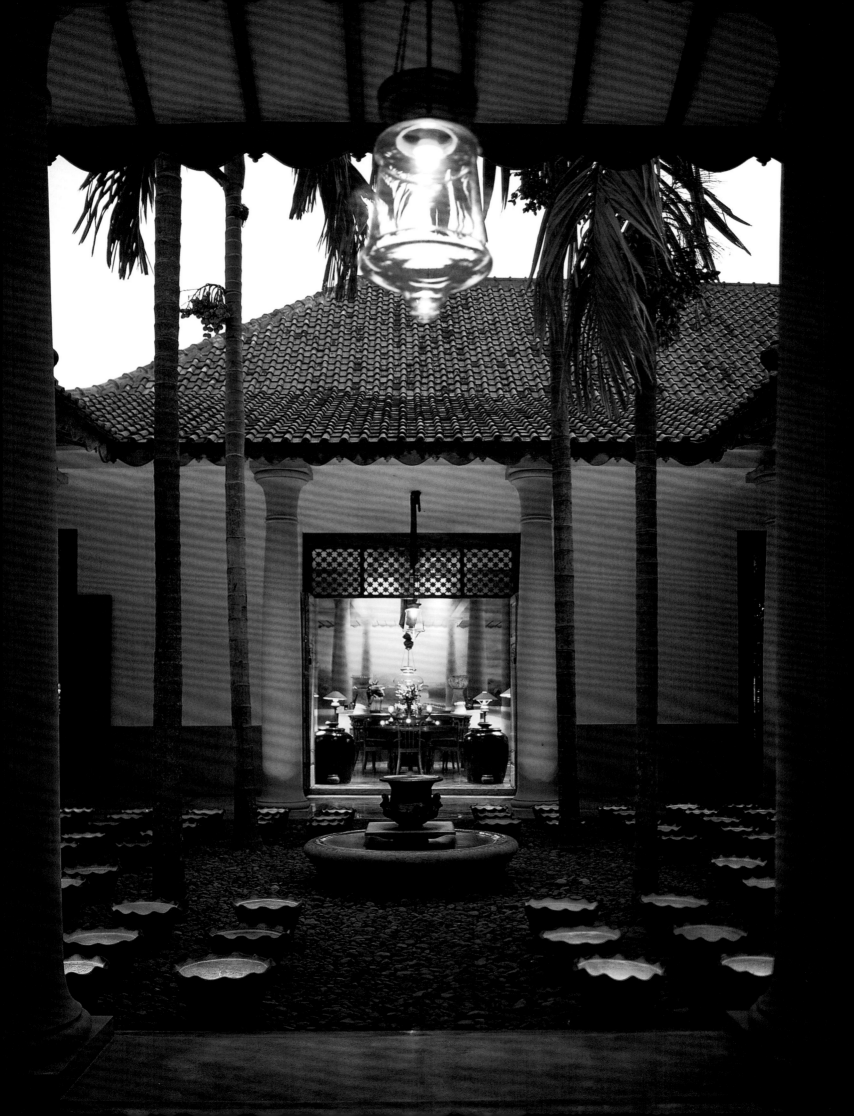

Javanese architecture is not so much about material and form but more about the organization of spaces and their relationship to each other. Cipicong is a fine example of the application of these principles. Entrance to the house is through a large formal garden, planted with 44 coconut palms in a geometric grid and contained within a boundary wall. The wall, however, is concealed behind a ha-ha, a device commonly used by English landscape designers such as Capability Brown. Behind the wall—which is level with the end of the garden—is a steep drop, so the garden and the house feel connected to the land. An impressive staircase leads up to the colonnaded *pendopo*, a traditional Javanese greeting area, providing uninterrupted views of the rice fields.

It is in the *pendopo* where the Indo-European influence is most strongly felt, and out of which, Jaya says, the rest of the house grew. The long deep verandah (below) facing Mount Salek evokes the neo-classical style of Jaya's great-grandfather's house in Yogjakarta. The outside areas were kept deliberately simple, with plain undecorated walls, to better focus on the stunning mountain views. The design of the house—with its extended verandahs and internal courtyards—promotes the free flow of air throughout and is above all practical for tropical living. In the octagonal dining room (overleaf), the centre of the house, a cabinet filled with Dutch china sits in front of a wall filled with prints.

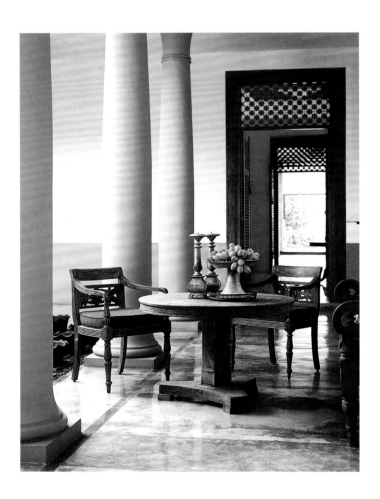

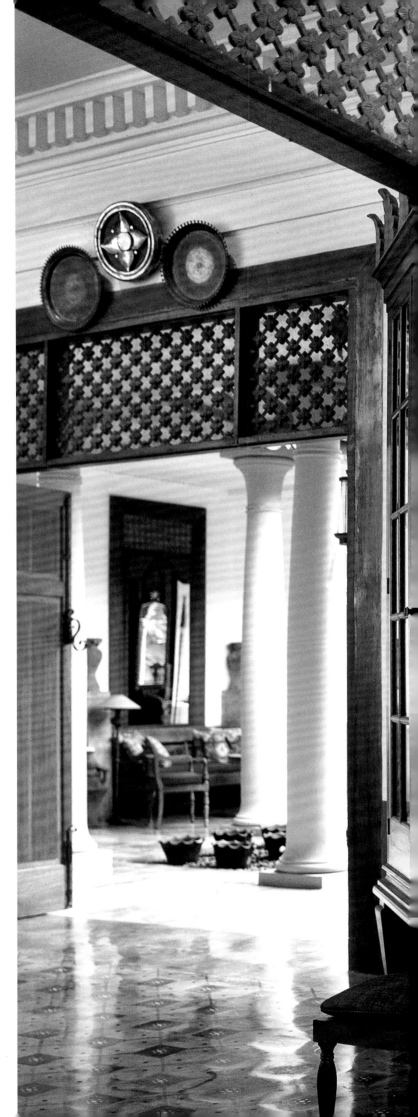

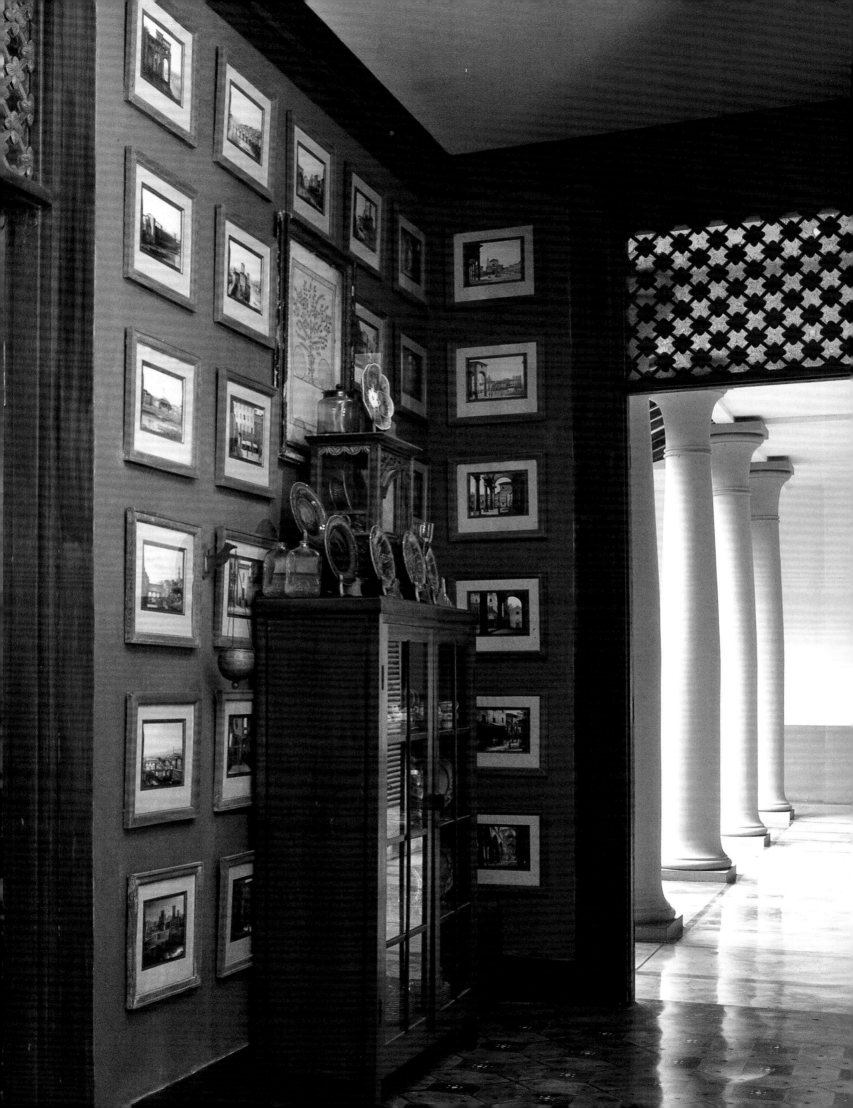

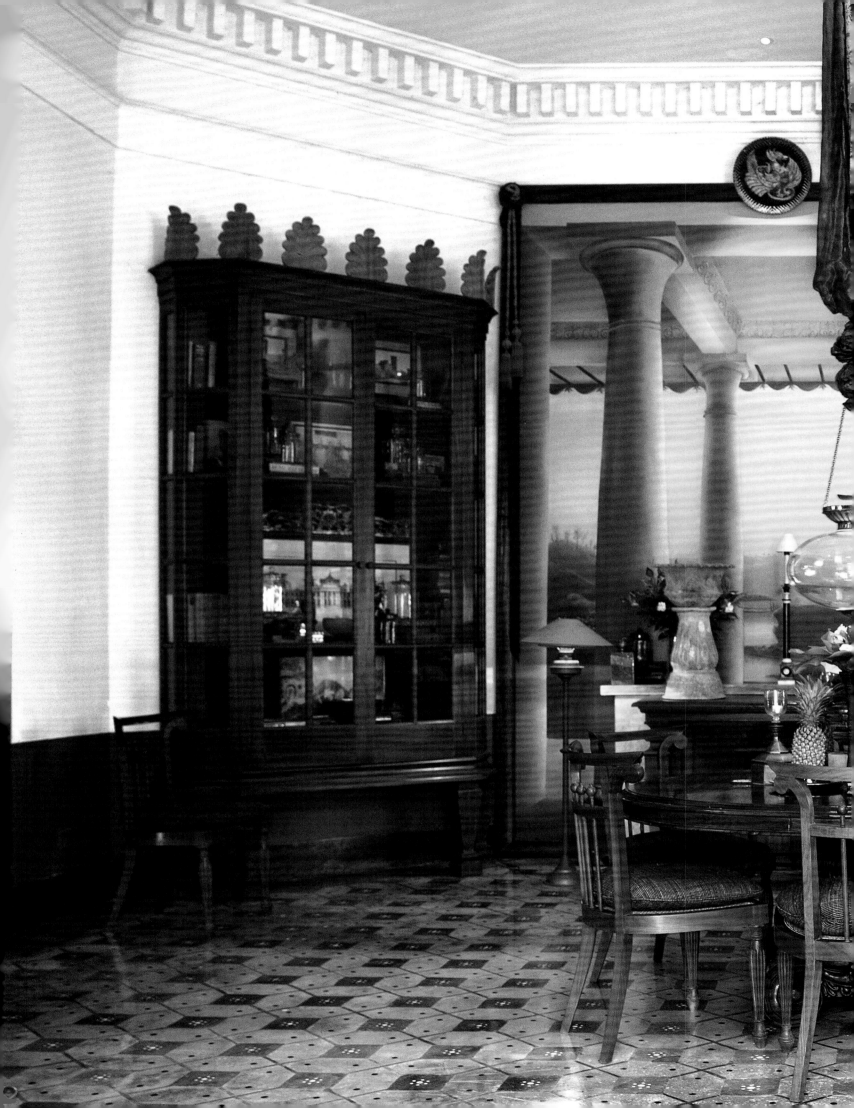

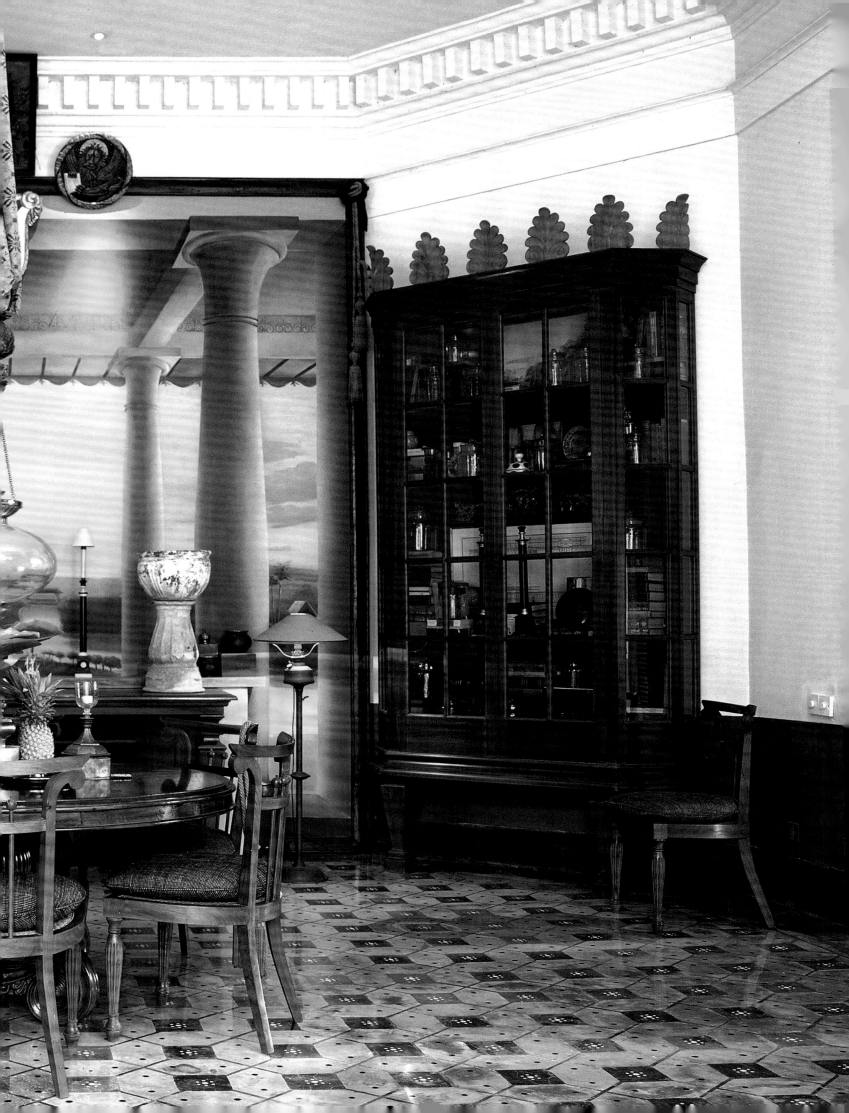

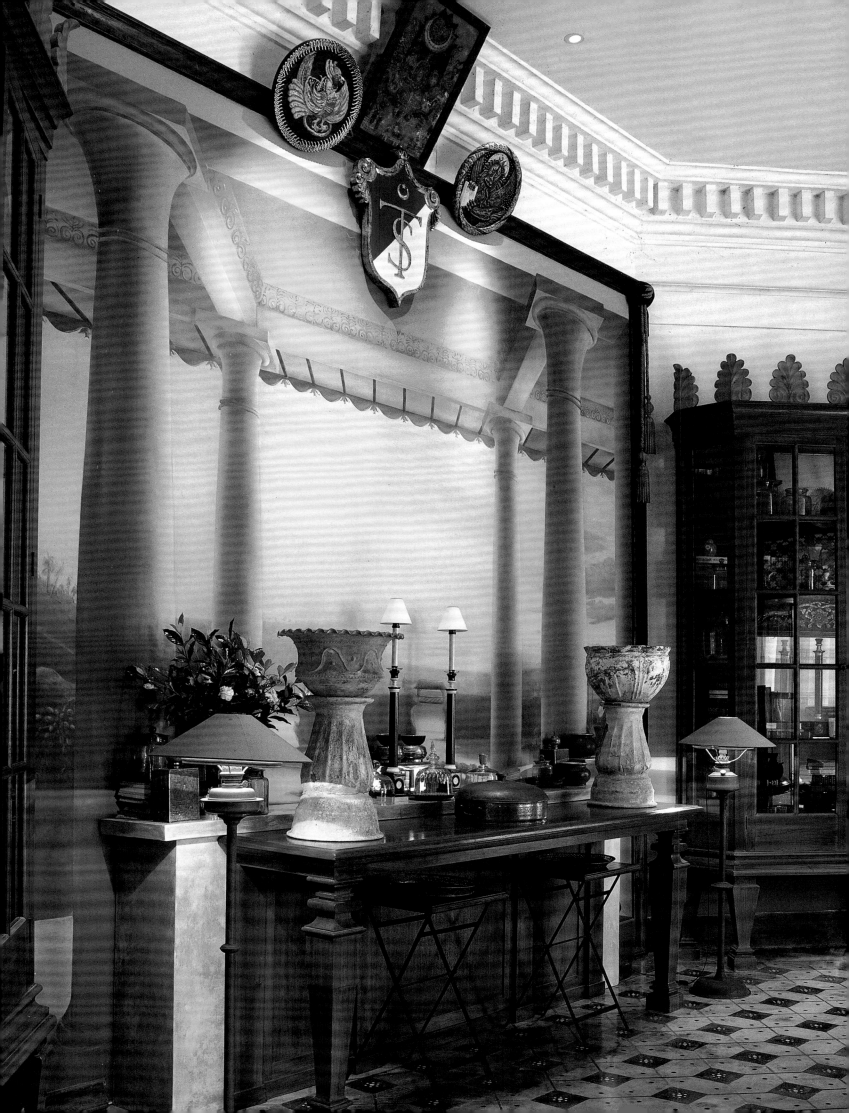

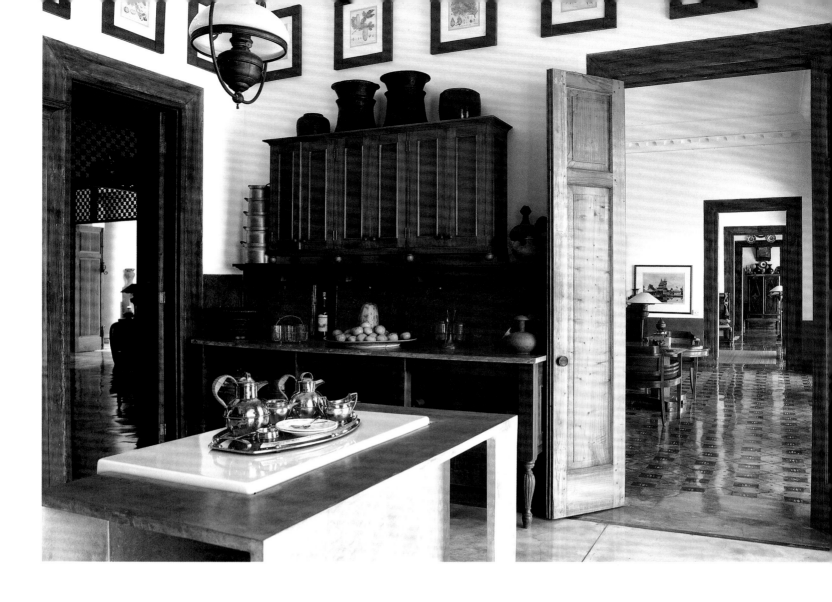

The story behind Jaya's selection of the land on which he built Cipicong adds to the romance of the house. While working in London as design assistant to Annouska Hempel, of Blake's Hotel fame, Jaya attended weekly auctions at Christie's. On one particular visit he was enamoured of a 19th-century painting by Dutch artist Abraham Salm; it showed an elaborate wedding procession through the fields surrounding Gunung Salek. He bid for the painting but lost. The image was so romantic, he says, that he never forgot it. When he was searching for a site to build Cipicong, he succeeded in finding a place that corresponded directly to his memory of the painting. "I may have lost the painting," he says, "but now I live with real-life views of Mount Salek."

Another work by the same artist is the inspiration behind the *trompe l'oeil* on the west-facing wall of the dining room (previous spread and left). In the Javanese scheme of things, the western side of a property is unimportant, so in Cipicong this wing is devoted to kitchens, garages and servant's quarters. As this is where the sun sets, Jaya commissioned an Australian artist to recreate a view from a Salm painting of a sunset, adding pillars to create the impression of an extra facade to the house.

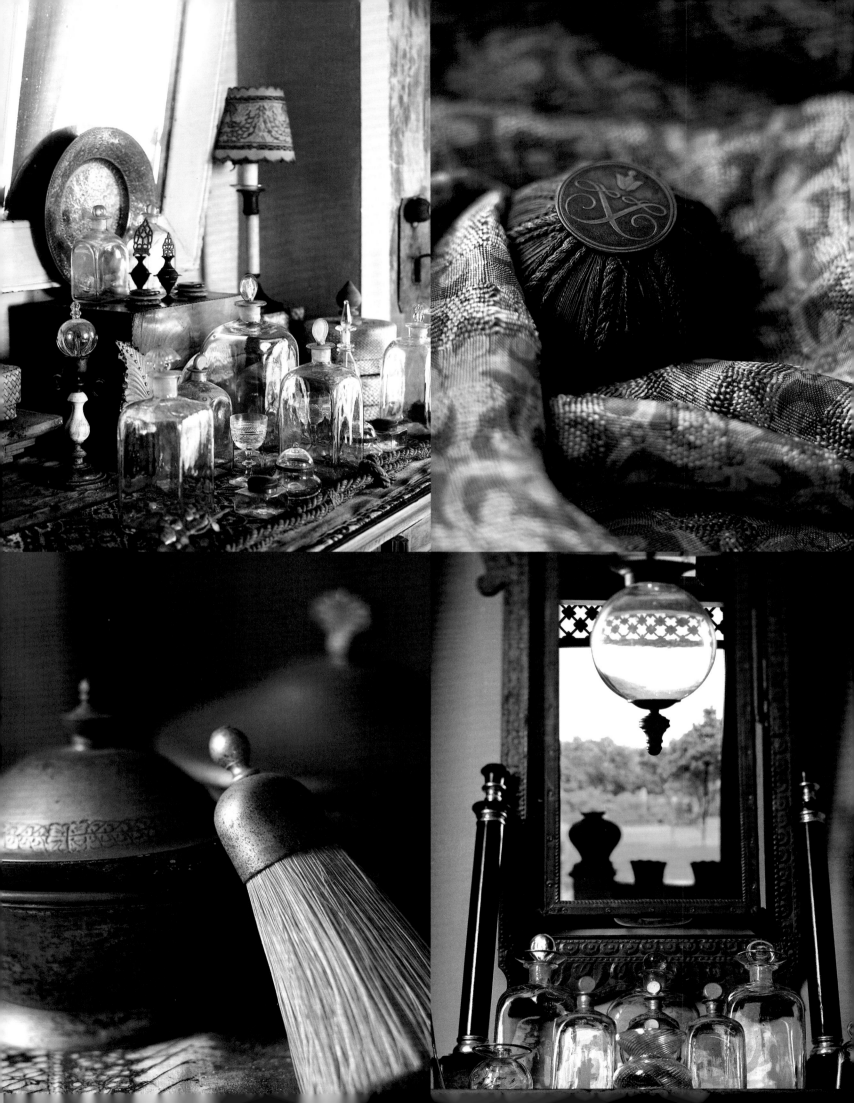

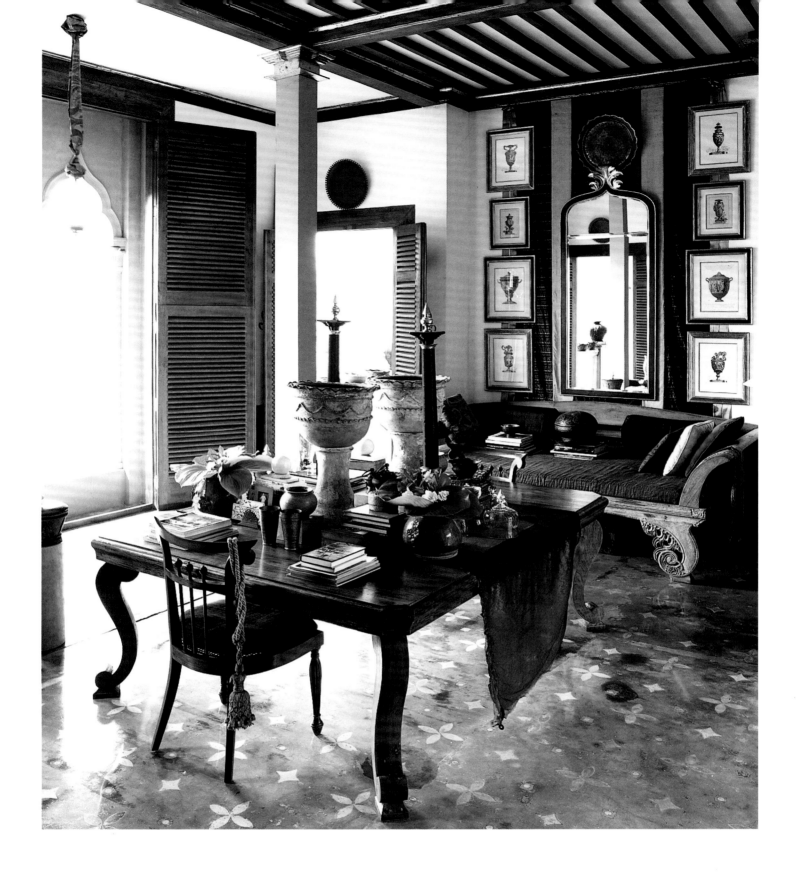

What is so striking about Cipicong is the way in which Jaya clusters and displays his extensive collections—including 17th- and 18th-century English prints, Venetian glassware (opposite, top left and bottom right), Celadon pots, Javanese furniture, Indonesian textiles and family mementos. Hundreds of objects are grouped in well-ordered layers that contribute to the beauty and originality of this extraordinary home.

The eastern façade, where Jaya's bedroom and study are located (above), presents a homage to Venetian architecture with three ornate arches and a balcony overlooking a reflecting pool that stretches out to the fields. The study is a "room for contemplation" and is the only place within Cipicong where gilding is to be found.

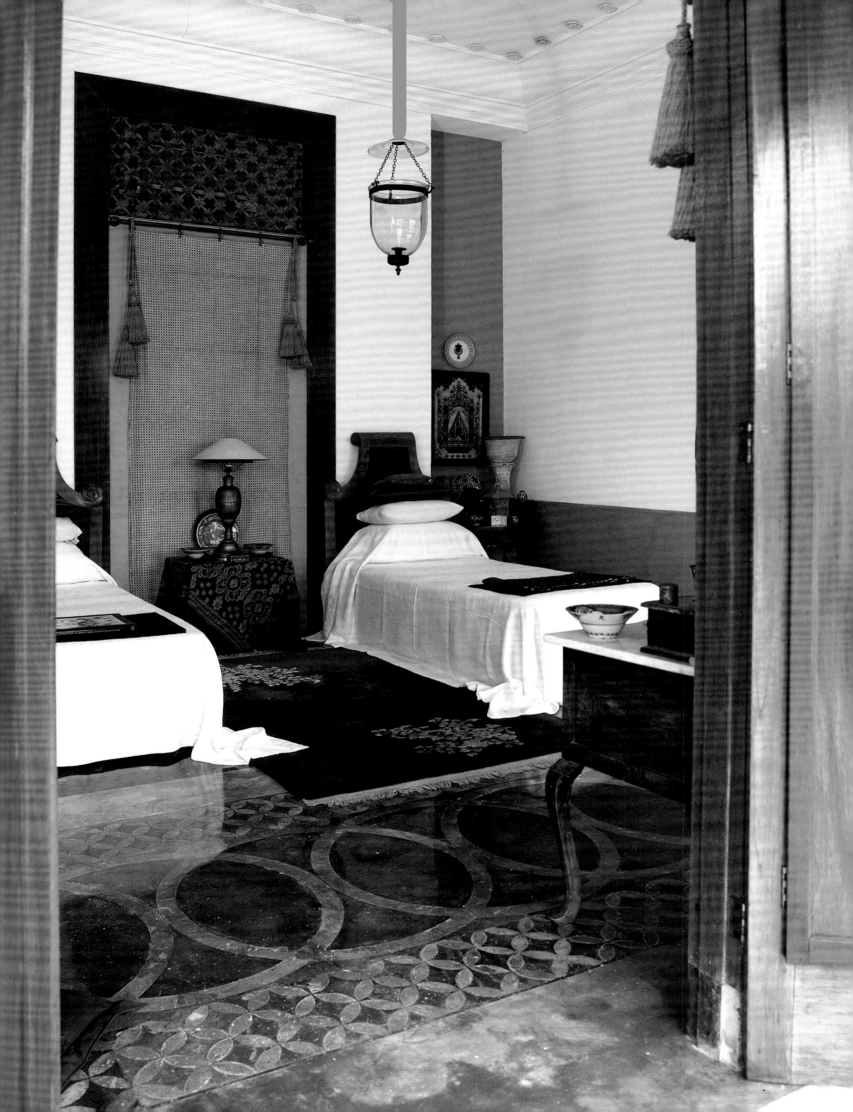

According to Jaya, there is an old Javanese custom which says that whenever you move house, you should take a handful of earth from the old place and scatter it in the new. Jaya has translated this custom by taking "bits and pieces" from his family's past and placing them within Cipicong. The cement floors, cool under foot, are reminiscent of the floors in his grandfather's house although he has introduced a batik-inspired design. In the octagonal dining room are three large glass-fronted cupboards filled with objects that each tell a story— one is dedicated to his father's memory while another is themed "lost causes". On the bedside table of the master bedroom (below) is a practice piece of batik his mother made when she was young.

Jaya's mother left the design of her bedroom (left) to her son, although like most Javanese she wanted it to be relatively sparse and stark. "She is not as sentimental as I am," says Jaya, "and she hates gold." Above the simple beds hangs an old oil-and-wick mosque lamp. Behind Jaya's bed (below) is a screen made from doors that he found in an old Javanese *pendopo*. The prints are floor plans of 17th- and 18th-century English houses. An old Sumatran glass lamp is suspended over the bed by a swag made from Balinese fabric. The crisp white linens are from Christie's.

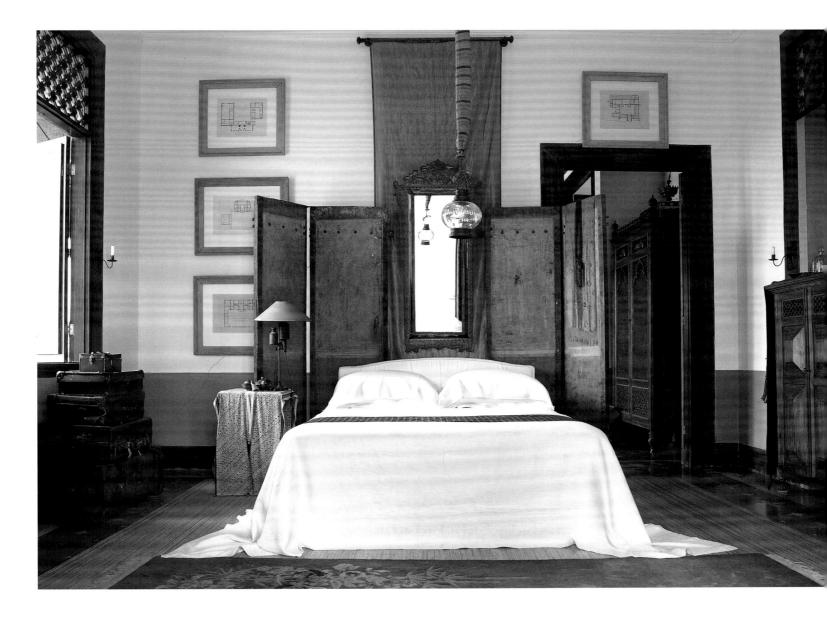

a collector's house

Anhar Setjadibrata's family home is located in a quiet residential area of Malang, one of the most pleasant of Indonesia's provincial towns. Built in 1925, the one-storey villa is in the Dutch colonial style, just one of many fine examples that populate the town's wide, clean streets. Hotel owner and avid antique collector Anhar has retained many original features of the house, while at the same time stamping a very individual style on the interior. He believes houses should be decorated with patience and love, and this often translates into an ever-changing design scheme. He originally planned to give this house a strong Arabic feel, but it has since evolved into a highly personal statement with bright colours and the careful placement of antique pieces throughout.

When you enter the house, the strong, contrasting colours of the walls are immediately apparent, giving the rooms a distinctive ambience. In the entrance hall, they are painted a bold lime green and terracotta (overleaf), in the reception room, indigo and fuchsia (left and right) and in the dining room (overleaf) pink and brown-red. Anhar has selected individual pieces from his art and antique collection that work well with the colour scheme. In the reception room, wooden carvings from central Java are mounted on walls. The paintings are by Antonio Blanco, who lived and worked in Bali, and Tan Liep Poen, a Chinese painter living in Malang who is now over 100 years old. The statue (above) is of Shiva and is from Mojokerto in East Java.

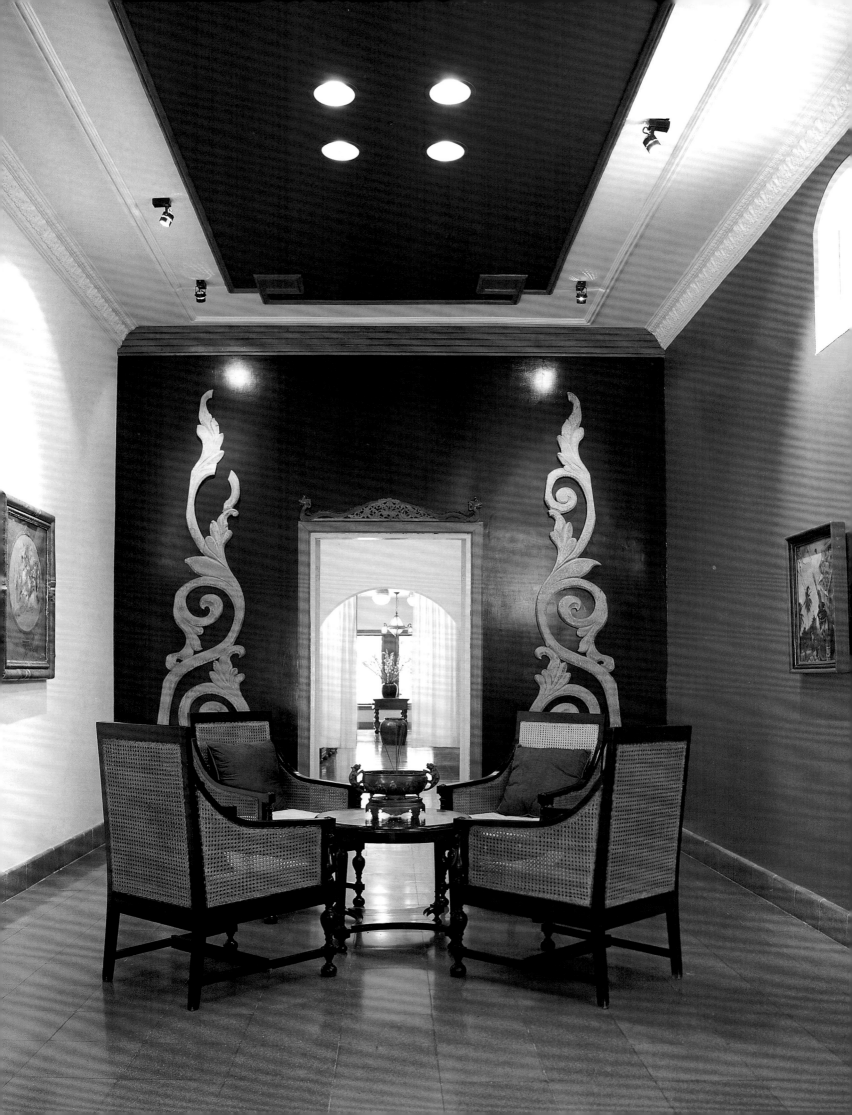

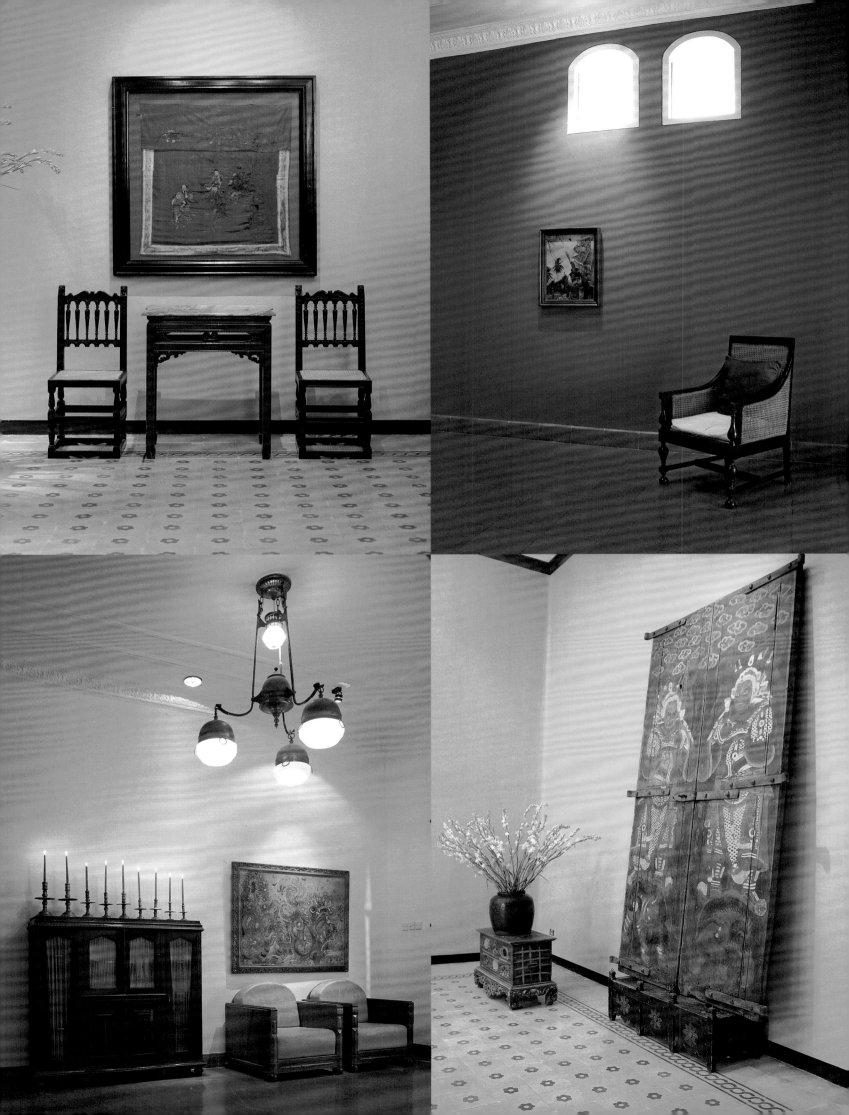

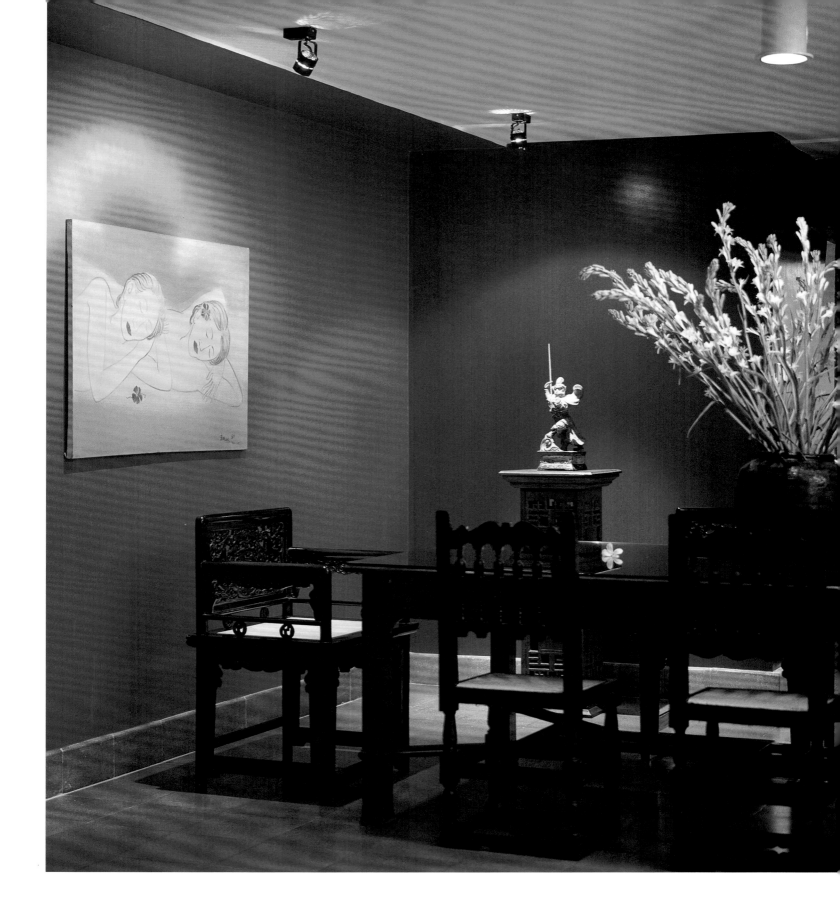

Anhar owns a comprehensive and diverse antique collection that retells the stories of Indonesia's rich past. One of his great passions is to group pieces together to create strong cultural themes. For example (opposite, top left), in the reception room he has placed a framed piece of Chinese embroidery from an altar over a marble top table that is more than 100 years old in a formal arrangement reminiscent of the Peranakan style.

However, he is not averse to mixing the old and the new. In the dining room (above), a contemporary painting of two young women by Balinese artist Ketut Budiono from Ubud looks down over an antique Chinese table with a large vase of sweet-smelling tuberoses. The ceramic floor tiles with a simple flower motif (opposite, bottom right) are a 1920s design that were part of the original house.

art deco style in bandung

Bandung, Indonesia's third largest city, lies in a high valley surrounded by mountains covered in tea plantations. It is a city that developed in the early part of the 20th century, a time when its architecture was heavily influenced by the European Modernist style and it became known as 'The Paris of the East'. Latterly, Bandung has become a centre of industry and in 1993 the Chedi Bandung opened its doors to provide stylish accommodation for visiting businessmen and those attracted to the city's cool highland climate.

The 44-room Chedi Bandung (recently renamed the Malya Bandung) was designed with unrestricted views of the verdant valleys and distant mountains beyond. The architects and interior designers were Singapore-based Kerry Hill Architects who aimed to respect the scale of the property's suburban context. "We deliberately kept it one-storey to relate it its surroundings," says Kerry Hill. "It's building on a domestic scale." The architecture is a contemporary interpretation of the Art Deco and European Modernist influence of the 1920s, a style that still exists in many of Bandung's old buildings. On approach to the hotel, the guest arrives at what first appears to be a single-storey building and it is only on entering that the three floors of rooms placed below the lobby and public spaces become evident. Built into the hillside (top), they command spectacular valley views.

As there are no elements of vernacular design in the architecture, Javanese interior accents have been used throughout the hotel, encompassing sculptures, artwork, furniture and fabrics. The seven suites (right) are spacious with breathtaking mountain views. The palette is muted. Plain hand woven fabrics made locally are used for the sofa and bed-cover, while batik cushions provide a colourful touch of Indonesia. The wooden floors, furniture and blinds add to the warm ambience. The Kerry Hill-designed wooden furniture includes an armchair that reinterprets the Beidermeier-inspired version of an Empire chair common throughout Indonesia.

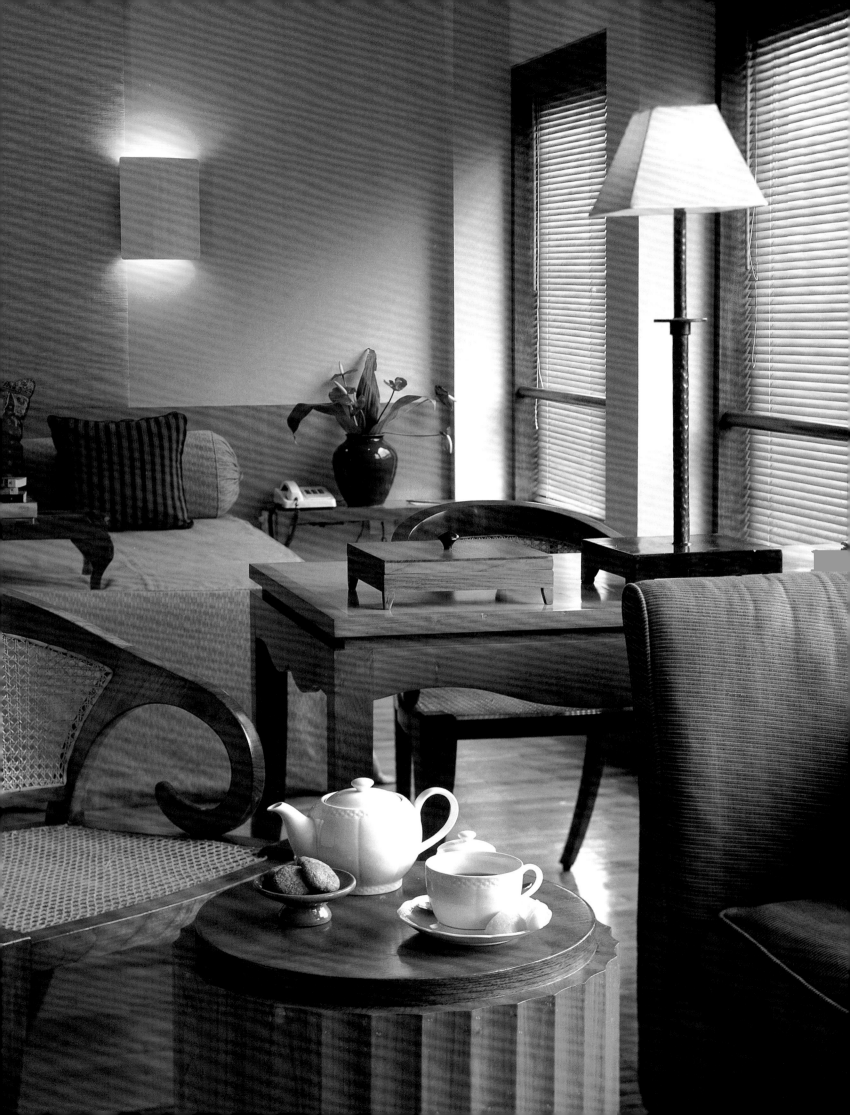

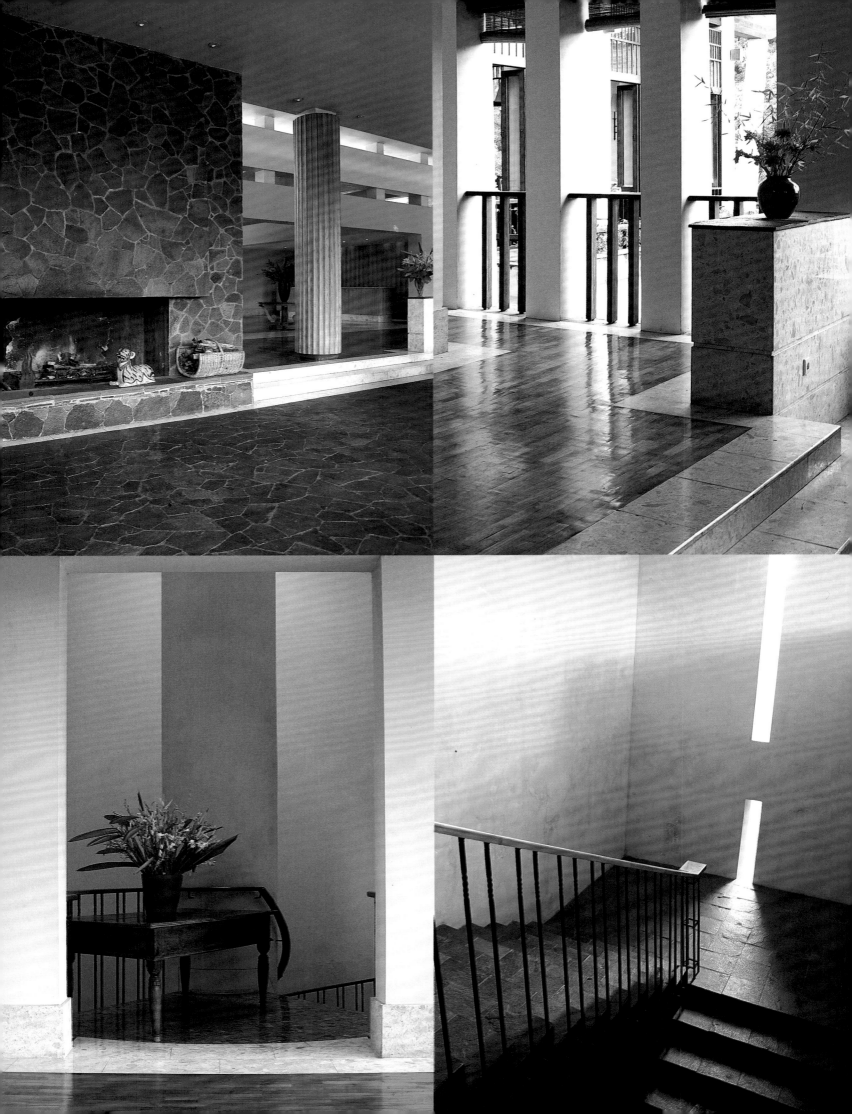

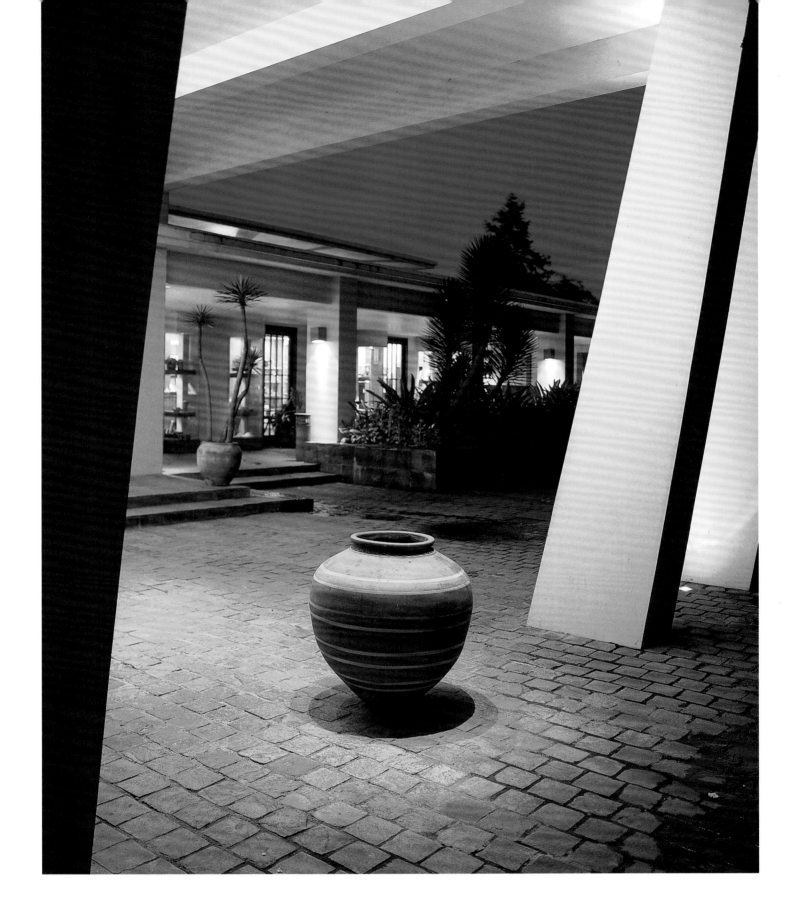

Bandung is situated some 1,000 metres (3,280 ft) above sea level and so enjoys a cooler climate than generally experienced in Indonesia. Taking advantage of this fact, the restaurant, bar and lobby are open and without air-conditioning, while the hotel's living room features an open fireplace to provide warmth. As the hotel is small, with just 42 rooms and seven suites, Kerry Hill Architects attempted to make it intimate and residential in scale. The interiors of the hotel were designed to feel like a country house, reflecting "contemporary living in a cool hill-top retreat". All materials were sourced from around Indonesia and include slate, stone, *merbau* and *sungkai* woods and locally produced terrazzo tiles. According to Hill they are "familiar to the local design aesthetic" and combine to create interiors that "enhance the architectural concept".

Dimitri Pantazaras house

looking at Java through greek eyes

When Greek financial adviser Dimitri Pantazaras found himself living in Jakarta during the political crisis of 1998, he decided to renovate his rented house in order to "create something beautiful amidst the chaos". The modern property, located in the residential area of Kuningan, was large and slightly cavernous. Impressed with the way that in Indonesia "the multiple layers of design elements constantly overlay one another", he wanted to achieve the same effect within his house and so enlisted the services of interior designer Jaya Ibrahim. For Dimitri, working with the acclaimed designer was a voyage of discovery, "a way to get to know and understand Indonesia's art and heritage".

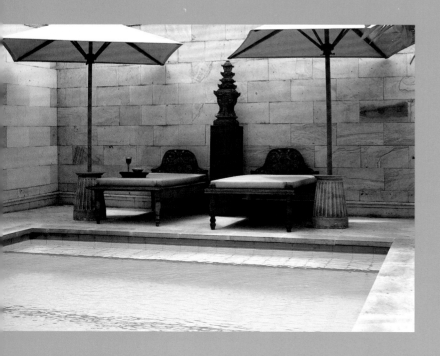

The concept behind the house redesign was to "look at Java through Greek eyes". One of the major challenges was the large internal courtyard (right), which is the visual centre of the house. Jaya wanted to create something "strong, in the Greek manner". The classically inspired structure incorporates carved Javanese wooden screens set into stone-clad walls and archways that surround an unusual fountain. Water pours from a sculpted Dionysius head into a large clam shell and a tiled pool. Large obelisks are set either side of the patio doors. Everything is arranged with a "symmetry, a geometrical balance" that recalls ancient Greece.

The pool area (left) was lined with white *palimanan* stone from Bali and sequestered behind high stone walls. Between large fabric umbrellas and two Javanese day beds is a stone *candi* reminiscent of the Majapahit era. In the dining room (top), ample three-legged teak armchairs with sweeping curved backs (a Jaya & Associates original design) complement the palette of deep red and pale green. On the wall is an unusual collection of 12th- and 13th-century Javanese bronzes mounted on hand woven ikat fabric from Sideman in Bali.

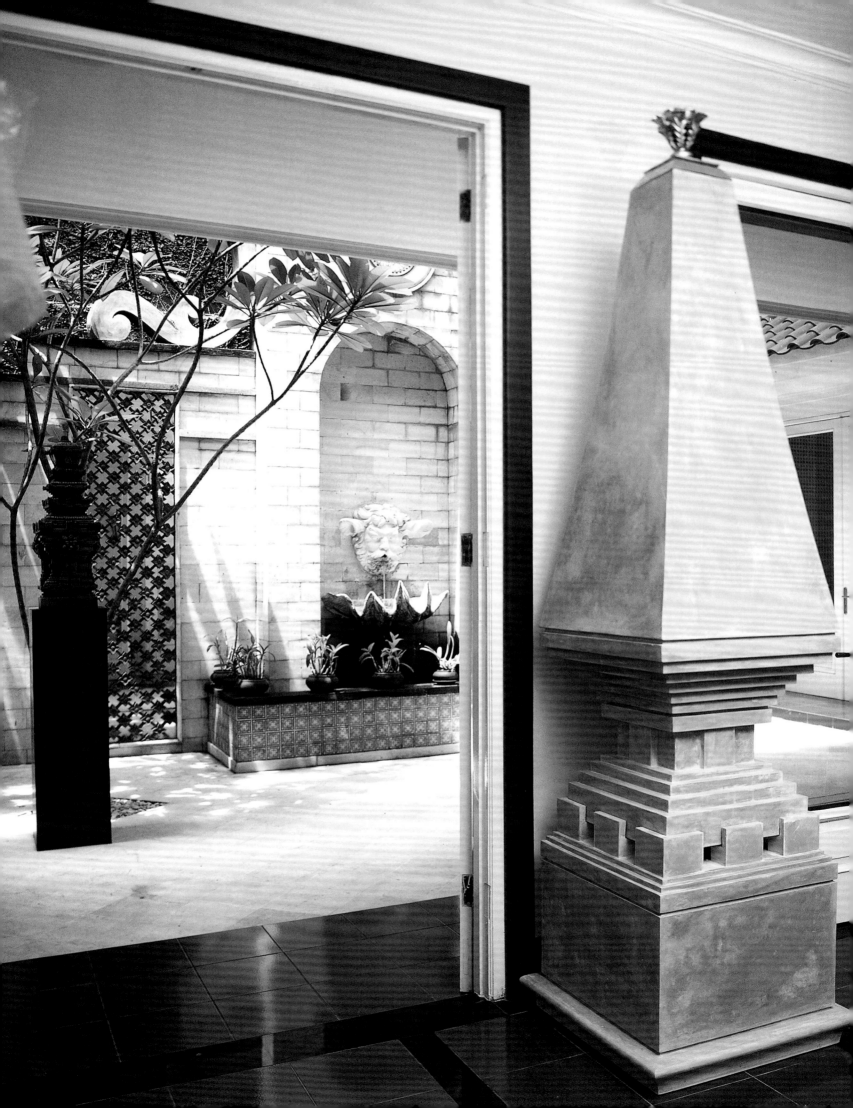

Dimitri first came into contact with Jaya Ibrahim's interior design at The Legian hotel in Bali which "deeply inspired" him, so he asked Jaya to recreate the same atmosphere within his home. Although the placement of furniture and furnishings is highly ordered, Dimitri describes living in the house as "very comfortable, very soothing". Jaya and his partner John Saunders designed most of the furniture, including the large teak sofa in the living room (right). It is called the Cintamani sofa (which means 'treasure of the thought' in Sanskrit) and its curved sides are based on a traditional Javanese design.

Dimitri collaborated with Jaya on certain elements of the interior and furniture design. "We experimented quite a bit," he says, "but eventually we agreed to simplify the forms as much as possible and then use the fabric as the means to unify and enhance the style and feel." The choice of fabrics included a muted gold for the sofa and burgundy and gold stripes for the cushions. These colours worked well with the distinct red and black tiled floors that had to be accommodated. The two men would also find pieces for the interiors together. The collections include lacquerware, old ceremonial swords and terracotta statues and pots, giving the house an earthy feeling. Jaya's greatest skill, Dimitri says, is his ability to identify aesthetic elements in a pure form and then use them to create his unique "Jaya style".

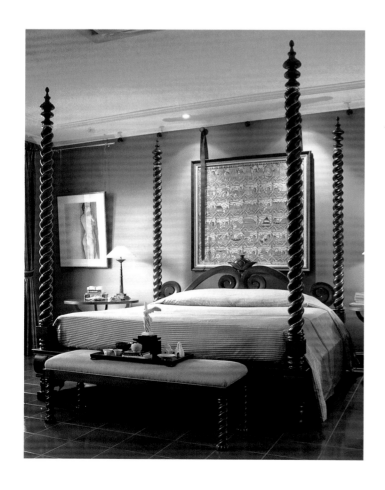

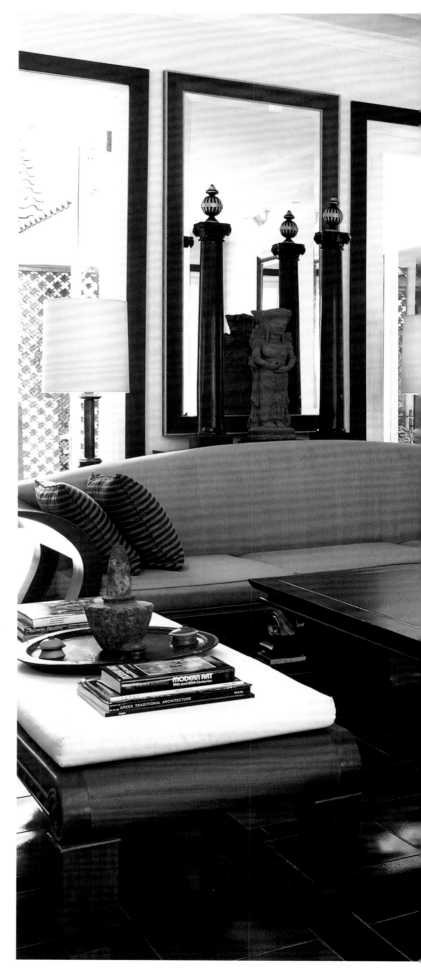

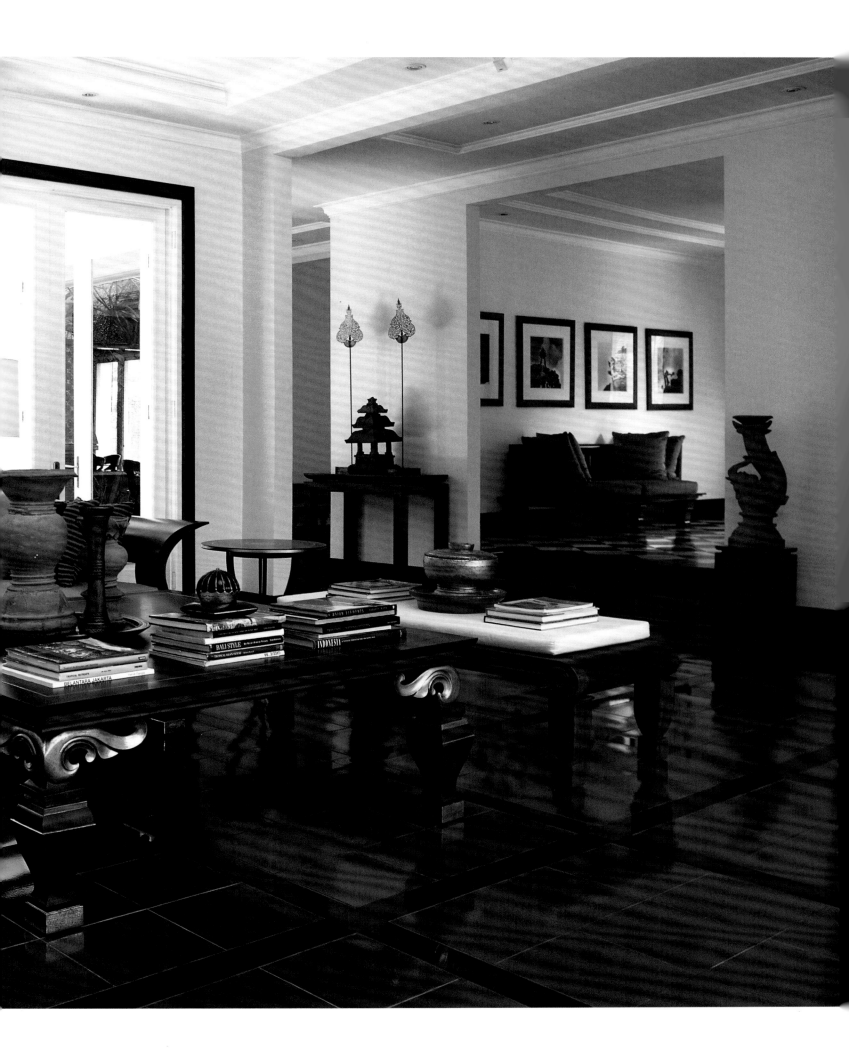

artful living

Kartanegara, homeware designer Warwick Purser's magnificent house in Yogjakarta, was built in 1938 for the sister of the Sultan. Set in 6,000 square metres (64,560 sq ft) of garden, it sits behind a wrought iron fence in the middle of a busy thoroughfare home to batik boutiques and antique shops. Within the ample grounds are more than a dozen stately *sawo kecik* trees, traditionally reserved for members of the royal family. Warwick uses the house mainly for guests and entertaining as he prefers to live in his village house (see page 40-45). "My business is selling Indonesian style," he says, "and this house is essentially a showcase of the Indonesian look."

Warwick moved into Kartanegara nearly four years ago. "I believe houses should be loved," he says. "I was attracted to this house because it was dark and uncared for." To brighten it, he painted the interiors in light colours, chose a few select antique pieces and combined them with contemporary furniture. He retained the grand covered entrance and added a swimming pool made of polished cement to reflect the natural colour of the water (above). The three rooms of the guest wing have European-style shutters that look out to the pool area within the back courtyard garden. Painted in shades of maroon, their colour is mirrored in the bougainvillea planted within large batik dye pots.

Another reason that Warwick decided to take on Kartanegara was that it provided him with space to hang his impressive collection of modern art by young Indonesian artists, including Putu Sutawijaya, Stephen Buana and Nasarun. "I believe their work is of international standard," he says "and as they are mainly young, I love to support them." At the main entrance room of the house (right) hangs a powerful triptych by Balinese artist Sutawijaya. The contemporary armchairs reproduce the sweeping curve of the 1920s art-deco style *becak* chair used extensively as verandah furniture at the time of the Dutch. Following the rounded lines of the chairs are large stone balls used as supports for the glass coffee table.

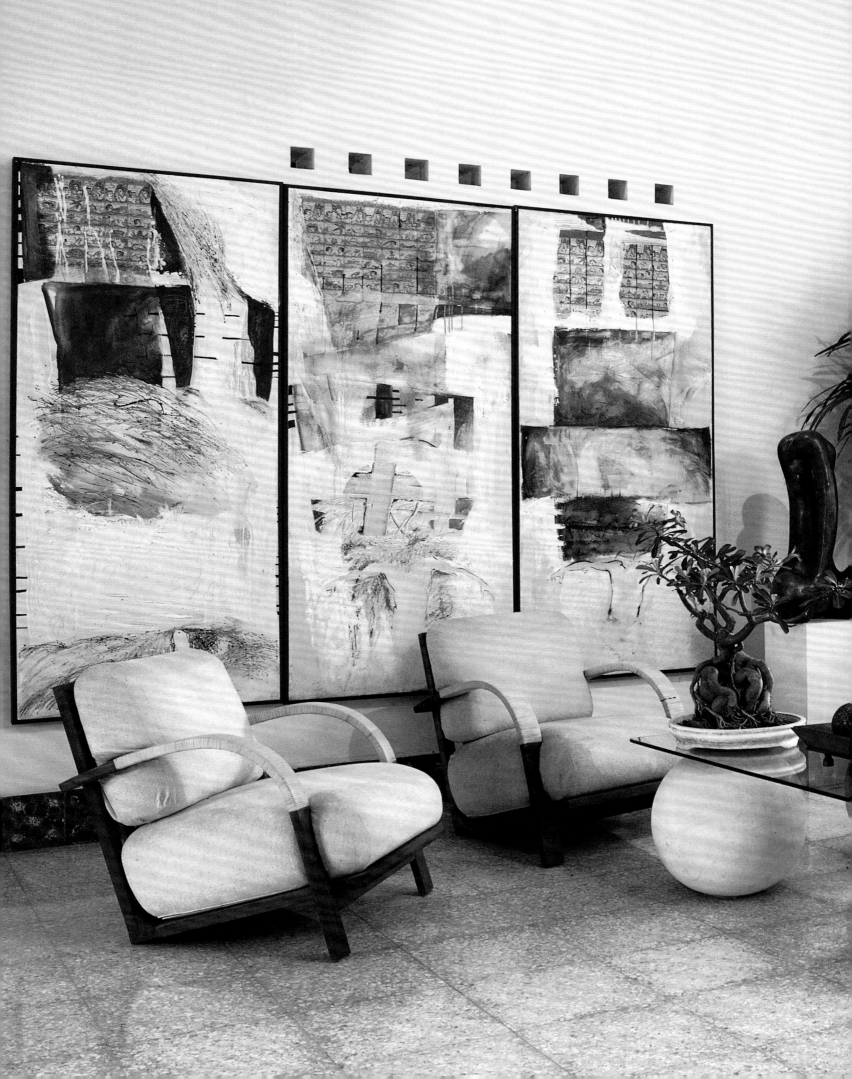

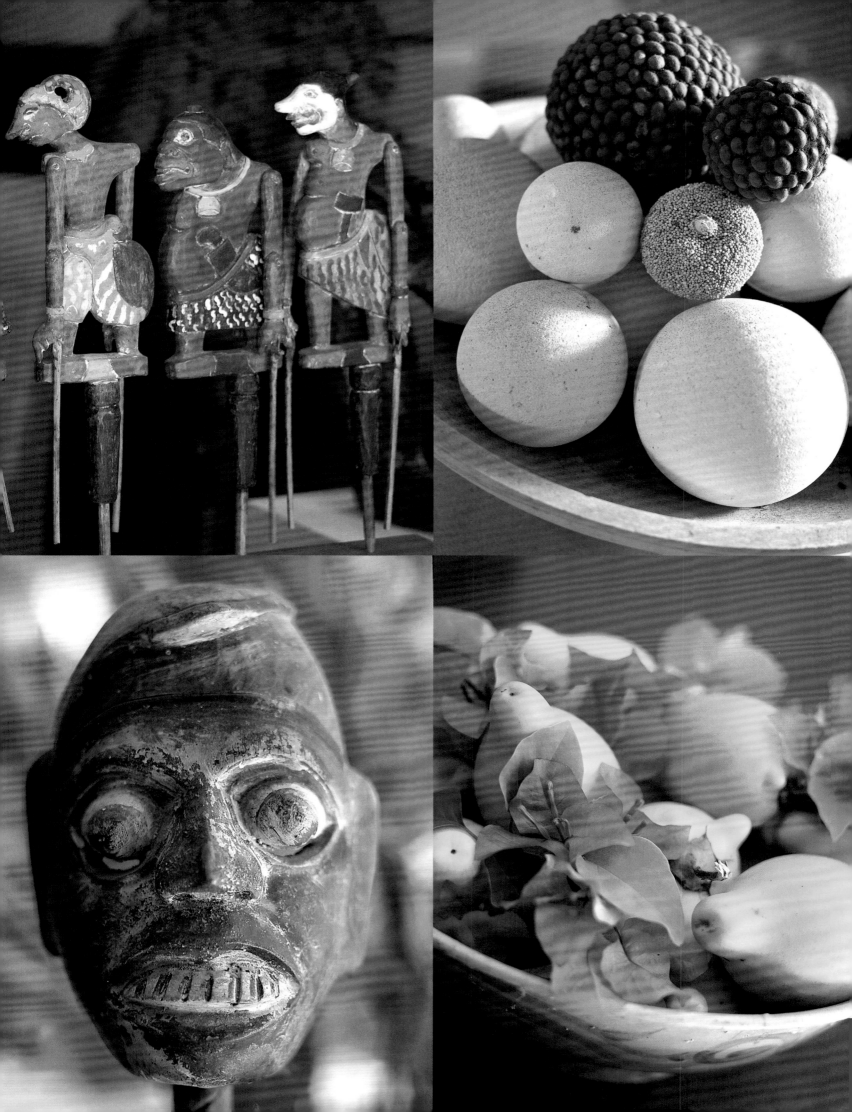

Warwick's main aim when designing the interiors was to "show international visitors a house comprised of things entirely locally made", including furniture, textiles, antiques and homewares. He strongly believes that the talent of local craftsmen in making extraordinary things with their hands is "one of the greatest assets of this country". Warwick has mixed old and new, cultural and decorative pieces throughout the house. Some attractive examples (opposite, clockwise from top left) include antique *wayang* puppet figures from the early 1900s, ceramic bowls containing textured balls made of stone, seeds and coffee beans, gourds with bougainvillea flowers, and an old Javanese *Topeng* mask.

The house is made up of three adjoining reception rooms with smaller sitting rooms and bedrooms leading off. Covered sitting and dining areas are contained within the ample balcony that surrounds the house. This breakfast area (above) is just outside the main dining room. Comfortable wicker chairs, contemporary in design, surround a circular table. While eating breakfast, guests are serenaded by doves in wooden cages, a gift from friends. A songbird is, after all, one of the five required possessions of a Javanese gentleman, the others being a house, a wife, a *kris* or dagger and a horse.

island hideaways

For centuries, artists, writers and dreamers have established romantic retreats in hideaway places: in hills, on beaches, in forests and even—famously, in at least one instance—under a volcano.

Many of these aesthetes have come under the spell of the mystical east and its languid tropical atmosphere. Pioneers in this quest for the ultimate private paradise include men like Count de Mauny-Talvande, who in the 1920s established a romantic island home named Taprobane off what was then Ceylon. It was ten years before his "endless seeking Destiny" brought him to a small rocky mount on the island's coast, the "one spot which, by its sublime beauty, would fulfil my dreams and hold me there for life".

For others, like French artist Paul Gaugin, the search was for a new way of life, one that was more primitive, more real, more sincere. In 1891 he left France for Tahiti where he could live on "ecstasy, calmness and art".

The literary and artistic world is littered with such tales, of aesthetes in search of their own private Eden. Indonesia,

too, has attracted more than its fair share of people seeking alternative lifestyles. From Walter Spies and the famous Ubud-based artists of the 1930s to contemporary lotus eaters, Bali has been a particular magnet. It is clear that principal among the prerequisites for an island hideaway is a feeling of seclusion, where peace and tranquillity are assured, providing time to reflect, to spend uninterrupted hours with loved ones, away from the intrusions of daily life.

A stunning natural environment is also paramount; the beauty of the place should allow the imagination to soar. The dwelling should—although perhaps not necessarily—be rustic in design, moving away from the sophistication that encumbers mundane daily existence.

In Indonesia, the vernacular architecture is perfect for the creation of simple, relaxed homes that provide an escape. Complementing the tropical climate and making use of natural ventilation, these breezy, open-to-the-environment houses are often constructed from the abundant natural materials available—from *alang-alang* grass roofs to pillars made from coconut palms. Nothing

is decorative and ornamental, the comfort comes from openness and simplicity.

Bathrooms are often sited within spaces open to the sky and the moon. The beauty of the natural world and the intense light filtering through tall trees add to the sensual experience of a morning shower. Going to bed is a magical experience, too, when the bedroom is housed within an open pavilion. Canopied four-poster beds provide a cocoon where the sounds of the tropics mingle with your dreams.

Our island hideaways are to found in places that are off the beaten track, from a simple Javanese house in a village under the shadow of Borobudur to an artist's retreat in a rice-terrace lined valley overlooked by Bali's mighty volcano, Gunung Agung. Some are Indonesian resident's second homes—escapes within an escape, you might say; others are treasure troves of the region's rich cultural and architectural history.

What they all have in common is simplicity and serenity, where looking at the view for hours on end provides a feeling of peace and inspiration.

thousand island dressing

Who hasn't dreamt of owning their own private tropical island? Jakarta resident David Salman realized the dream in 1993 when he bought Kaliage Kecil, one of more than a hundred islands that make up Pulau Seribu (The Thousand Islands)—a three-hour boat ride from Indonesia's bustling capital city. Over the next few years, David transformed the coral-ringed island into a relaxed and informal week-end retreat. He built a series of Indonesian village-style houses and planted frangipani, hibiscus and bougainvillea within the existing casuarina, palm trees and native vegetation. Arriving on the 7500 square-metre (80,700 sq-ft) island is like discovering your own private Eden. White sparkling sand, clear turquoise waters teaming with tropical fish and thick tropical vegetation greet you as you come ashore.

Hidden within the trees is the owner's residence (right), a traditional wooden house with a *joglo* roof from Demak in Central Java. The house, which is over 120 years old, was about to be demolished when David stepped in to save it. He disassembled the structure, numbering every part, and then brought it to the island (left) where craftsmen reassembled it. A large wooden terrrace, a stone's throw from the water, fronts the house (right), the perfect place from which to watch the sun sink beyond the horizon. The guest houses on the island include a Malay-style guest house with a tiled roof and a Balinese *lumbung* or rice barn with an outside bathroom fashioned from white limestone. A separate kitchen and dining pavilion with an ample cushioned seating area forms the island's centre of activity.

David chose an amalgamation of simple village designs for the entire complex as he wanted to give the island a relaxed mood while still retaining a strong Indonesian character. And when placing the buildings on the island, he was careful to find the best location for each, without cutting down any existing trees.

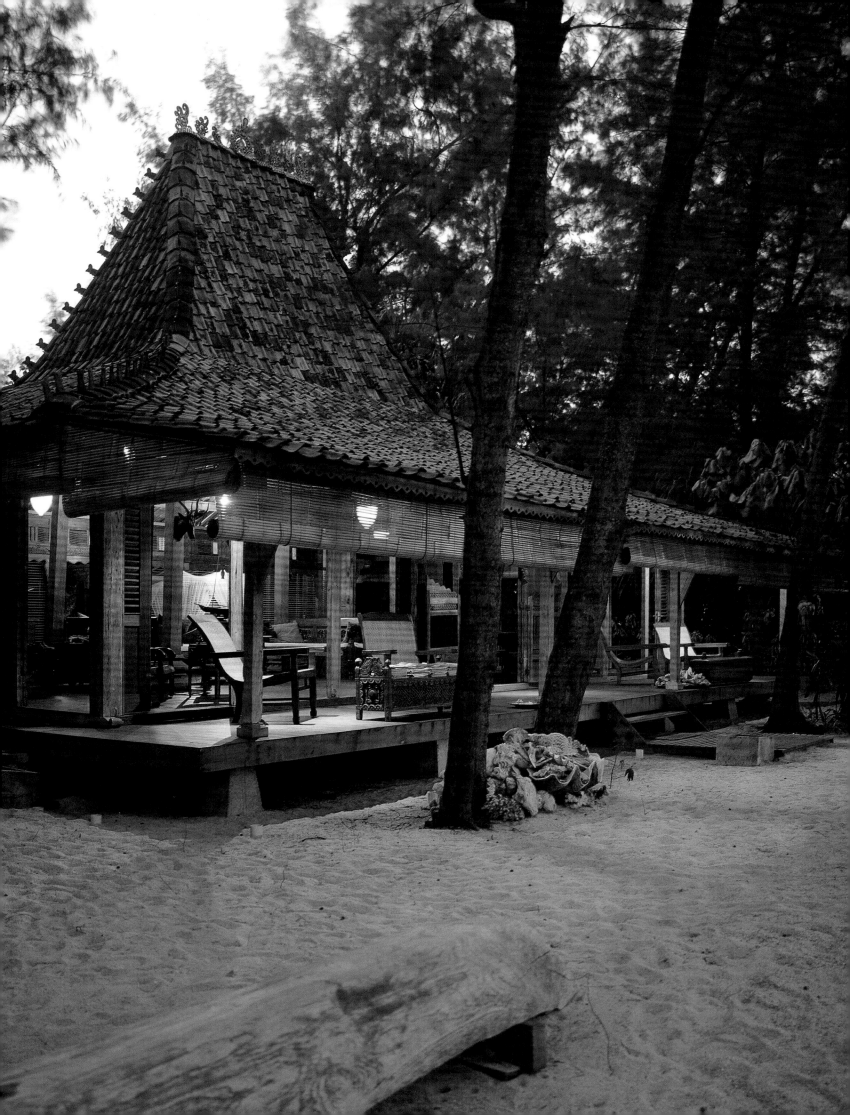

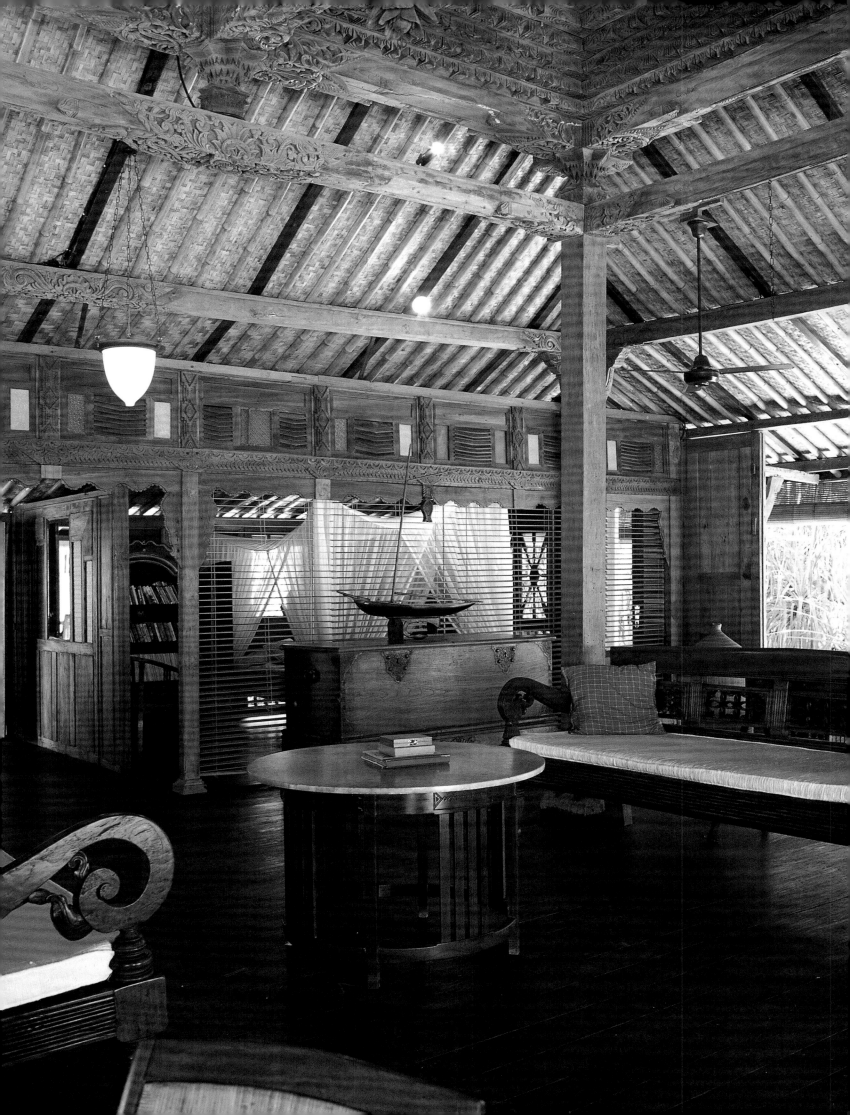

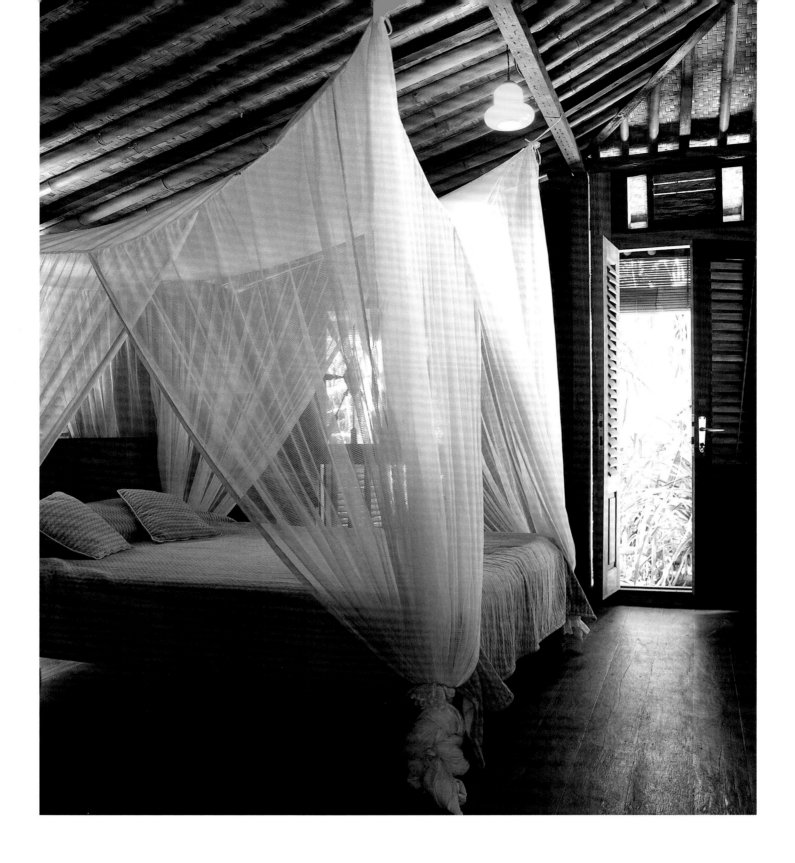

When stepping into the interior of the owner's house (left) it is hard to believe that it hasn't always been there as it blends perfectly with the natural environment. At its centre is the elaborately carved ceiling of stepped timbers called a *tumpang sari* that ascends into the pointed tiled *joglo* roof. The room is open to the cooling sea breezes, though panels can be placed within the framework for protection against the occasional tropical storm. Beyond the spacious living and dining space are two bedrooms behind an original carved wooden frame and Venetian blinds. The green and yellow glass of the frame is testament to the Dutch colonial influence. A corridor leads to two large bathrooms.

When it came to interior design, David wanted to avoid the over-designed look. An avid collector of antiques for the past 25 years, he was able to turn to Indonesia's past for inspiration. Large wooden chests from Madura and Java are placed in front of the bedrooms (left), while an impressive collection of old Dutch plantation chairs is scattered throughout the room and on the terrace. Embedded in their arms are original 2.5 cent Nederlandsch Indie coins. Complementing the ironwood floors are antique day beds and a marble-top table. In the simple bedrooms (above), mosquito nets are suspended sail-like over the beds while louvred doors open on to the island's wild gardens.

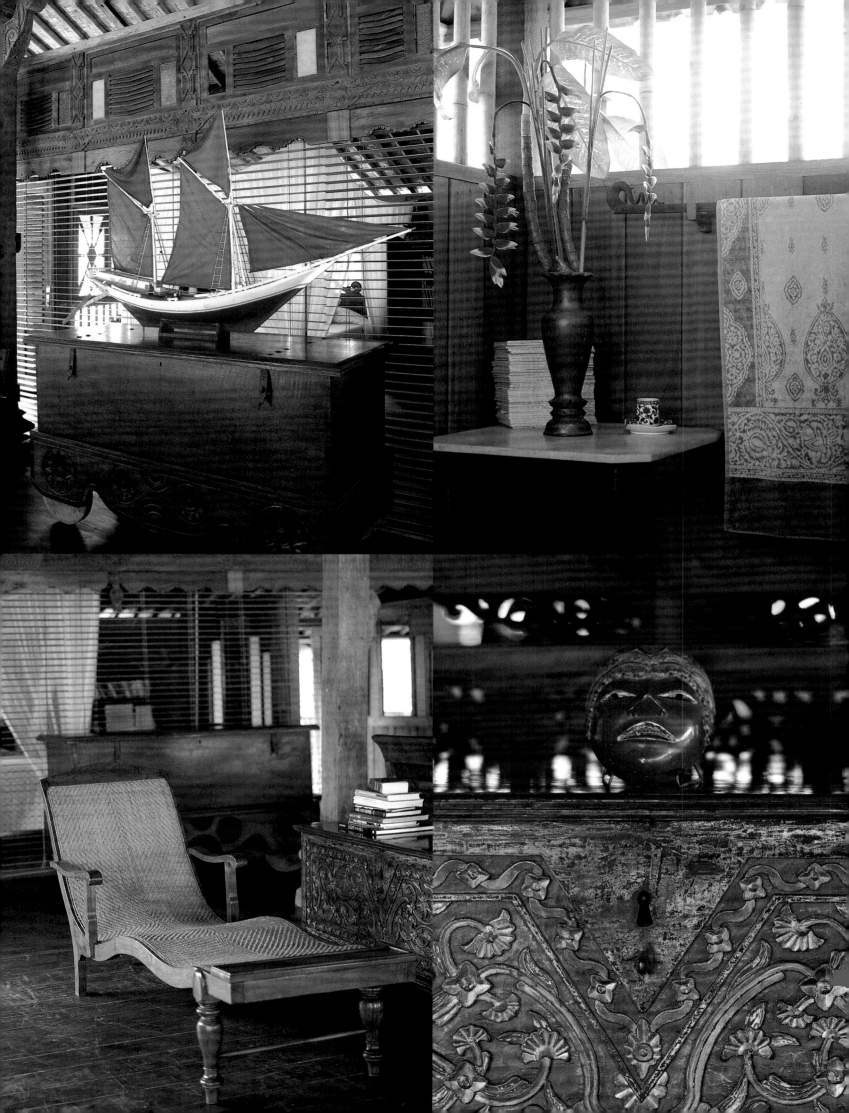

Although the island's theme is simplicity, as befits a retreat, the owner has not compromised on comfort. The bathrooms of the main house (opposite, top right) are spacious yet open. A bamboo grill lets natural light filter in. The shower is lined with patterned tiles from the Dutch colonial era while an unusual double enamel sink was rescued from the Dutch Club in Surabaya. Magazines are placed throughout the house as it's the ideal place to catch up on some reading. The décor of Kaliage Kecil is above all personal, reflecting the interests and passions of the owner. In the dining pavilion a remarkable collection of old wooden refrigerators from the past,

before the advent of electricity, are used as cupboards. Maritime paraphernalia such as an old ship's telegraph and bell and a replica of a wooden *prahu* sailing boat communicate the owner's love of the sea.

Hidden in the jungle at the end of a winding sandy path is the island's rice barn house. A stepladder provides access to the raised sleeping area, a cool bed among the casuarina trees. An outside bathroom includes a Balinese-style gate made out of white limestone and a shower open to the skies. Two antique four-poster beds are hung with mosquito nets in this simple wooden Malay-style house (above).

the house that jean-jacques built

The family home of Annelies and Jean-Jacques Audureau in the Balinese village of Seminyak is one of the most original on the island. Its design inspiration came from an unlikely source—Villa Villekulla from the Pippi Longstocking children's stories by Swedish author Astrid Lindgren. It is an old-style wooden house made up of three *joglo* houses from Java that were dismantled then reassembled by Jean-Jacques. The roof tiles came from an old Javanese mosque. The wooden panels, interior walls and beams have been painted white, as have the louvred doors and windows, creating a cool Caribbean feel.

Annelies, who exports furniture and furnishings to Europe, and Jean-Jacques, an expert on building tropical island houses, took one year to gather all the materials for their home, and another year to build it. But as long-time Bali residents, they have been collecting old furniture, doors and wooden panels from all over Indonesia that have provided colourful details to their home. Jean-Jacques's factory in Bali makes pre-fabricated island dwellings for export so he was able to provide additional materials such as the white wooden fretted eaveboards that are suspended from the traditional tiled roofs (right). Wooden Javanese house panels are used in innovative ways through-out the house. Here (above) they have been used to create a desk and study area.

The cosy family home consists of a two-storey building at the entrance which houses an office, play room, guest rooms and laundry and the main living section which overlooks the tropical gardens. They are linked by a covered walkway. Within the ample grounds is an inviting swimming pool (left). An old *lumbung* or rice barn provides a shady sitting area while traveller's palms add an evocative feeling of the East.

Annelies's interior design skills are evident in the warm, comfortable living room (right). The reds and golds of an old Afghani kilim are picked out in Balinese fabrics on a large wooden bench while capacious sofas are covered in cream and fawn fabrics. Although the house is predominantly white, wood detailing remains in the unpainted doorframes and the *bengkerai* wooden floors. "White is never boring," says Annelies. "We painted the ceilings, the pillars and beams white, which was considered sacrilege by some people, but left the doors and floors in their original state." The unusual candle chandelier, which was made in Bali, provides a focal point for the room. It is unusual in that real candles provide the light source. A rope tied to the side of the wall allows it to be lowered for lighting.

The Audureau house is above all a personal statement. "It expresses our love of Javanese art and furniture," says Annelies, who has literally scoured the country for original pieces. "We could have sourced everything in Bali but it is nice to look a bit further." A collection of striped Tunisian glassware sits on top of a cupboard from Bali (below). At the side are old clay pots from Java. The louvred windows (below) can be opened to the intense tropical light, or closed when shade is required.

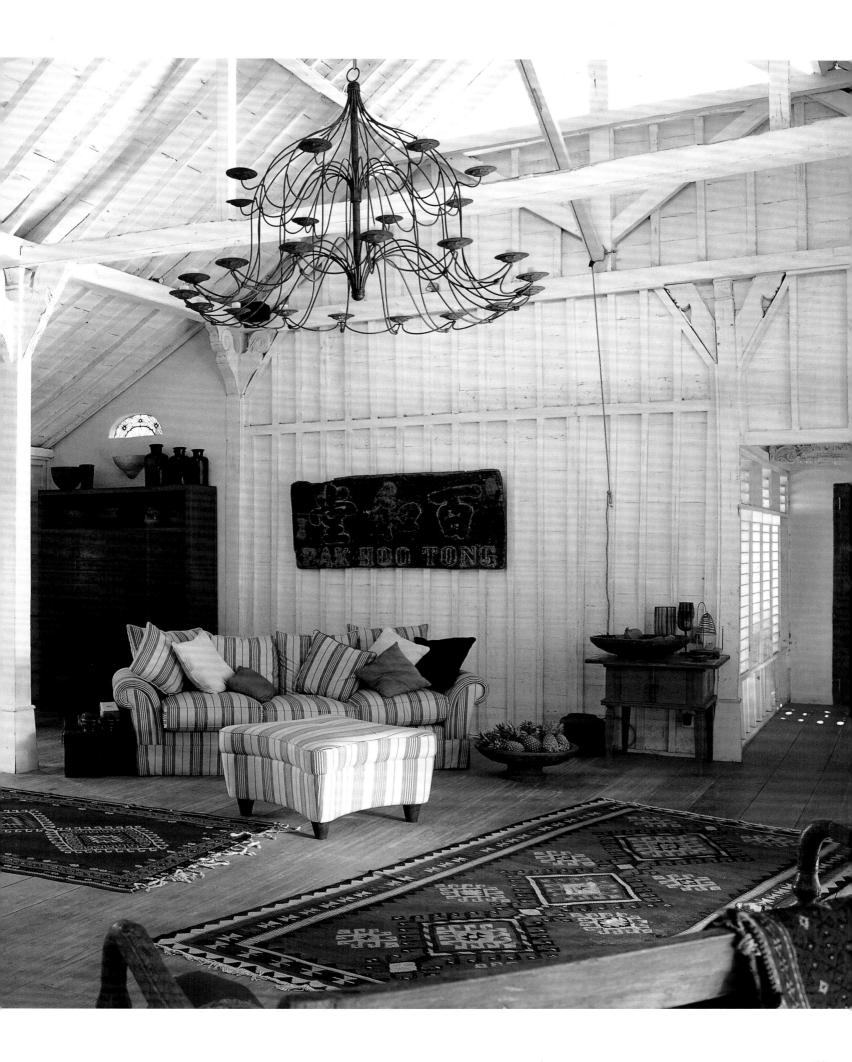

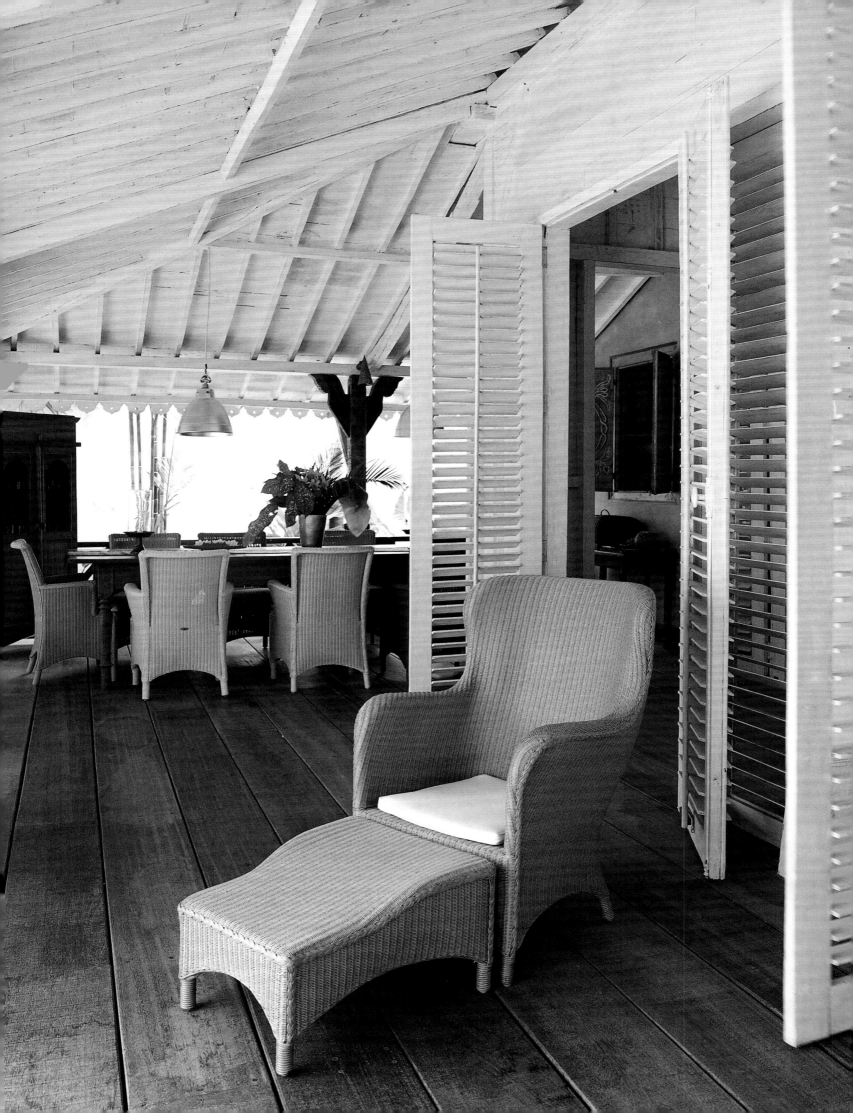

The spacious verandah (opposite) is the heart of the house, where most activities from family meals to evening drinks take place. The large dining table that seats eight is surrounded by a collection of Lloyd Loom chairs in pastel colours. Made in Java for export to Europe and the US, they are actually samples but the different hues work well together. A comfortable armchair placed in front of the louvred doors contributes to the relaxed, tropical colonial feel.

An old wooden door from one of the original *joglo* houses leads through to the entrance hall of the living room (above). Inside the doorway is a series of fisherman's baskets from North Bali. The insides are coated with black tar for water-proofing, enabling the day's catch to be kept fresh before it is brought to market. The antique colonial wardrobe was rescued from the Hotel Batavia in Surabaya following its renovation.

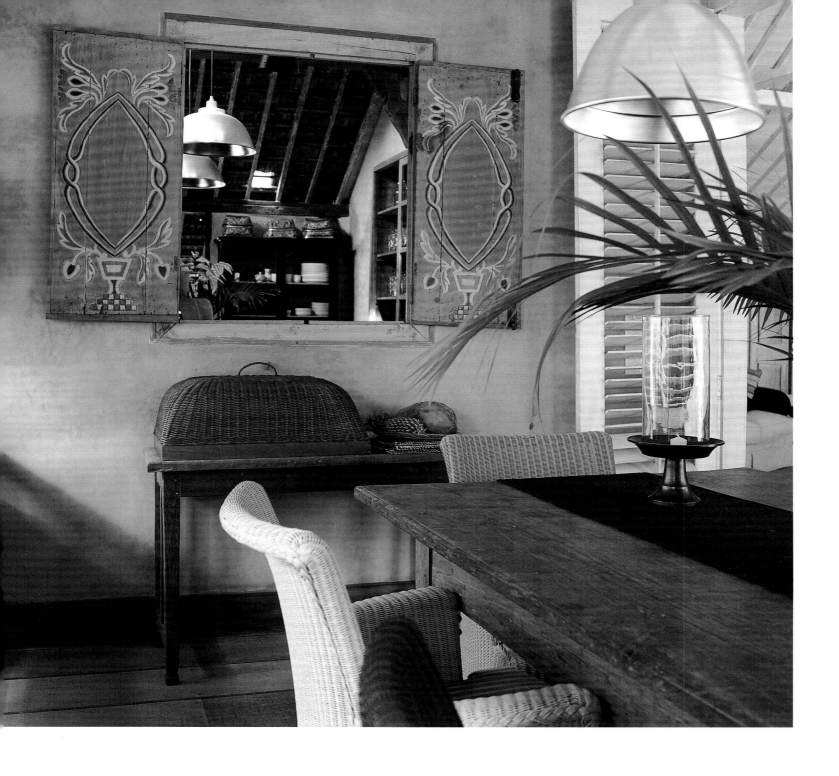

The rustic kitchen (right) retains the simplicity and muted colours of a traditional Javanese house. The facing wall is a complete wooden panel from one of the *joglo* houses that has been kept in its original condition. The roof is made up of bare terracotta tiles with glass blocks added in certain places to allow natural light to enter. The classic country-style furniture consists of an old Javanese teak table—its top one enormous piece of wood—and simple benches. A typical tradesman's stool sits at one end. Black terrazzo has been used for the kitchen sink and work surfaces, the colour echoed in the painted concrete floor.

Brightly coloured Javanese wooden shutters (above) provide a decorative touch to the serving hatch between the kitchen and dining area. Simple ceramic oil and vinegar bottles (right) from Bali's Jenggala ceramics company sit on a hand-carved wooden bowl.

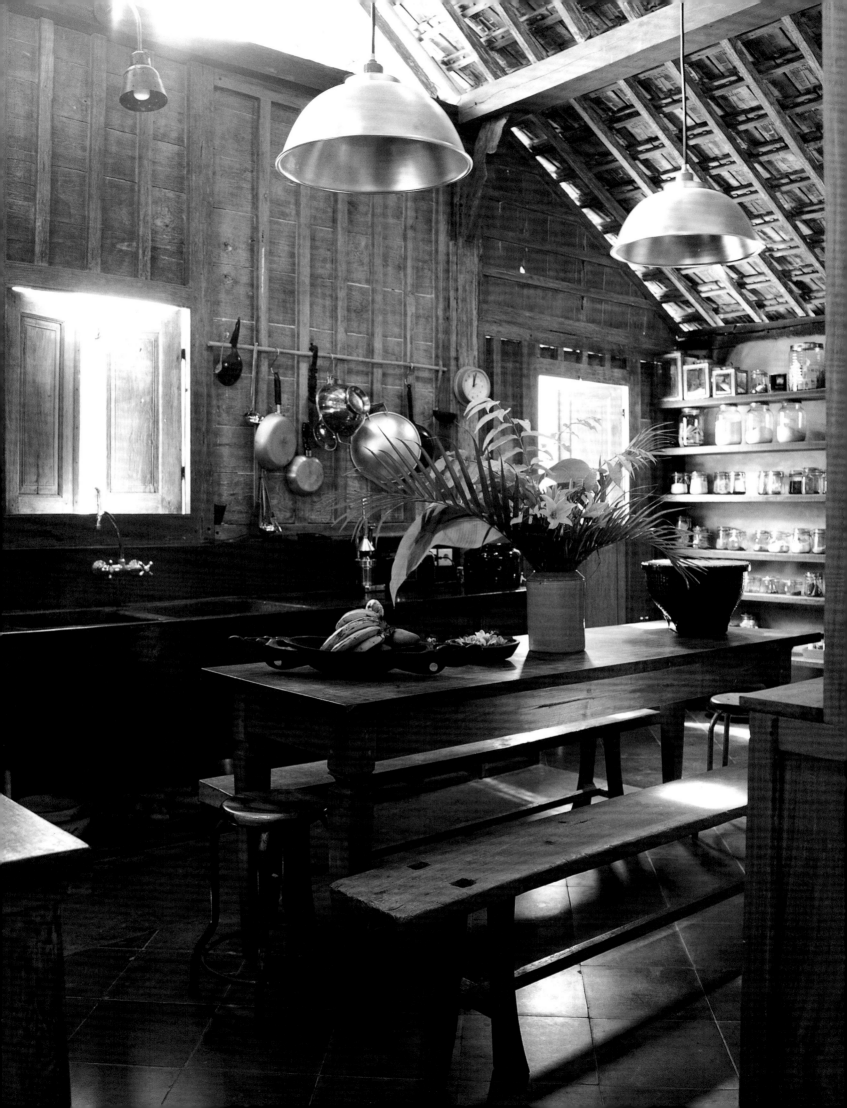

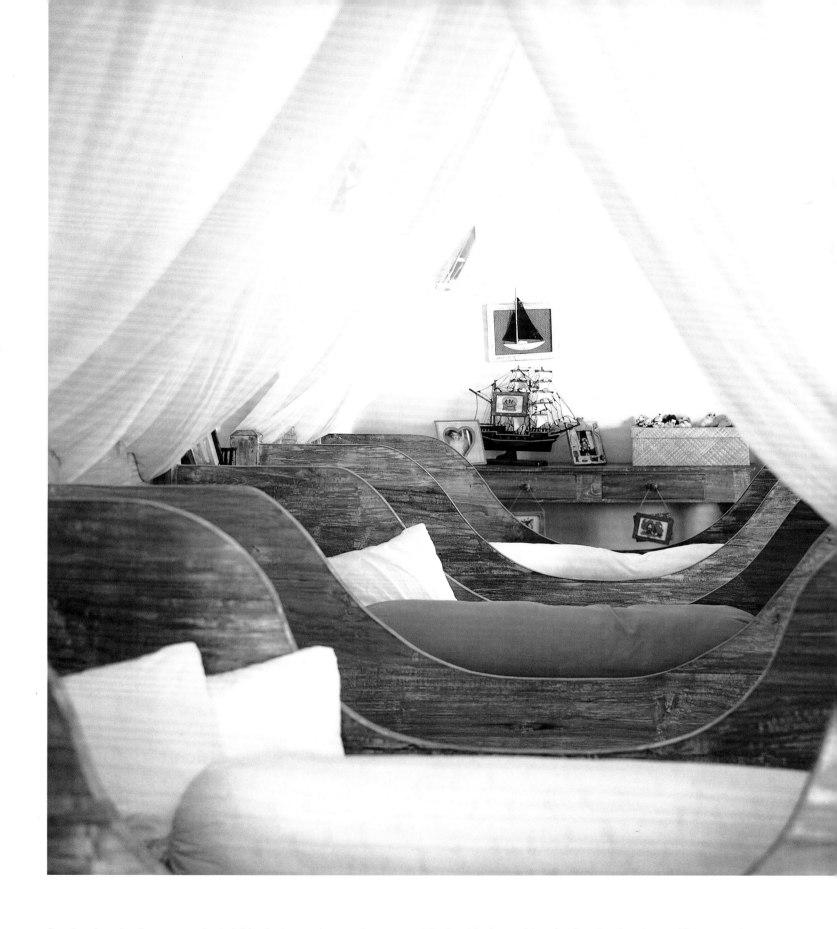

Annelies describes her two sons' cobalt blue bathroom (opposite) as the "folly of the house", but it was the colour they wanted. The large circular bath (see page 10) sits in the open air behind a high bougainvillea-covered wall. Towels are stored in a rough wooden cabinet with chicken-wire panels made in Bali's famous wood carving centre at Tagallalang. Carved house beams painted white add to the exuberant design.

The boys' bedroom (above) is fun. Annelies designed large, wooden boat-like beds that are liberally strewn with pillows. The draping sail-like mosquito nets add to the nautical theme, while an extra bed has been added for friends' sleepovers.

a rural idyll

Simplicity was the quality that most appealed to Olivia and Francois Richli when they decided to move their family from the luxury of the Amanjiwo hotel, where Francois is general manager, to a traditional wooden house within a rural Javanese village. They scoured the area surrounding the Buddhist monument of Borobudur, where the hotel is located, to find the right property and finally settled on a house in a nearby rural community that belonged to the *Lurah*, the village head. He no longer lived in the house which was being put to use as a chicken coup.

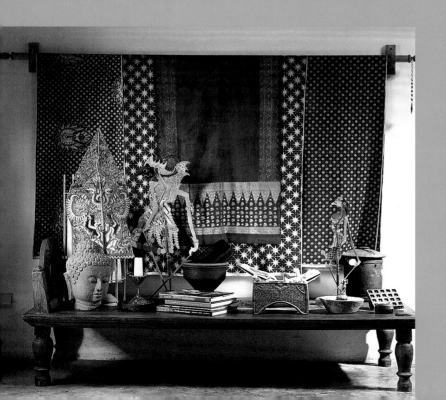

The Richlis wanted to keep the house as true to the original as possible. After a fairly extensive clean-up operation, they re-did the polished cement floors, added some glass blocks to the tiled *limasan* roof for additional light and opened up some of the small rooms into larger spaces. The house consists of a number of rooms arranged around an open-to-the-sky central courtyard (above), providing the all-important air circulation required of a house in the tropics. The Richlis transformed what was the village meeting room (right) into their sitting room. It is unusual for a traditional Javanese house in that it has shutters all around, providing more light than normal. They created an intimate space in the voluminous area by placing the furniture within the four central teak pillars. The black copper table in the centre of the room was made by a village craftsman who lives on the slopes of one of the area's surrounding volcanoes. Old Madurese wooden doors, a new addition to the house, lead through to the dining room. The Richli's abiding interest in indigenous culture is evident in the artefacts placed within the house. Olivia has a passion for textiles and her fine collection of *songkat* and ikat fabrics hang from wooden poles on the room's back walls. A collection of *wayang* puppets is grouped on a table in front, many of which represent the comic figure of Semar, Francois' favourite character.

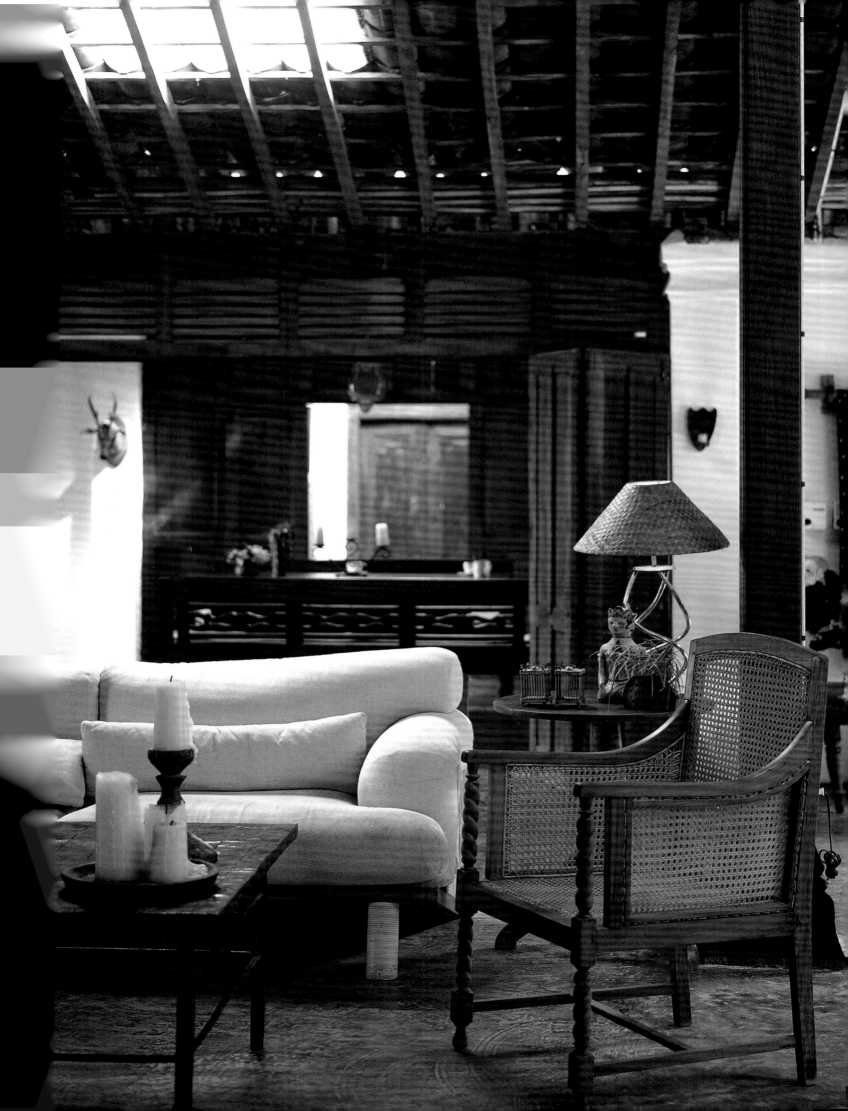

Most of the furniture in the house is rustic in design, but there are many more modern touches throughout the house. Silver figures from Yogyakarta (opposite, bottom left) are displayed within an old wooden betel nut box. The simple kitchen table (opposite, bottom right) is a roughly hewn piece of teak; the wooden chairs are known in Java as 'cowboy's chairs'. The unusual industrial-looking aluminium lights are used in Indonesia to light the country's streets. The bowl on the table (opposite, top right) is a piece of Ming kitchenware, originally brought to Indonesia by Chinese traders, who used it for ballast in their ships.

The Richli's two children, Ivo and Bronte, enjoy an idyllic life in the village. Their rooms look out on to an area where chickens and water buffalo wander while their horse is kept in a stable at the front of the house. Bronte's room (above) is colourful and bright. The Javanese four-poster bed features interesting carved motifs while the rustic cupboard has chicken wire in its doors in place of glass. The unusual striped fabric is made by a weaver called Pak Rakman, known locally as 'the pioneer'.

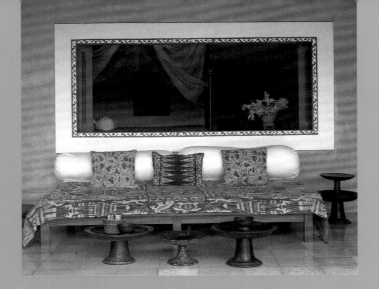

mountain magic

The stunning mountain retreat of Brazilian Hugo Jereissati at Iseh, in East Bali's Sideman valley, is a house with an illustrious history. Perched beneath majestic Mount Agung, it was originally built in 1937 by German artist Walter Spies as his atelier. Quiet, remote and with one of the most spectacular views in Bali, Spies came here to work in splendid isolation. Later, Theo Meier carried on the artistic tradition, remaining in the house until the 1970s. In 1985, Italian writer Idanna Pucci rebuilt the house—which had been damaged during Mount Agung's violent eruption in 1963—with a sensitive and light touch. Hugo took over in the early '90s, retaining the striking pink and green exterior colours of the Pucci renovation while adding a vibrancy to the once austere interiors. This simple, three-bedroom complex remains one of the most magical hideaway houses on the island.

In keeping with the secretive nature of the place, entrance to the walled compound is through a small wooden doorway accessed from the cobbled village square. The three pavilions that make up the house feature tiled roofs, lichen-clad with age. A covered colonnade leads visitors to the spacious open terrace (right), the focus of the house. On approach, the powerful form of Mount Agung rises in the distance, while a small boulder-strewn river can be seen at the bottom of the valley below. The beauty of the 180-degree verdant rice-terrace view is simply breathtaking. Sitting on the large day bed with its sun-faded fabrics (above) and looking across the timeless terrain makes one feel that not much has changed since the '30s. One can imagine Spies relaxing here—and listening to the same sounds of the village cockerels, the cicadas, the river and the girls gossiping in the kitchen.

The powder pink exterior walls provide a striking contrast to the intense green of the rice fields. According to Made Wijaya (an Australian landscape designer also known as Michael White), who was 'aesthetic adviser' to Idanna Pucci during her renovation project, this colour was a feature of the original house. Carved wooden pillars, simple wooden furniture and polished concrete floors all add to the unpretentious feel of this open-air space.

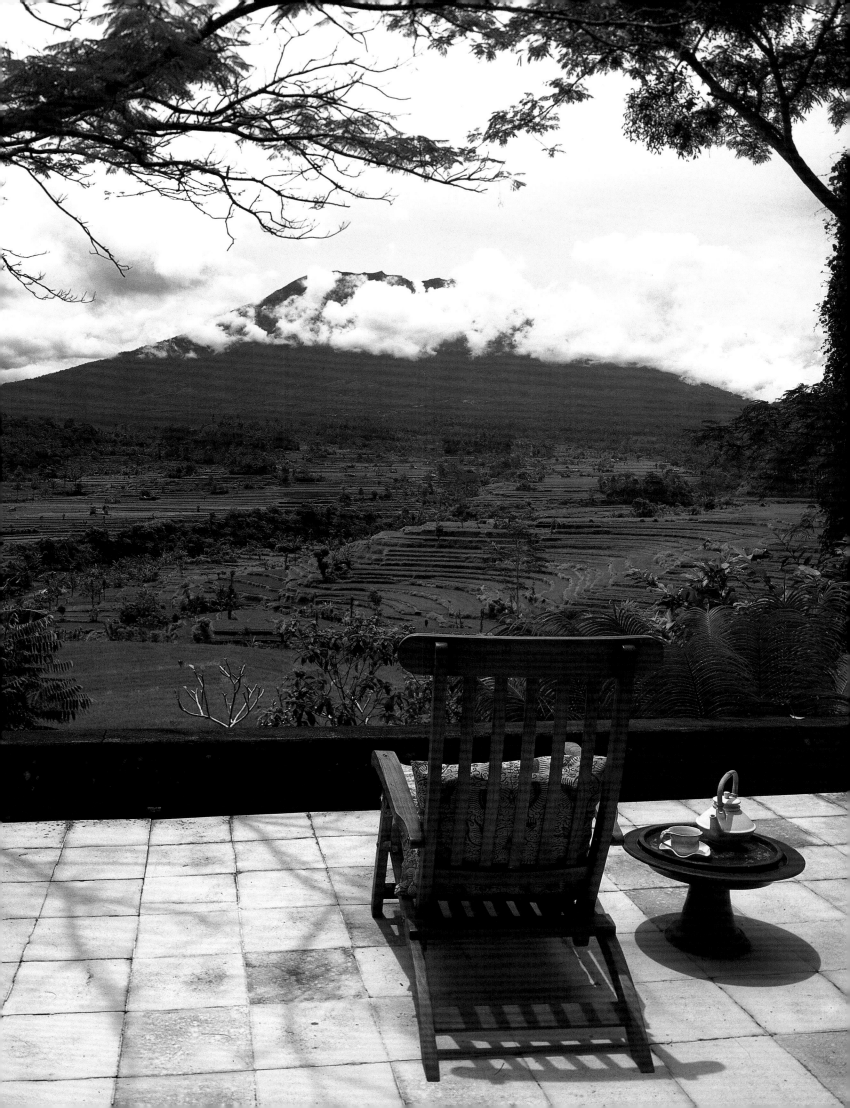

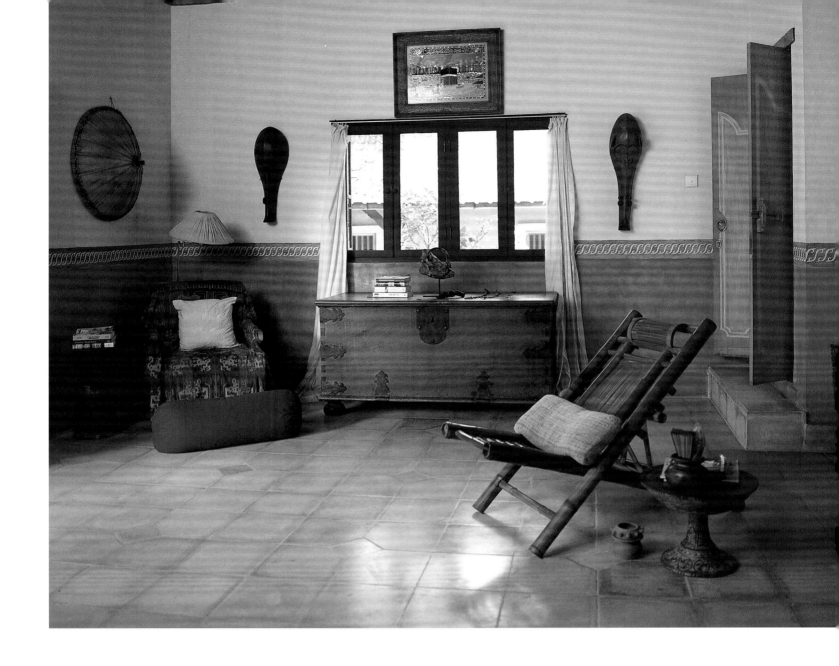

Hugo's master bedroom and study (above and left) contains an eclectic mix of antiques and artefacts: it is as if the owner had raided his grand-mother's attic. A large wooden chest—standard issue for colonial traders—sits under the simple window. An attractive inlaid Sumatran chest becomes a bedside table when positioned next to the large canopied four-poster bed. Furniture includes a simple bamboo deck chair and wicker armchair. Nothing is over-designed or deliberate. Saffron yellow diamond details break up the monotonous pattern of the green tiled floors. Bringing the interior to life is the beautiful paint work by Australian artist Stephen Little. The bottom half of the wall is painted in a rich, warm orange with an attractive green hand-painted border.

The bathrooms of the Jereissati house are colourful and bright. The deep saffron and green colours of the bedroom are repeated in the master bathroom (right). Attractive ceramic tiles in muted colours are set behind and around the white sinks. Old Javanese glass lamps recreate a feeling of the past. Woven rattan panels—which permit air circulation—are set into the doors of the vanity units. The bamboo grills on the window mirror the lines of the bamboo grove outside.

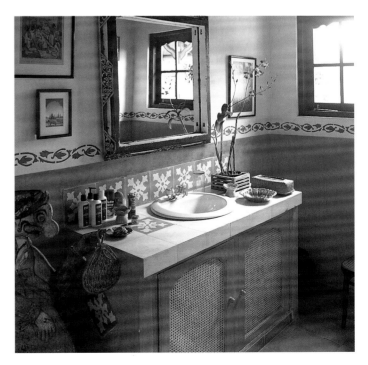

royal balinese

The magical Villa Tirta Ayu overlooks Taman Tirta Gangga, the European-inspired formal water gardens in East Bali built by the last Raja of Karangasem in 1947. This Balinese compound in traditional palace architecture—formerly the Raja's summer retreat—was transformed by Australian designer Carole Muller into a small luxurious villa. Her aim was to "preserve the original style and scale of the pavilions, while creating multi-functional living spaces suitable for casual alfresco tropical living". The renovation retains the romantic vision of the late Raja, "uniting the historical past with the elegance and luxury of an international style".

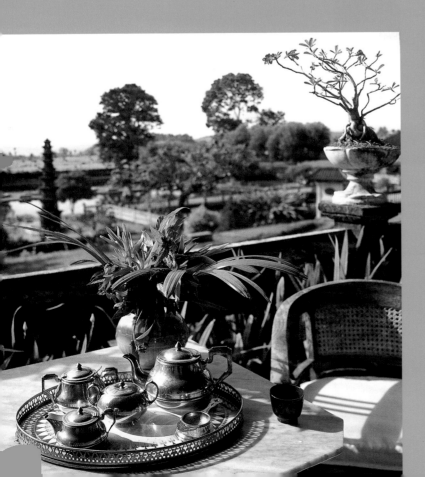

Tirta Ayu's two main pavilions—one for sleeping and bathing, the other a meeting place for shared activities—are open to meditative views of the terraced water gardens with Mount Agung rising in the distance. A kitchen pavilion and open 'moon-viewing' terrace sit behind, while the villa's gardens mimic the water palace in miniature. The four-poster bed (right) provides the perfect place to listen to the sound of the fountains below. Adorned with white embroidered pillows and Indian muslin curtains edged in saffron, its canopy is a delightful screen-printed collage of Balinese motifs by Ubud-based American artist Symon. Another of his sybaritic paintings hangs behind a dresser in the dining pavilion, on which sits a collection of Burmese lacquerware (above).

A long verandah terrace fronts the villa (left), providing a place to take tea and gaze across the stunning vistas. On the balustrade a row of neo-classical planters filled with desert roses (*Adenium obesum*) pay homage to the formal style of the late Raja. A square, marble-topped table and empire chairs—where Cleo the cat is often to be found curled up asleep—contribute to the 'European-in-Asia' style of the villa's decor.

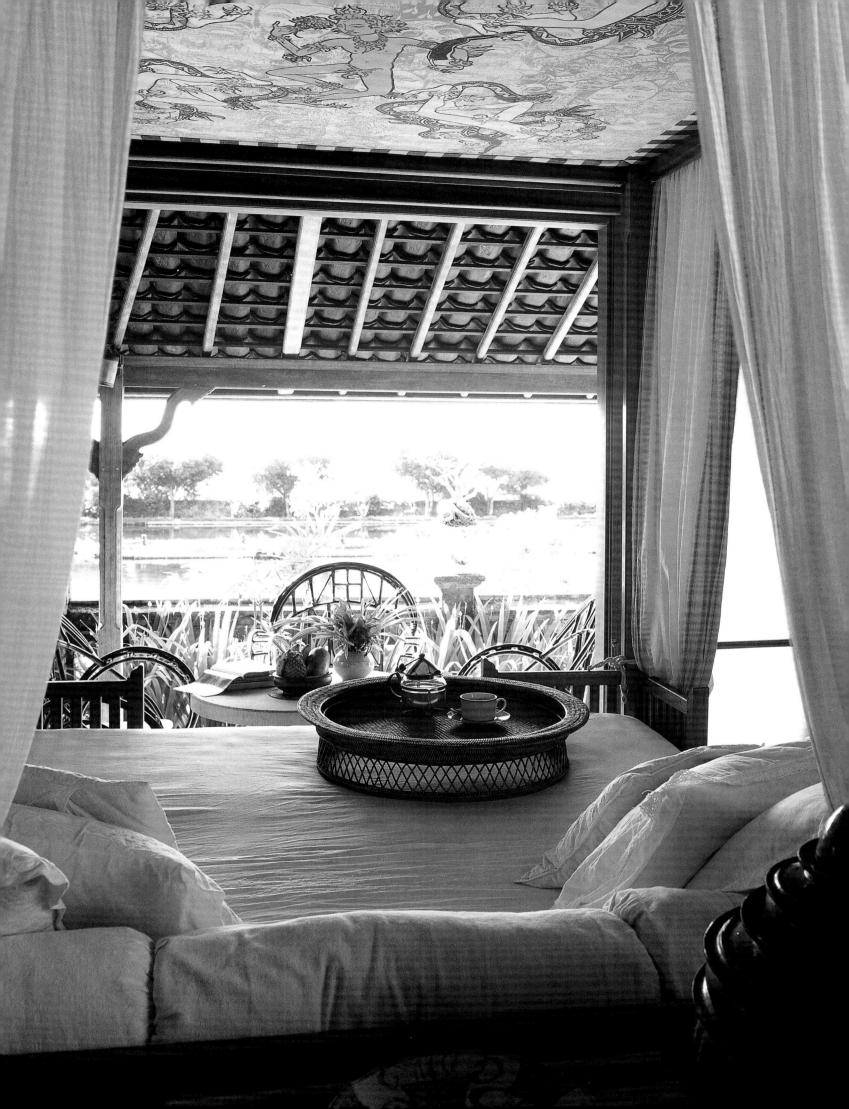

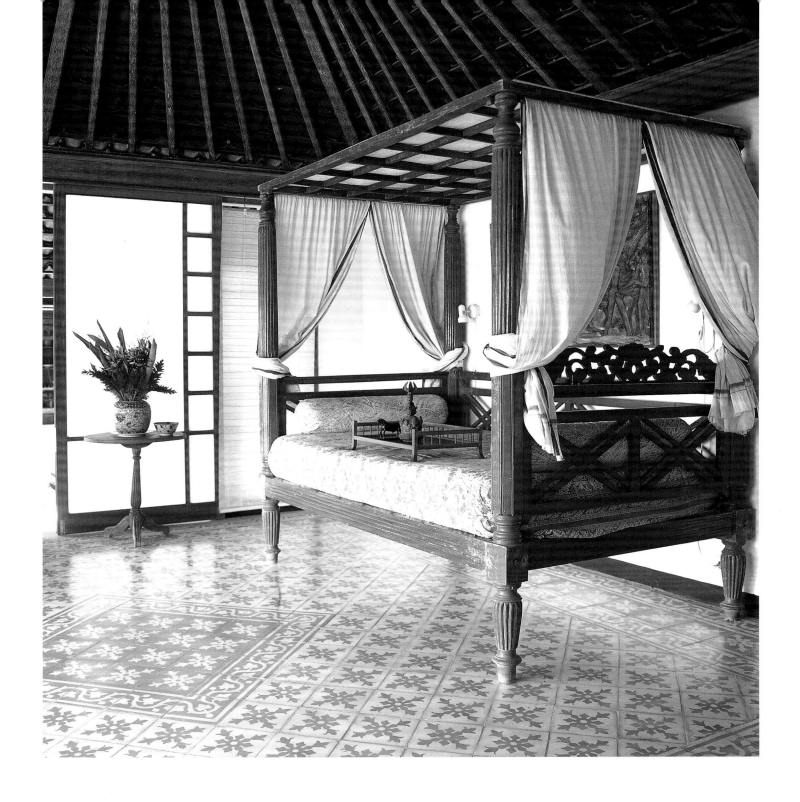

In her quest to preserve the architectural integrity of the original, Carole has incorporated unique palace motifs into the villa's design. For example, a life-size Vishnu statue, cast from an original teak mould commissioned by the Raja in 1937, stands above the black volcanic stone plunge pool (left), while the villa's entrance court tiles are carefully reproduced versions of an original palace design. The raised Raja's pavilion adjacent the pool is the focus of the villa. A rotan chaise longue beside the pool is one of Carole's own designs. Interior colours of saffron and green are used to great effect in the attractive floor tiles and painted Regency-style four-poster bed (above). Carole uses Indian fabrics throughout the villa—green-edged *lunghis* become bed curtains. There is after all a mythical connection between Tirta Gangga (which means holy water of the Ganges) and India: local people believe that India's holy Ganges river is the source of the sacred spring that feeds these magical water gardens.

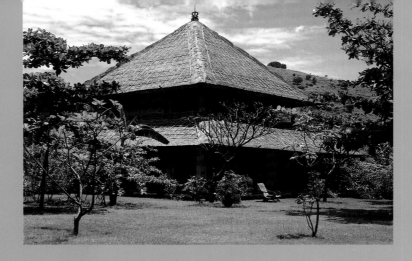

wantilans on the waterfront

In the quiet fishing village of Pemuteran in the northwest corner of Bali is Puri Ganesha, a group of four two-storey thatched villas set between the ocean and the tropical mountain forest. Owned by intrepid Englishwoman Diana von Cranach, it was designed as a rustic getaway where guests feel like they are staying in an old friend's house rather than a hotel. The villa resort artfully combines traditional Balinese architecture and the spaciousness of large colonial houses with design elements from around the Indonesian archipelago. It's a simple, peaceful place that Diana describes as "laidback luxury".

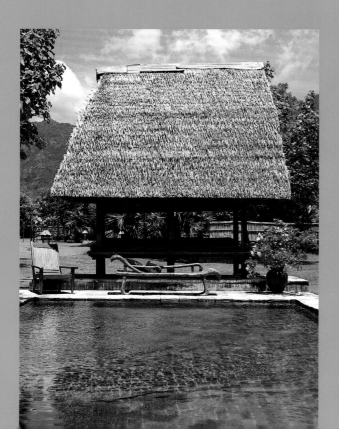

The design of Puri Ganesha is inseparable from the stunning natural landscape. The spacious pavilions (above) have been built in the Balinese *wantilan* style, the two-tiered community hall seen in all the island's villages. Set directly on the beach, the pavilions feature traditional *alang-alang* grass roofs. Each has an ample terrace on the ground floor and a large wrap-around balcony on the second with doors that open to the sound of the sea. The private swimming pool of Villa Santai, also known as the 'Honeymoon Villa', includes an antique *lumbung* or rice barn from Negara in West Bali (left) as a shelter from the sun. This is the place to recline on a simple bamboo lounger and view the West Bali mountains in the background.

There are four villas altogether, each decorated in a different colour theme. Villa Santai makes extensive use of double ikat *geringsing* cloth from Tenganan in West Bali and Balinese *poleng* black and white check material at the base of fine linen curtains (right). The defining characteristic of the villas is spaciousness. On the ground floor large day beds provide a place to relax with a book or enjoy a siesta.

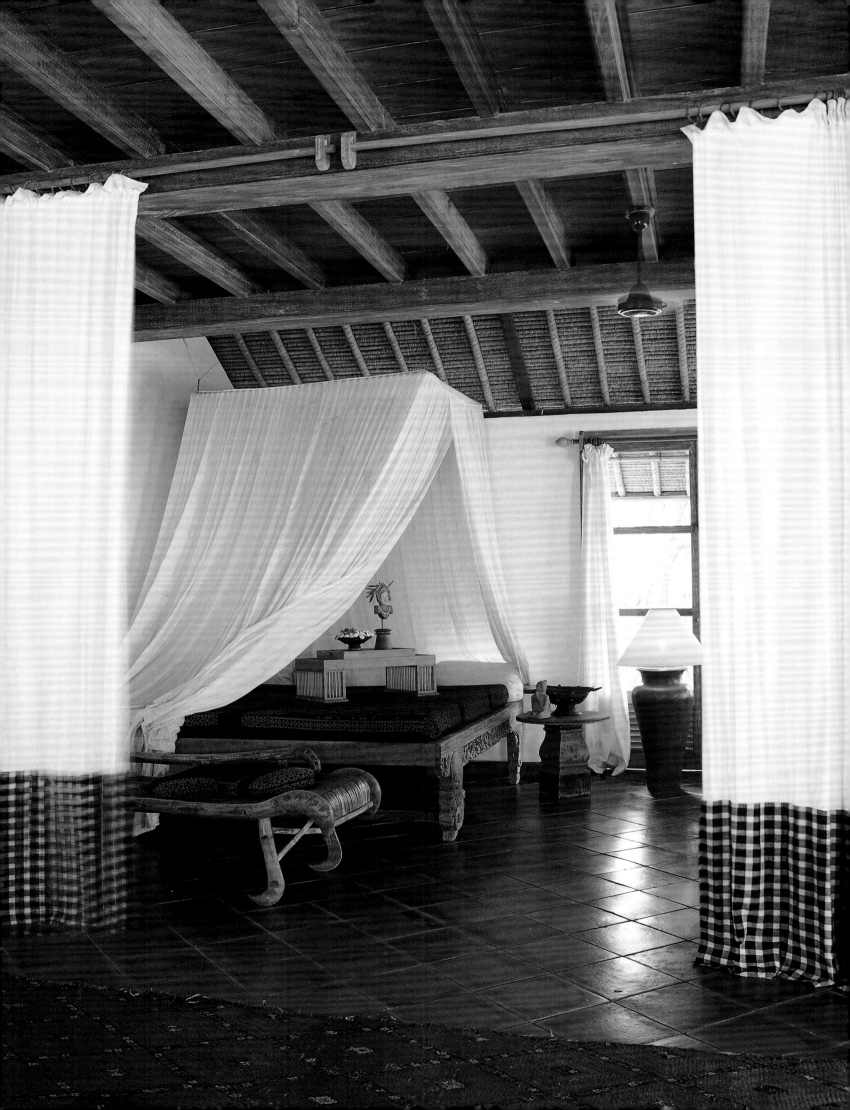

Diana's mastery in bringing different elements together to create her laidback-luxurious style is evident throughout the villas. Furniture found on Diana's many forays through the antique shops of Bali and Java is complemented by high ceilings and wooden beams (above). Each of the villas has its own kitchen where staff prepare tropical breakfasts; guests have the luxury of choosing one of several locations to eat: their own dining pavilion in the grounds, a verandah, a dining room or the informal restaurant called Warung Sehat (which means healthy cafe). Everything is prepared from fresh ingredients sourced from the mountain market of Bedugul.

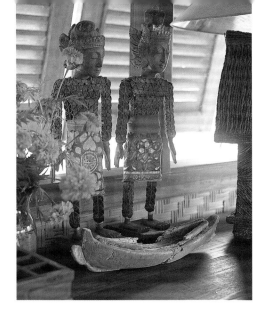

Former interior designer Diana has stamped her individuality and style throughout the resort: her talent can be seen in the details. All the villas have a kitchen, bedroom and a choice of places for relaxing and eating. In the Honeymoon Villa, two antique Rambut Sedana figures (left) from her personal collection grace the desk in the bedroom along with an old wooden boat that washed up on the beach. A ganesha (below) represents the elephant, the symbol of the resort. An inlaid wooden door from Lombok leads through to the villa's open garden bathroom.

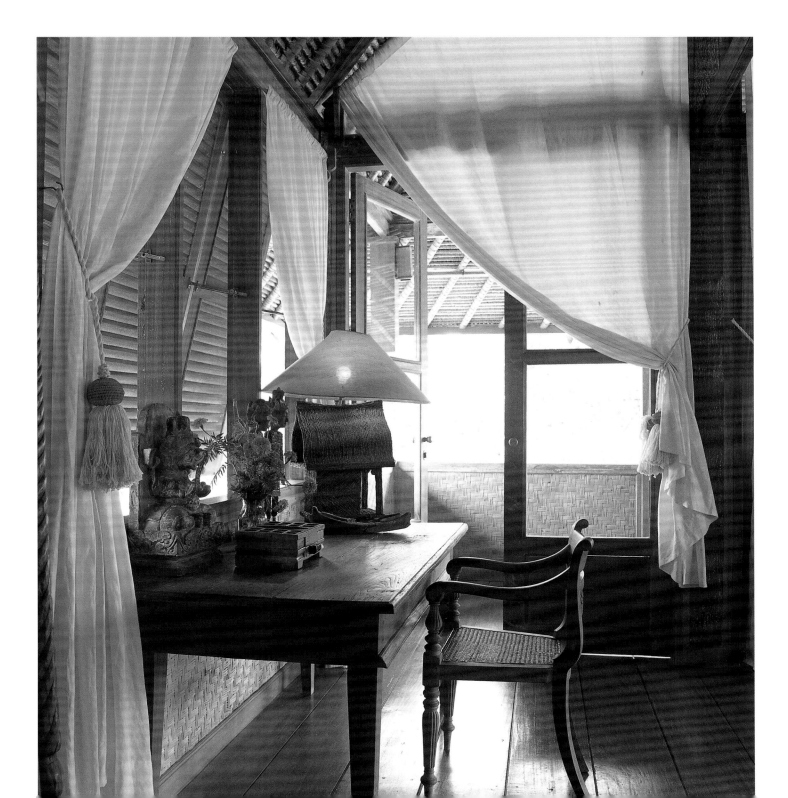

a taste of java

Hidden deep in the volcanic highlands of central Java is Losari, an old world coffee plantation set in a stunning (22-hectare) 55-acre site. Losari, which means "the essence of the trees" in Javanese, is a working plantation with fields of robusta coffee growing in the shadow of eight volcanoes. The heart of the property is an old plantation house that was built originally in 1828 and has been renovated recently. The creative force behind the development is Italian Gabriella Teggia, who has a history of creating exceptional properties in Indonesia. This is her latest project and she plans to develop the site into a deluxe resort and spa.

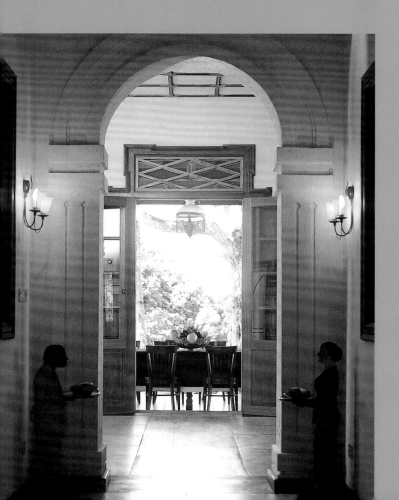

Losari is one of those special places that provide a glimpse of the past. Gabrielle bought the property in 1992 and commissioned two Italian architects to restore the main house and gardens. They added broad white columns and an expansive terrace. A well-tended lawn complete with croquet hoops surrounds the house, while a stone path lined with terracotta planters leads to the main entrance (above).

Common areas within the plantation house include a lounge, dining room and library furnished in the Dutch colonial style. It is easy to feel transported to a bygone era when sitting in the library, gin and tonic in hand, listening to the strains of Louis Armstrong playing softly in the background while waiting for dinner to be served. The wide wrap-around verandah (right) is where breakfast, informal lunches and high tea are served. A speciality of Losari is the traditional unfiltered Javanese coffee *tubruk*, made with the plantation's own beans which are roasted and ground the old-fashioned way—by hand, using traditional machinery. The wide wood-lined eaves (right) provide ample protection from the hot afternoon sun and tropical storms. The furniture—old-style wood and rattan rocking chairs and comfortable loungers—adds to the colonial atmosphere. It's a relaxing place to lie back and take in the view of the coffee-covered hills and the cloud-wrapped mountains beyond.

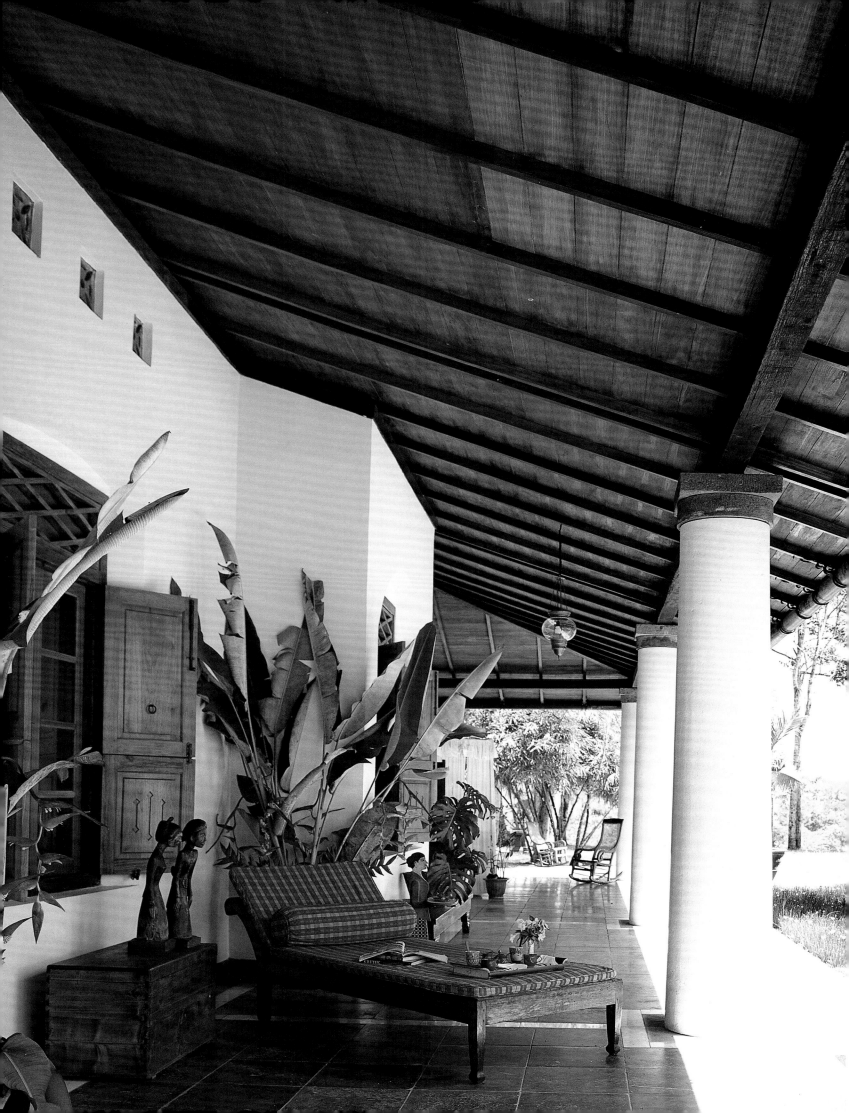

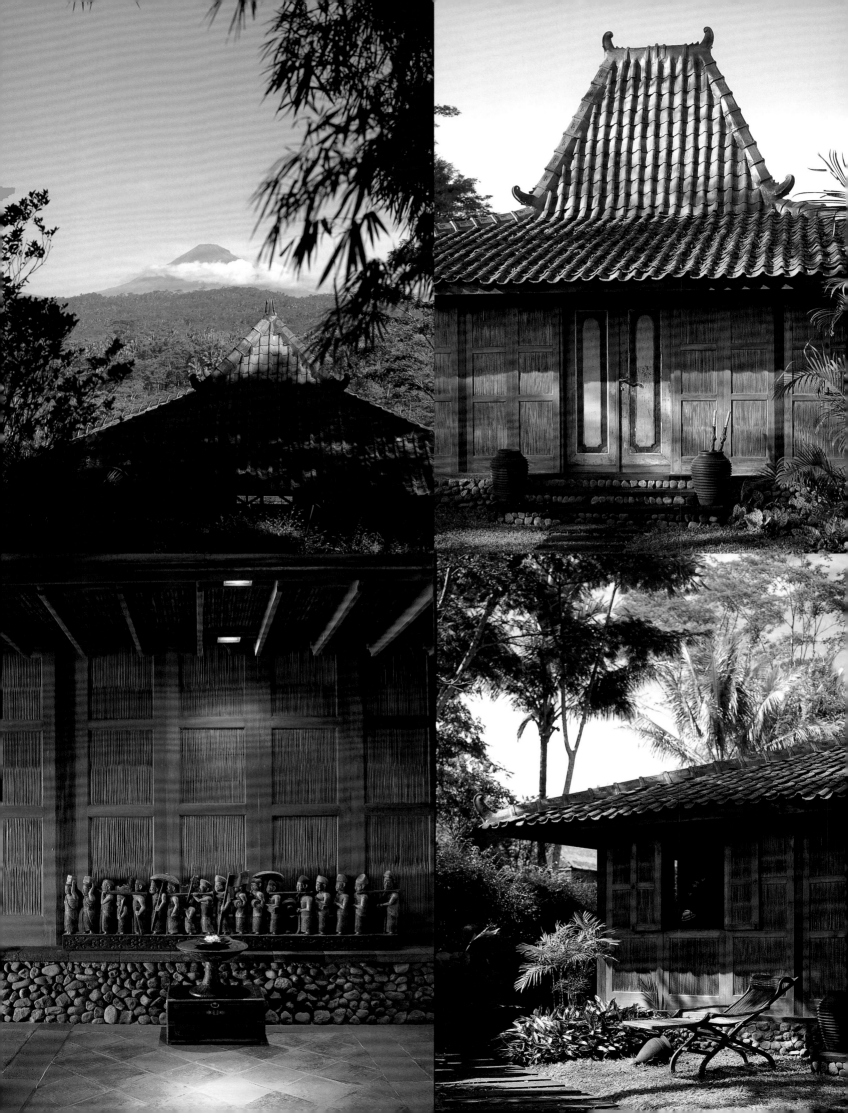

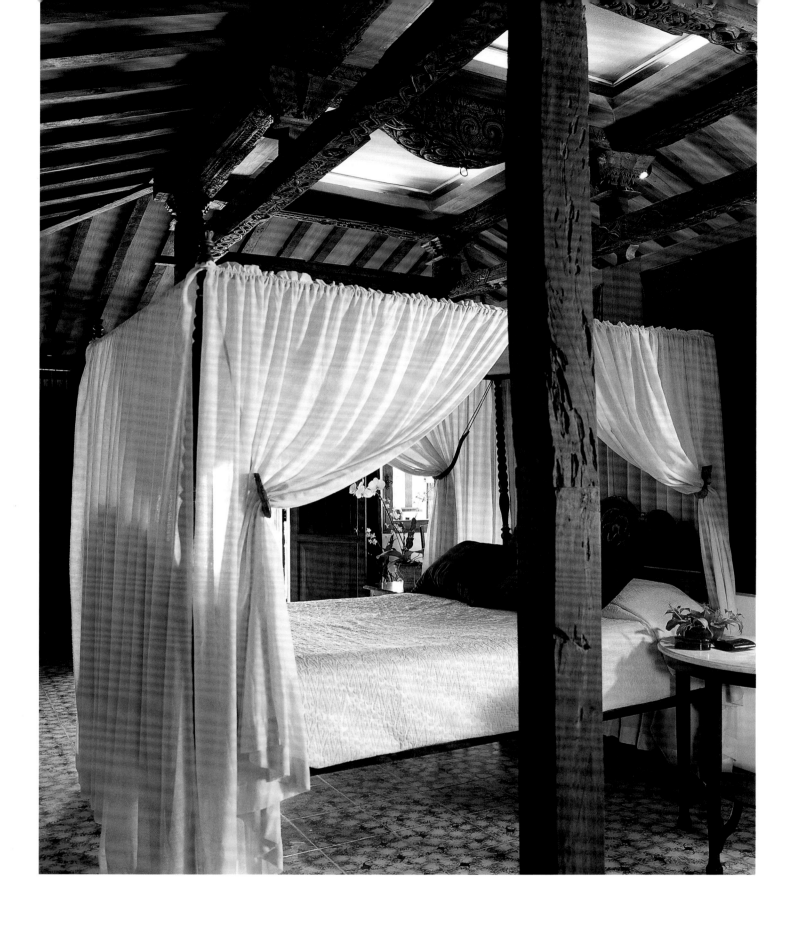

Within the grounds of the plantation are the all-suite villas. Traditional Javanese architectural styles have been used in order to promote the skills of local craftsmen. When the Javanese look at houses they see roofs—either *limasan* (opposite, top left) or *joglo* (opposite, top right). Supporting the roof of the *joglo* suite (above) is a carved *tumpang sari*—a series of stepped beams—made of teak and over 100 years old. These are much sought after by antique collectors for use in new buildings and are fast disappearing. The panels of the villa walls (opposite, bottom right) are made of woven bamboo strips, while the interiors echo the old-style mood of the plantation house, with curtain-lined four-poster beds, marble-top bedside tables and other antique furniture. Wooden terraces and garden sitting areas offer a private place to take in the stunning views while enjoying a cup of *Robusta javanensis*, the incomparable taste of Java.

celebrating the past

In the centre of the east Javanese city of Malang, located in the mountains 90 km (50 miles) south of Surabaya, the Hotel Tugu Malang stands as a testament to one man's vision. That man is Anhar Setjadibrata, who opened the hotel in 1990 as a showcase for his extraordinary collection of antiques that recall the romantic past of Malang and, indeed, of Java. Anhar is no ordinary collector. Over the past 30 years he has been on a crusade to preserve his country's history, often buying the contents of entire houses that would otherwise have been destroyed.

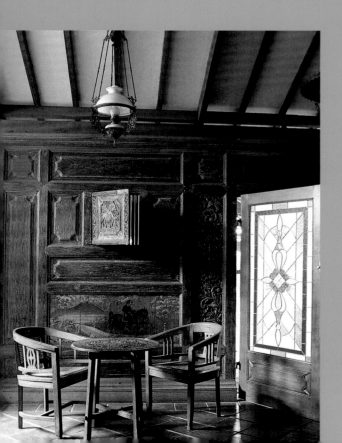

Antiques are arranged in themes within the three-storey mansion of the Tugu Malang. A private dining room, for example, is dedicated to the memory of Indonesian sugar baron Oei Tiong Ham, who died in 1924, and contains a large teak dining table that seats 16, as well as a life-size portrait of his beautiful young wife. "I open my store-room and see what would look nice," says Anhar of his approach to interior design. "I try to combine several pieces into one story." This approach results in a very intimate feeling within the hotel, which was the aim of Anhar and his wife Wedya Julianti, who wanted their guests "to feel like family staying in our house".

Malang, which was established in the late 18th century as a coffee-growing centre, is a city of wide streets and old Dutch architecture that still retains a colonial air. When staying at the Tugu Malang, it feels like you have quietly slipped back in time. The Tempo Doeloe Bar (which means "the good old days" in Bahasa Indonesia) makes use of old wooden house panels, antique *becak* chairs and brightly coloured stained glass windows to create a 1920s atmosphere (left). Carved panels from an original Kudus house that was owned by a family in Malang provide a point of visual interest in a hotel corridor (above). A blue Javanese *gebyok* screen from the nearby village of Jombang and wooden posts from a Madurese house decorate a public area (right).

Everywhere you turn at the Tugu, treasures from Indonesia's past are to be found—whether it's a cupboard full of antique *wayang golek* puppets, a wall lined with Ming and Qing plates, art-deco stained glass or old enamel advertisements from the 1930s (left). All are grouped in such a way to represent "a moment in our forgotten history".

Anhar has also gone to great lengths to preserve the cultural heritage of the Chinese migrants who settled in Indonesia. A 1900s clan house entrance doorway and pillars that originally came from Surabaya is placed on an interior wall of the hotel (below). The original house was demolished to make way for a modern shopping mall so Anhar stepped in to save at least part of the impressive building. The calligraphy at the side of the door is a poem that talks about the importance of education for children and was translated into English by the late wife of Singapore's previous president, Ong Teng Cheong, on a visit to the hotel.

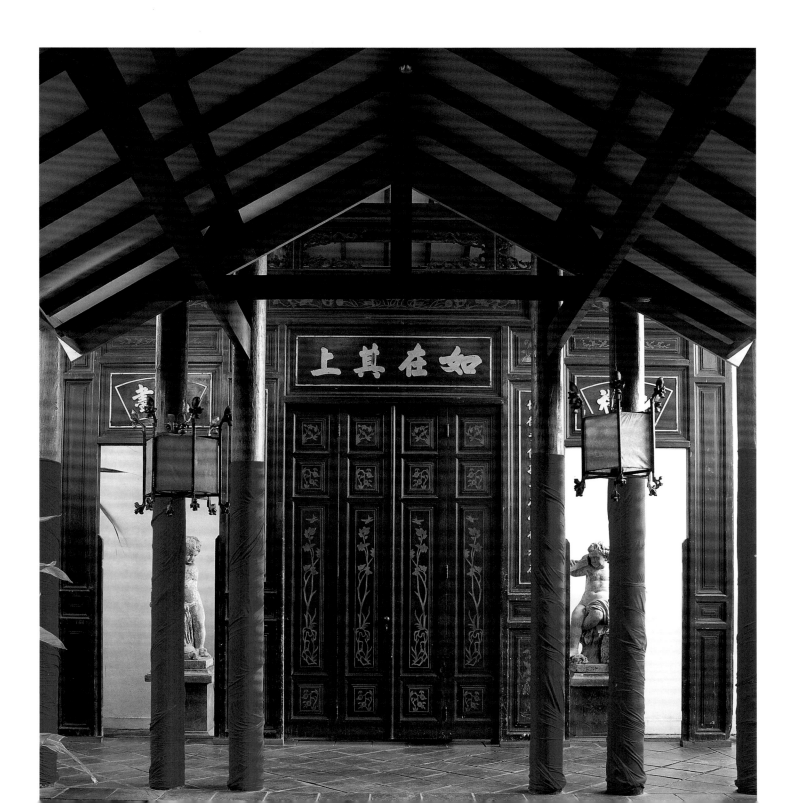

life on the edge

When an Australian writer on music and the arts decided it was time to build a house of his own on Bali, he had several requirements. "I was looking for a place that had no road past it, I wanted an inspiring view, and it had to be in a rural community. A place where I could work, listen to music, read books, where few people could find me." Luckily he found just the place in Banjar Baung, a small mountain village overlooking the sacred Ayung River in Bali's central foothills near Ubud. He built several traditional Balinese-style pavilions on a plot of land that juts out over the river far below. He describes his mountain home as "an oasis within an oasis", a quiet and meditative place for his disciplined working life.

The owner had been a frequent visitor to Bali since 1973 and later lived on the nearby Sayan ridge until he built his own house 11 years ago. Enlisting the help of long-time Bali resident Made Wijaya, the brief was to build a home that incorporated a *gamelan* (traditional orchestra) and dance pavilion overlooking the valley. Together they created a house that draws its inspiration from traditional Balinese architecture. The site affords incredible views north down the course of the river to the mountains, and west across sculpted terraces.

Like any true artist's retreat, this house is not easy to reach. The visitor has to take a long walk in over an earth ridge between two steep valleys. Built into a steep-sloping cliff, access to the house is through a small wooden village door and over a narrow wooden bridge. The heart of the property is the open-air dining and sitting area, the place where the owner welcomes his guests. The view is truly spectacular—a manicured lawn (right) drops down dramatically to the river below, with rice terraces and a sacred temple in the distance. The simple gardens are described by Wijaya as "English-Ubud-tropical-natural". Interiors are unaffected, with some delicate paint finishes by Australian artist Stephen Little. He is responsible for the "Picasso Lemari" (left), a cupboard that pays homage to the Spanish artist through a pastiche of drawings from his sketchbook.

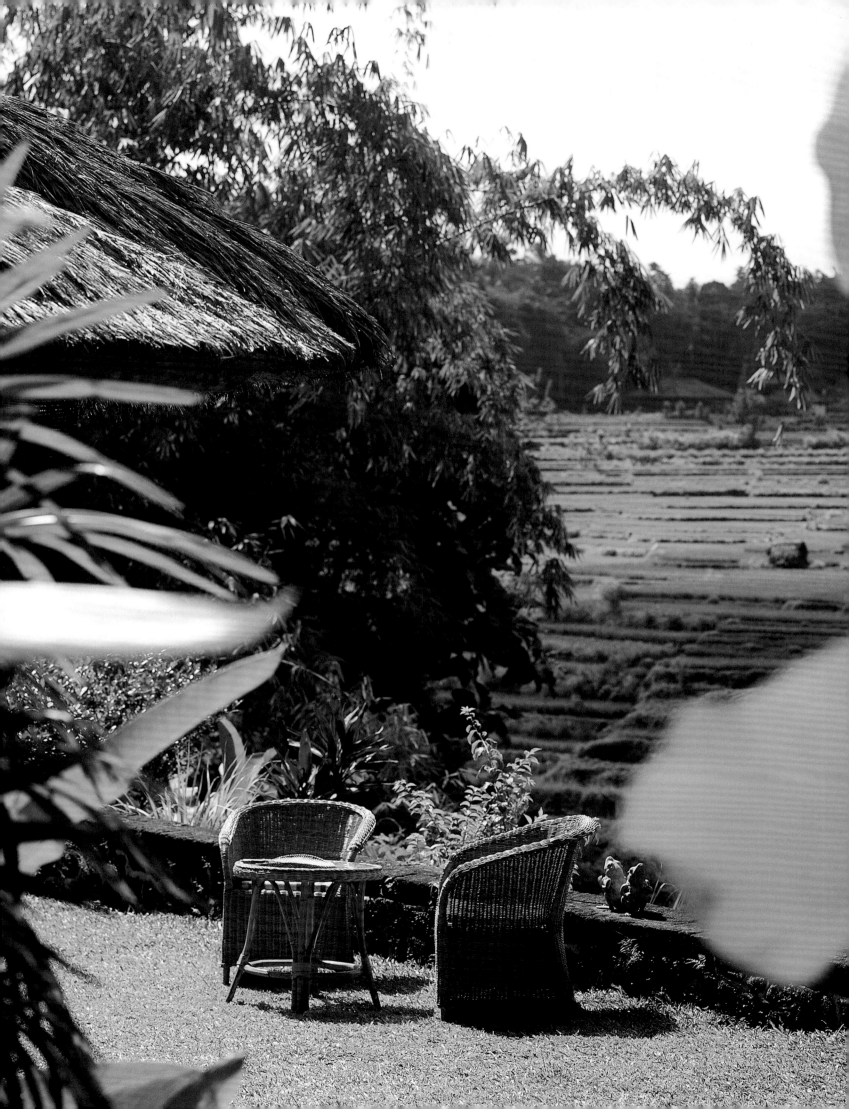

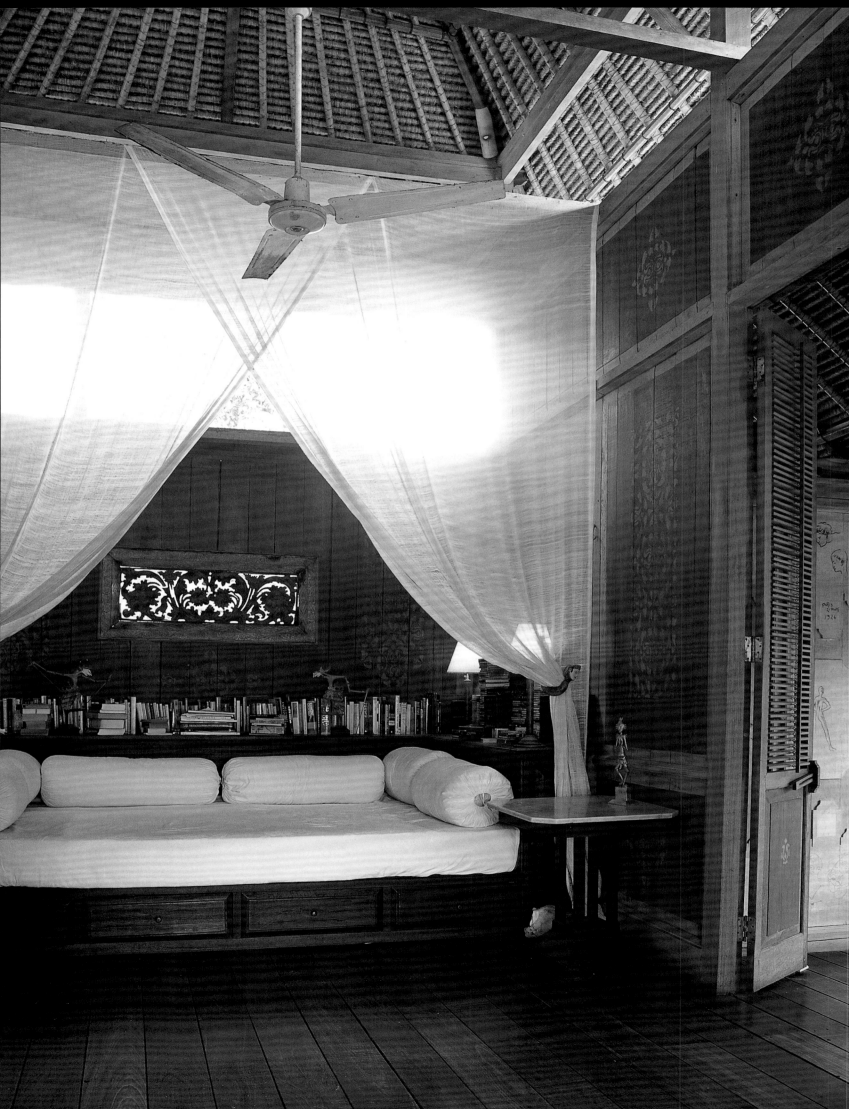

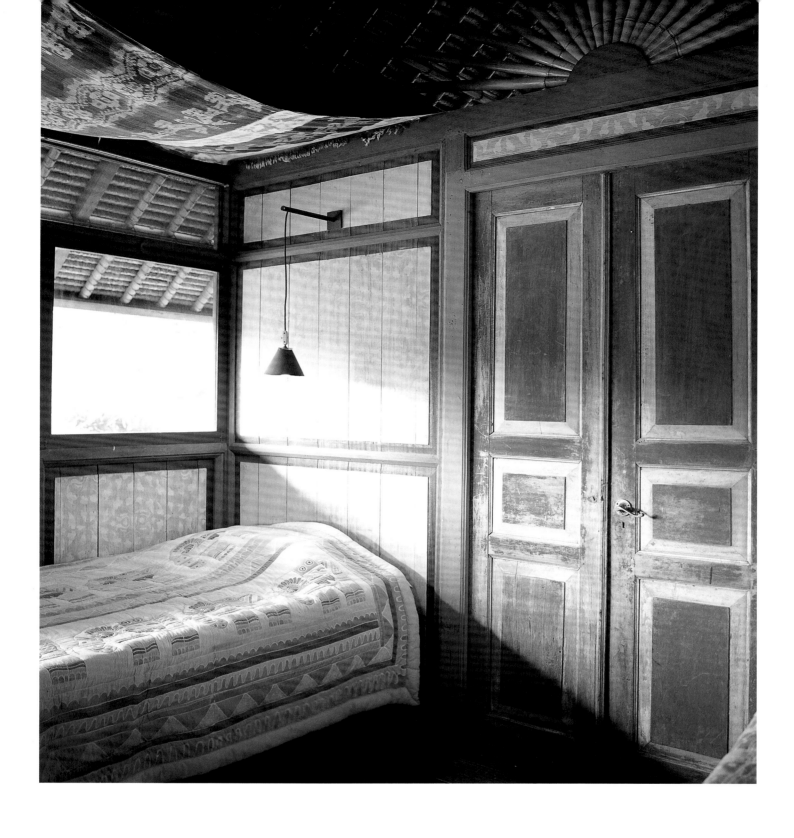

The simplicity of the house is complemented with furniture and artefacts collected from antique shops in the late 1980s. The owner's pavilion is on the site's north-west corner, nestling under a giant bamboo grove. This is where he does most of his work, reads and listens to music. The wall-to-wall bed (left) was specially designed to include a shelf that is home to an array of books and a stereo system. Simple wooden walls and tall louvred doors are adorned with stencil designs by Stephen Little. Above the door of the guest bedroom (above) is a bamboo star-burst, a design implemented by the house's original Balinese builder. Stephen Little has once again worked his magic with the attractive stencilled wooden panels behind the bed. Bright batik quilts on the two beds are matched with the strong ethnic design of fabric from Sumba hanging above.

island decorating

This Island Decorating chapter provides a visual celebration of the Indonesian furniture, furnishings, arts and crafts, that have contributed to the beautiful interiors featured in this book.

Traditional crafts have existed in Indonesia for thousands of years. Originally utilitarian or for ritual purposes, they were produced by artisans who fashioned the abundant natural materials available throughout the archipelago—from bamboo to sandstone—into both useful and celebratory items for daily life. Weavers and dyers, stone masons and wood carvers, basket makers and potters, sculptors and painters have all been recipients of traditional skills passed down through generations.

In recent years, however, the talents of these craftsmen have been harnessed to create a wide variety of items for the modern home. The fact that these items are hand made and feature natural materials means they are sought out by consumers moving away from a mass-produced, throw-away culture to a more eco-friendly, back-to-nature design aesthetic.

Warwick Purser, founder of Out Of Asia, a leading producer and exporter of locally made homewares, is a man who has done much to promote the artistic abilities of the Indonesian people. The interiors of his Yogyakarta house, Kartanegara, provide international visitors with a showcase of the Indonesian look. His vast range of products includes boxes made of leather strips, woven by traditional basket weavers and now sold internationally in Ralph Lauren shops.

Increasingly, Indonesian furniture and furnishings are finding their place within urban environments. Furniture, mainly from Java, is exported the world over, much of it reproducing the colonial-influenced designs that were popular earlier this century. These pieces do not look out of place in homes in decidedly sophisticated metropolitan settings, be it a London townhouse or a New York loft.

Interior designer Jaya Ibrahim is taking furniture design in new contemporary directions with his innovative creations. Not content to blindly reproduce the designs of the past, his pieces represent a melding of east and west, reinterpreting influences—be they Chinese or European—through an innate sensitivity to Indonesian culture. By employing handmade materials such as rattan and woven fabrics, his designs "take away the rationality of the west", he says.

Batik is often called the king of Indonesian crafts and it is not hard to see why. Intricately crafted pieces, which take months to finish, instantly add character to any home, whether used for soft furnishings or as wall hangings. Jakarta-based Bin House is another Indonesian company that has taken this craft to new heights; their fine silk pieces of contemporary and traditional designs are perfectly at home on the shoulders of fashionistas or on the walls of apartments from New York to Paris.

It seems that Indonesian craftsmanship is finally getting the recognition it deserves. In a world that is taking a new interest in the traditions and skills of the past, such items provide a contemporary design aesthetic that complements modern living.

water works

1. Teak, bamboo, stone and bronze contribute to the elegant simplicity of this bathroom in Begawan Giri Estate's Tirta Ening residence. 2. Unadulterated luxury is the theme of Uma Bona, the residence designed after a Majapahit water-palace at Begawan Giri Estate. The large circular terrazzo bath looks out to an internal water-filled courtyard and a terracotta *candi*. 3. Original tiles from the Dutch colonial period are combined with plain sand-coloured tiles at David Salman's private island 4. Local stone lines the shower at Tejasuara, Begawan Giri Estate. 5. Antique glassware and embroidered linens are a study in elegance in Jaya Ibrahim's Bogor House. 6. In the Audureau bathroom the colours of the black terrazzo sink and bathtub and grey walls come together in the attractive floor tiles, reproduced in Yogyakarta to a traditional design. 7. A circular metal frame with radiant spokes provides an interesting backdrop to the shower head at Tugu Bali. 8. A hand-beaten copper sink blends well with the simple painted cement walls in the guest bathroom of the Yusman house. 9. The laundry room at the Audureau house features colourful floor tiles and industrial size sinks.

In her book *The Bath*, Diane Von Furstenberg wrote: "Life is made up of many routine events; what makes each of us unique is the way we choose to celebrate them." This is particularly true of bathing. One has only to be at the riverside as the sun sets in Bali to realize that, for the locals, bathing is a ritual; it is not only about cleanliness and purification, but also a communal activity. That it takes place outside—in a stunning natural environment—is of course an added bonus. Some of the bathrooms featured here take the essence of the tropical river bath and adapt it to the western needs of privacy and luxury, marrying ancient ceremony and modern technology. Others have been designed to provide a private moment of peace and pleasure. All are sanctuaries that harness design possibilities using the rich array of raw materials available in Indonesia.

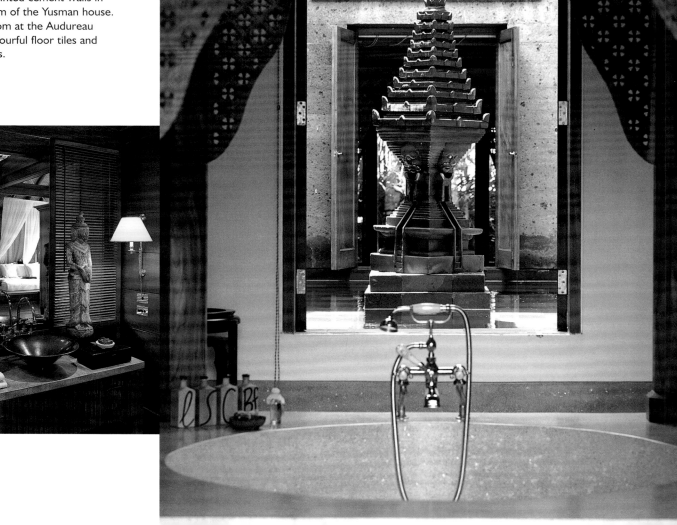

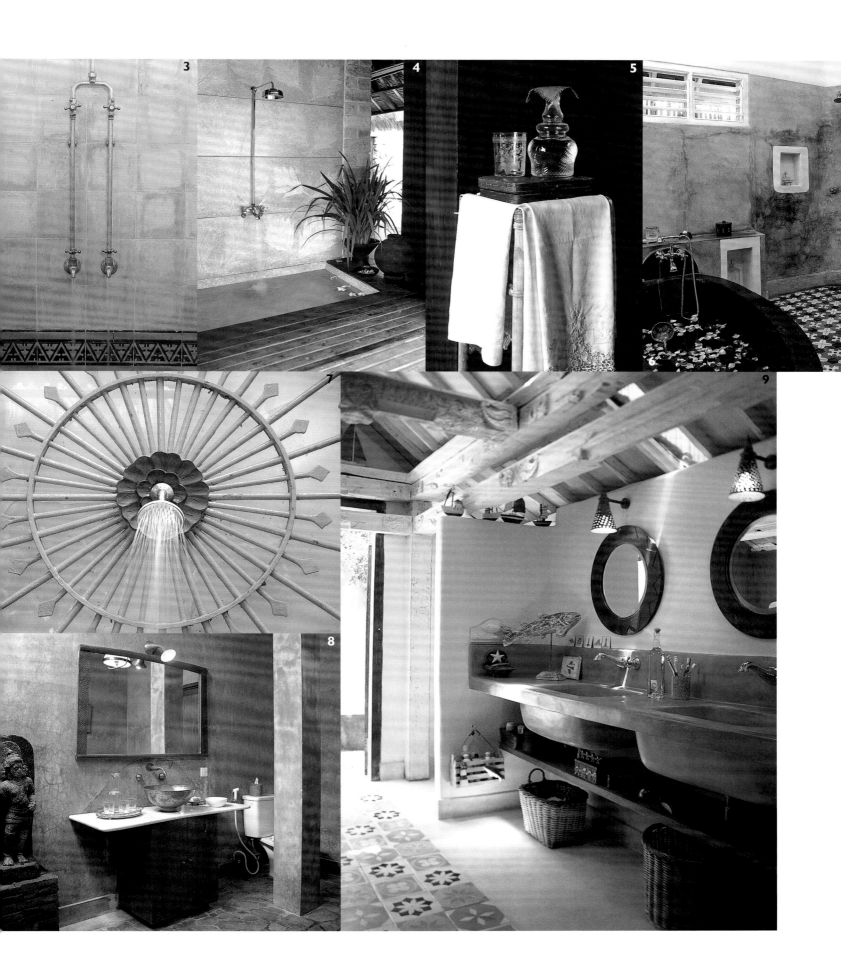

decorative finishes

1. Talented wood carvers have created an attractive panel that not only features a striking geometric design but also allows light to enter an otherwise dark room. 2. In his Jakarta home, Jaya Ibrahim employed the services of a village boy to roughly apply several layers of red paint to the walls to create the impression of raw silk. 3. Australian artist Stephen Little created this attractive stencil design in a Balinese-style house near Ubud. 4 and 5. Local artists can be called upon to add colourful, artistic touches to walls and pillars. 6. A painted door panel provides interesting detailing to Tugu Bali Hotel. 7. High ceilings are delineated by patterned mouldings and grills covering ventilation holes. 8. A beautiful carved and gilded wooden panel at Amanjiwo features a *wayang kulit* puppet motif. It was carved by a famous craftsman from Batubulan in Bali. 9. Indonesia's artists —both local and foreign—are adept at creating intriguing *trompe l'oeil* features. This fine example recreates a piece of batik fabric complete with realistic folds.

Indonesia's talented craftsmen, who learned their art to create objects that celebrate their religious beliefs, can be called upon to create decorative flourishes within a home that are strong in style and provide a natural expression of its character. Whether an intricately carved stone panel that recalls the Majapahit era or a detailed wooden screen with a traditional motif, these finishes imbue a sense of place and authenticity. As they are hand made, not manufactured in a factory, their strength lies in their individuality. Their irregularity of appearance and feel—be it in a *trompe l'oeil* effect or a painting on tin—provides a direct connection with the process of craftsmanship, serving as a reminder of the creativity of the artisans who made them. And with such a rich cultural tradition to draw on, the possibilities are endless.

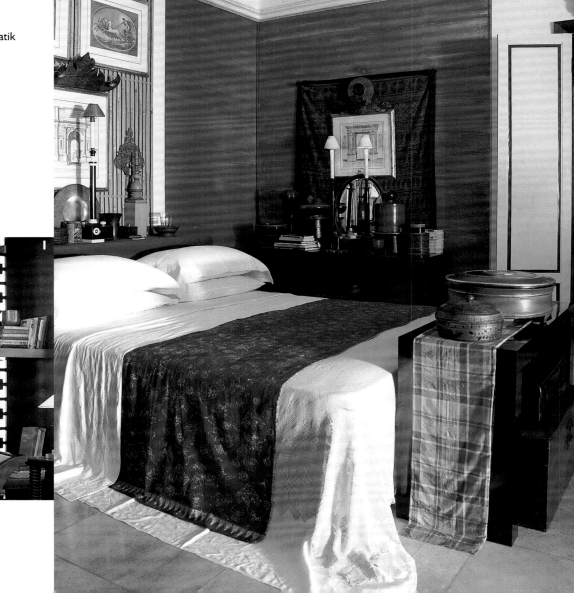

crossing the threshold

1. The attention to detail in this traditional carved wooden door exemplifies the extraordinarily intricate work of Indonesia's many skillful craftsmen. 2. At Begawan Giri Estate, the owners acquired an original Kudus house that dates back 150 years. Now home to a restaurant, the exquisite carved panels, beams and lofty doorway represent some of the finest work found on the archipelago. 3. The serrated edge of this carved concrete entrance that leads to rooms at Coralia Novotel Lombok is in keeping with the resort's relaxed and whimsical design. 4 and 7. The shadow of palm fronds falls across this simple wooden doorway in a house at Iseh, while stencilling creates a point of interest to the dining room door in the same house. 5. An ornately carved Balinese wooden door in the palace style is to be found at Begawan Giri Estate. 6. Even a door that leads through to a bathroom receives a creative touch at this house in the hills near Ubud.

There's something quite magical about arriving at a small, elaborately carved double-leaf wooden door, set within a brick exterior wall, and turning a circular brass door knob to discover what mysteries lie within. This is a common experience in Bali where such doors are used as gateways into a compound or as entry into a pavilion-style house. The variety of doorways in Indonesia is quite astonishing, and it is a common sight to see complete wooden doors and pillars for sale in antique shops. The most sought after are doors in the Kudus style with their detailed high-relief carvings and panels that are carved right through, creating screens. But with such attractive regional variations—from the inlaid Lombok style to the colourful and rough Madurese designs, all featuring the finest craftsmanship—it is easy to create an interesting feature in any home.

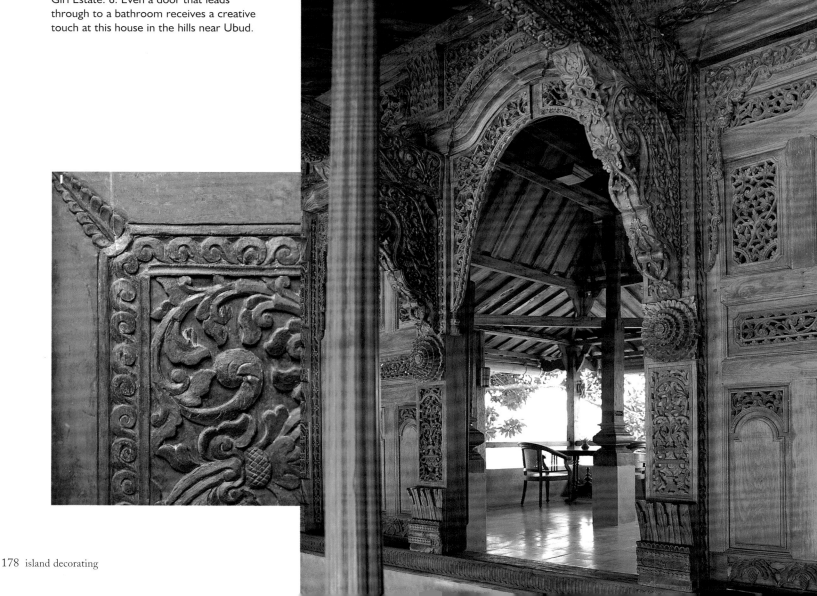

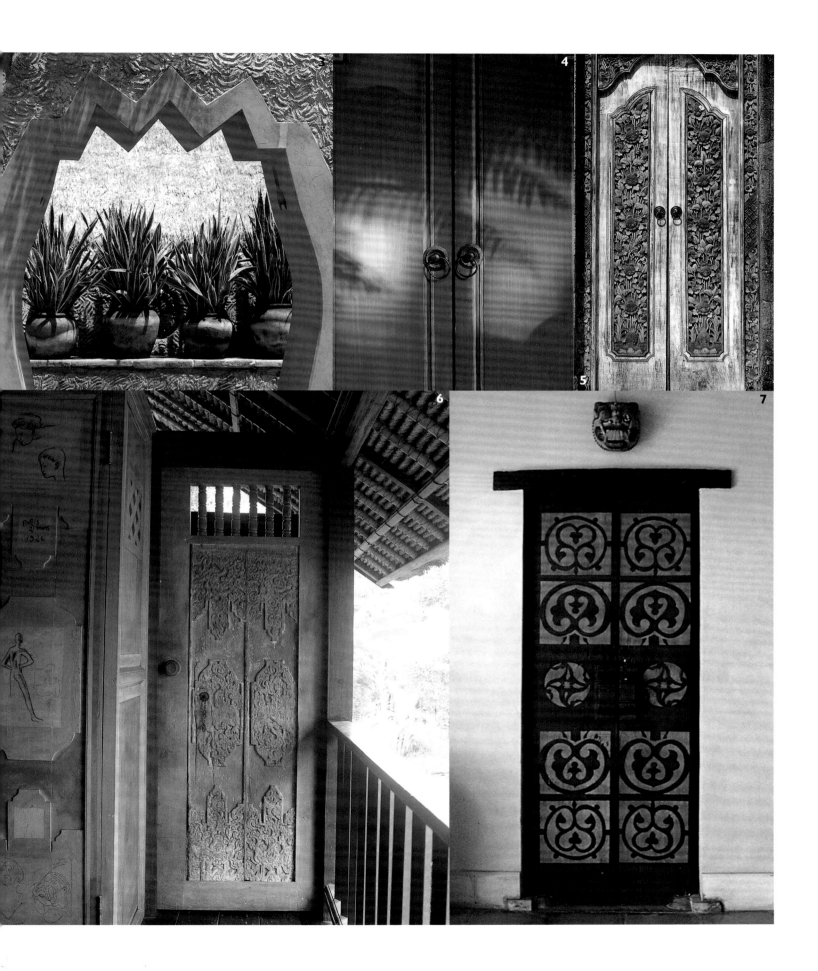

floor plans

1. Old style black and white floor tiles are used throughout Hotel Tugu Malang contributing to the colonial ambience.
2. In the Audureau house on Bali, brightly coloured ceramic tiles are used in the bathrooms, playroom and laundry. They are reproductions of early 20th-century Dutch designs that are made in Yogjakarta, the only innovation being a livelier colour palette. 3, 4, 5. These three pictures show the various batik-influenced designs that Jaya Ibrahim created for the polished cement floors of his Bogor house. 6. The saffron colour of the patterned tiles laid in Carole Muller's Tirta Ayu is mirrored in the villa's soft furnishings. 7. The ceramic floor tiles with a simple flower motif in the entrance hall of Anhar Setjadibrata's Malang family home are a 1920s design that were part of the original house. 8. Jaya Ibrahim recreated a European Regency pattern on the floors of his house in Bogor that is repeated on the back of a wooden bench he designed for the house.

In a tropical climate, where rooms are often open to the elements, floors need to be hardy cool under foot. Wooden floors made of ironwood, teak or other local hardwoods create a feeling of luxury. Simple polished concrete floors, common in Java in the 18th and 19th centuries when only Sultans could afford marble, are used to great effect in many modern homes, and they come in an exciting range of tints. Indonesian designer Jaya Ibrahim has created a new style with his batik influenced designs, adding coloured cements in shades of grey, black and beige to build up elaborate patterns. The Dutch influence is apparent in the tiled floors of houses built during the colonial period. As these houses are redeveloped, the tiles are sometimes preserved for re-use in new homes, as in the island home of David Salman. Workshops in Yogjakarta now produce modern versions of these old Dutch designs, using bright colours and modern techniques to create a feeling of the past.

2

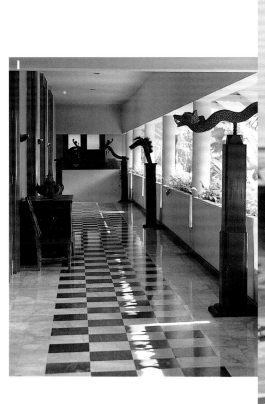

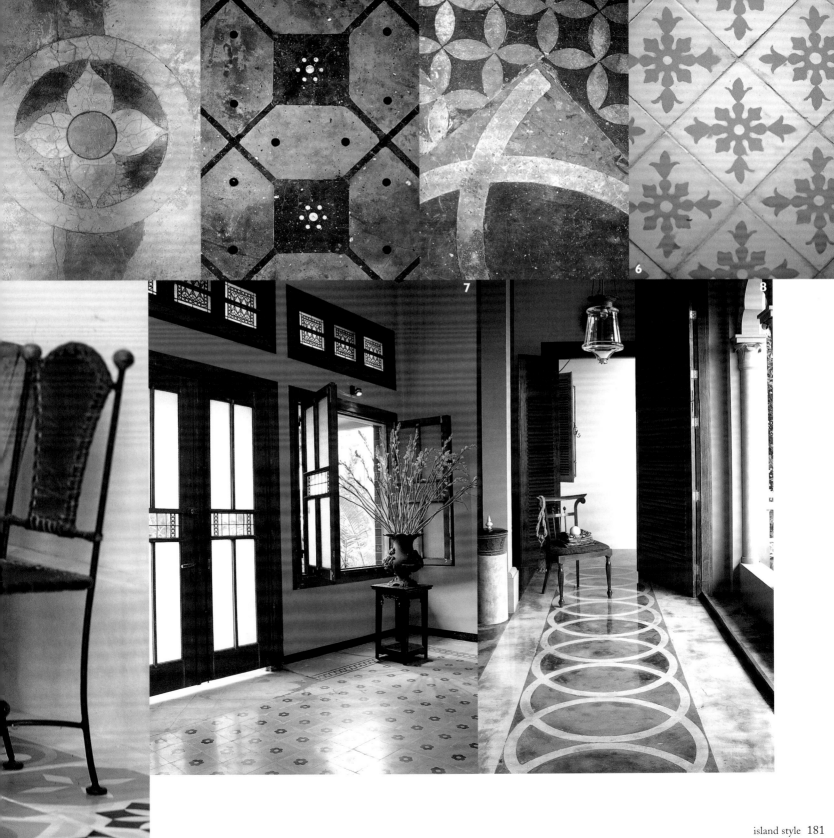

heaven scent

1. At Amanjiwo, stems of delicate spider orchids (arachnis)—the resort's signature flower—are arranged within a twisted black oxidized copper vase. 2. A colourful selection of flower petals float on the water contained within a large terracotta pot. A hollowed-out coconut shell allows water to be scooped up and poured over the body for a fragrant Indonesian-style shower called a *mandi*. 3. Deep purple blooms surround a holder for incense at Amanjiwo. 4. Bright yellow allamanda blossoms are arranged in a colourful display at the Losari coffee plantation. 5. Also at Amanjiwo, a stunning and richly perfumed garland woven from jasmine and champak blooms is placed upon the guests' beds at turn down. 6 and 8. Beautiful fragrant frangipani flowers are used in offerings throughout the archipelago. 7. Scented tuberoses are placed within a simple wooden vase at Warwick Purser's home. 9. The same blooms are placed within a simple Lombok basket at Coralia Novotel Lombok, their scent wafting on the fresh sea air.

One has only to visit a local Indonesian flower market to be overwhelmed by the colour, variety and number of the blooms available. They are used by local people as an integral part of religious and social ritual, particularly in Bali where flowers such as magenta globe amaranth, hibiscus and frangipani find their way into offerings to the gods. In the tropical island home, this abundance of year-round flowers allows an extravagance in the creation of floral arrays that can only be dreamed of in the west. Armfuls of heavenly scented tuberoses placed within a large terracotta pot, for example, provide a room with a delicate perfume as well as a dramatic display. Orchids, in their seemingly infinite variety, create colourful, delicate arrangements while the waxy, brilliant hued helconia provides an instant touch of the exotic.

light shows

1. The brass base of a lamp in Uma Bona at Begawan Giri Estate takes its design inspiration from the Majapahit era. 2. The base of a tall lamp in the Sumba-influenced Tejasuara residence at Begawan Giri Estate is a basket that the local people use to carry piglets to market. 3 and 5. These fine examples of antique glass lamps can be found throughout Indonesia. 4. Large lamps suspended from the wooden roof beams in the restaurant at Puri Ganesha are the owner's homage to Venetian Fortuny lamps. They are made locally from *prada*, the gold dancer's fabric, although here it has faded to a pale yellow from the sea air. 6. A bronze figurine provides an unusual lamp base in Warwick Purser's Yogjakarta town house. 7. In Begawan Giri Estate's Bayu Gita residence, a closely woven basket from Borneo has been turned into a lamp. 8. Yusmann designed all the light fittings in his house, many of which are sold in the Bin House homeware range. 9. Following an English-influenced style of interior design, a pair of brass lamps is set on either side of the wooden Biedermeier-style sofa in Jaya Ibrahim's Jakarta home.

Architect Le Corbusier once described a house as a "receptacle for light and sun". And even though lighting can be a very powerful force in interior design, it is often neglected—or worse, left to the last minute. Good lighting can make the difference between a room that is dull and spiritless and one that is bursting with life. In Indonesia, designers are increasingly taking the opportunity to get creative with lighting—by making use of antique glass lamps, wrapping candles in a piece of banana leaf, placing giant bamboo flaming torches in gardens, finding artisans to make individually designed lamps or by transforming locally crafted baskets and pots into attractive lamp-bases.

garden accents

1. Large pots such as this fine example are plentiful in Indonesia and add interest to a garden or courtyard. 2. Scalloped-edged terracotta pots, a design feature in the courtyard of the Jaya Ibrahim Bogor house, represent courtiers of a Javanese *kraton*. At night, candles are placed within them to create atmosphere. The Majapahit-era pot within the central fountain dates back to the 14th century. 3. This 1.3-metre (4-ft) tall wooden statue within the garden of Warwick Purser's Tembi village house is an antique lamp-holder that was originally used for the *wayang kulit* shadow puppet plays. 4 and 7. These beautiful stone carvings of Borobudur retell the story of Buddha's life. Copies of these bas-reliefs, made of a local sandstone, are produced by masons in Yogjakarta and make attractive wall panels. 5 and 6. A carved wooden figure and a gargoyle-like statue, covered in moss, provide good examples of attractive garden features. 8. The villas of Tugu Bali, connected by a maze of narrow, meandering pathways, are decorated with stone carvings made by local craftsmen. 9. A large batik dye pot is placed within the local stone clad garden of the Bayu Gita residence at Begawan Giri Estate near Ubud.

The success of landscape design in the tropics depends not only on an artful blend of exotic plants and trees but also on how design features are placed within a garden to enhance its natural beauty. Attractive garden art is plentiful in Indonesia, a country blessed with an army of talented stone masons able to reproduce even the most elaborate carvings—from copies of Borobudur bas-reliefs to images of Hindu Gods—and skillful potters who produce beautiful earthenware and terracotta pots and statues. Hand-crafted fountains and water features can also make a statement with their soothing sound. Urns, statues or stone tablets quickly become lichen clad in the tropical climate and gain a rich patina; this gives the impression they are centuries old, and adds to their appeal.

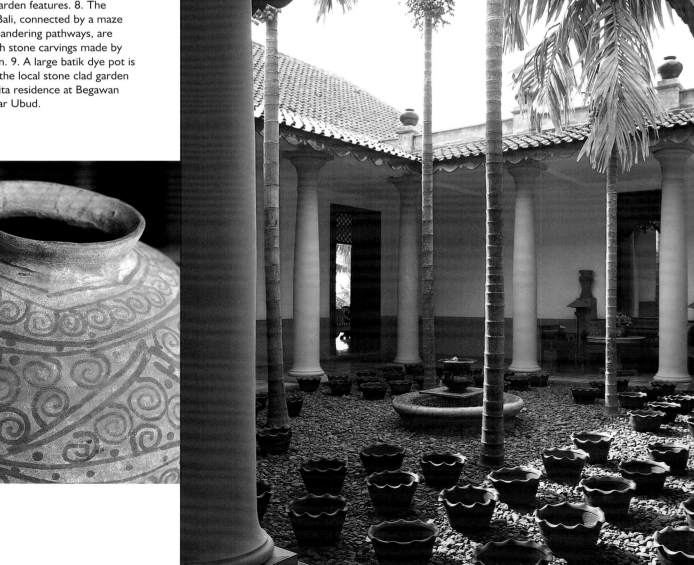

homespun charms

1. A fine piece of hand-embroidered fabric with tassels and flower motifs in the guest bedroom of the Nicholas Morley house. 2, 3 and 5. The textiles from Bin House, one of Indonesia's leading producers of fine batiks that are sold worldwide, feature many traditional patterns that were in danger of disappearing forever; they are printed on finely woven silks and cottons. 4. The motif of this piece of batik cloth in the Richli house bathroom, suspended from a simple wooden pole, is the fabled Chinese-influenced Mega Mendung (stormy clouds) and it comes from Cirebon on the north coast of Java. 6 and 8. Jaya Ibrahim, an avid collector of fine Indonesian textiles, uses them extensively throughout his Bogor house. The first example is an attractive wall hanging while in the second, he has placed a narrow piece woven with gold thread across his fine English linen bedsheets. 7. Fine batiks make attractive wall hangings, providing a flash of colour to the earthy tones of this room's furnishings.

Indonesia's scattered islands produce some of the world's most varied and beautiful traditional textiles used to great effect in today's homes. The sophisticated warp and weft ikat fabrics coloured with natural dyes from the Lesser Sundas are woven on a backstrap loom and are therefore quite narrow—they're the perfect size to create a band of colour across white linen bed sheets or a table runner. The dazzling *songket* textiles of Sumatra, interwoven with gold thread, make stunning wall hangings framed or suspended from a carved wooden pole. The solid colours of the hand-woven ikat of East Bali are perfect for furnishings. And then there's batik, Indonesia's most well-known textile craft, which is produced primarily in the Javanese cities of Yogjakarta, Cirebon, Solo and Pekalongan. Batik can be applied in myriad ways—from tablecloths to bed-covers to cushions—bringing a touch of Indonesian style to any home.

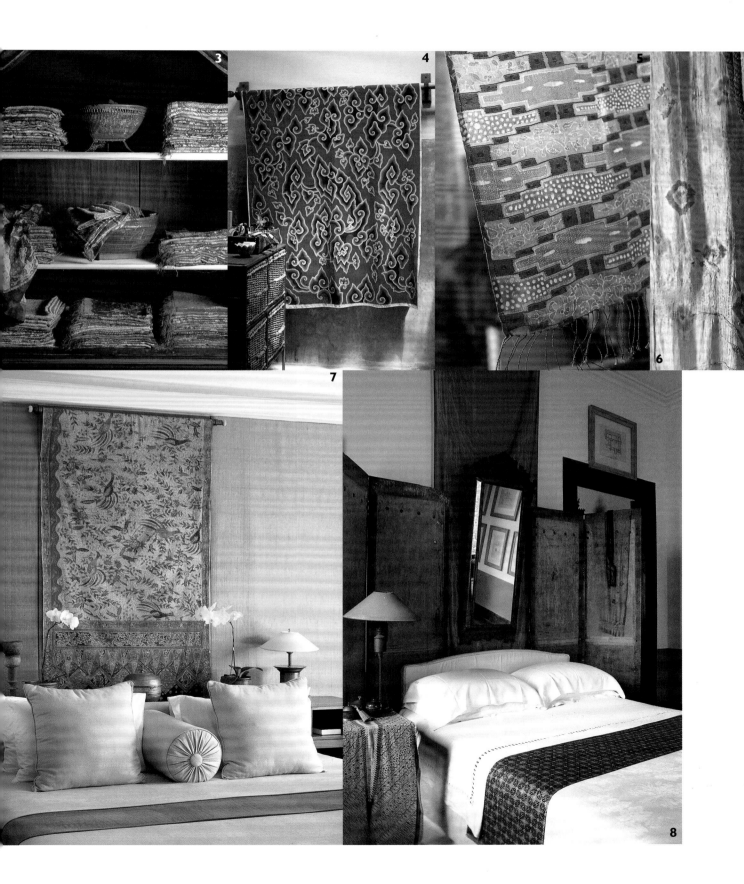

figure heads

1. In the Jean-Francois Fichot house in Ubud, Bali, an unusual wooden figure is put to an unusual use—to store his collection of bracelets. 2. In Amanjiwo, *loro blonyo* figures in the resort's library sit behind a wall panel made from a woven water hyacinth set within a *sungkai* wooden frame. On the wall hangs 300-year-old Ming plates. 3. At the Tugu Bali wooden Madurese house panels form the entrance to the hotel's spa which provides an array of traditional massage and herbal beauty treatments. At the side of the pool this unique statue provides a point of interest. 4 and 5. These *loro blonyo* provide just two examples of the vast array of styles and sizes available. No Javanese home is complete without them. 6. Two beautifully carved, expressive figures exude sinuosity and style; from a private collection. 7. A 1.3-m (4-ft) tall wooden statue that was traditionally used in shadow puppet plays makes an attractive candle holder in Warwick Purser's Tembi village house.

Indonesia's tradition of wood carving goes back centuries to the time when craftsmen would carve sacred statues, ritual objects, even musical instruments to celebrate their religious beliefs. Today, the archipelago produces a wide array of wooden accessories—from the much sought-after primitive carvings of the archipelago's remote island cultures to beautifully crafted dance masks from the Balinese village of Mas. One of the most popular accessories from the island of Java is the inseparable pair of statues called *loro blonyo* that represent the rice-goddess Dewi Sri and her male consort Raden Sodono. Other popular items include puppets from the *wayang kulit* shadow theatre, strung up against a coloured backdrop or decorating a tabletop.

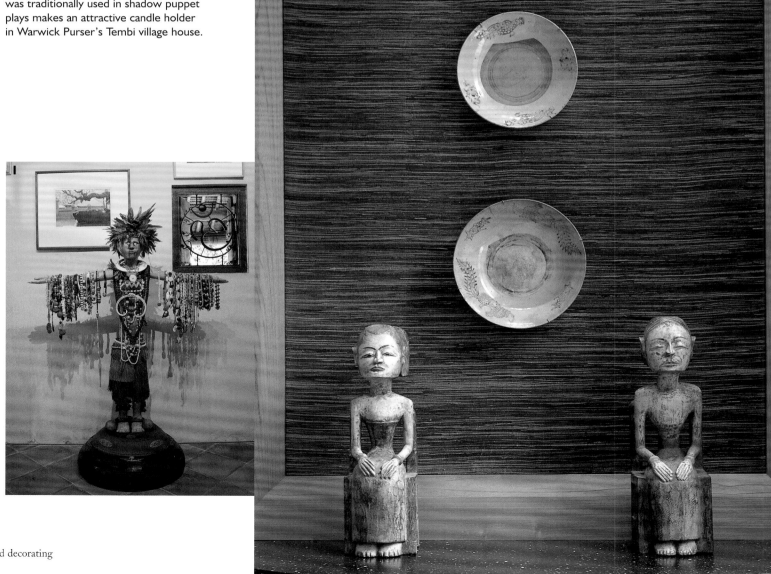

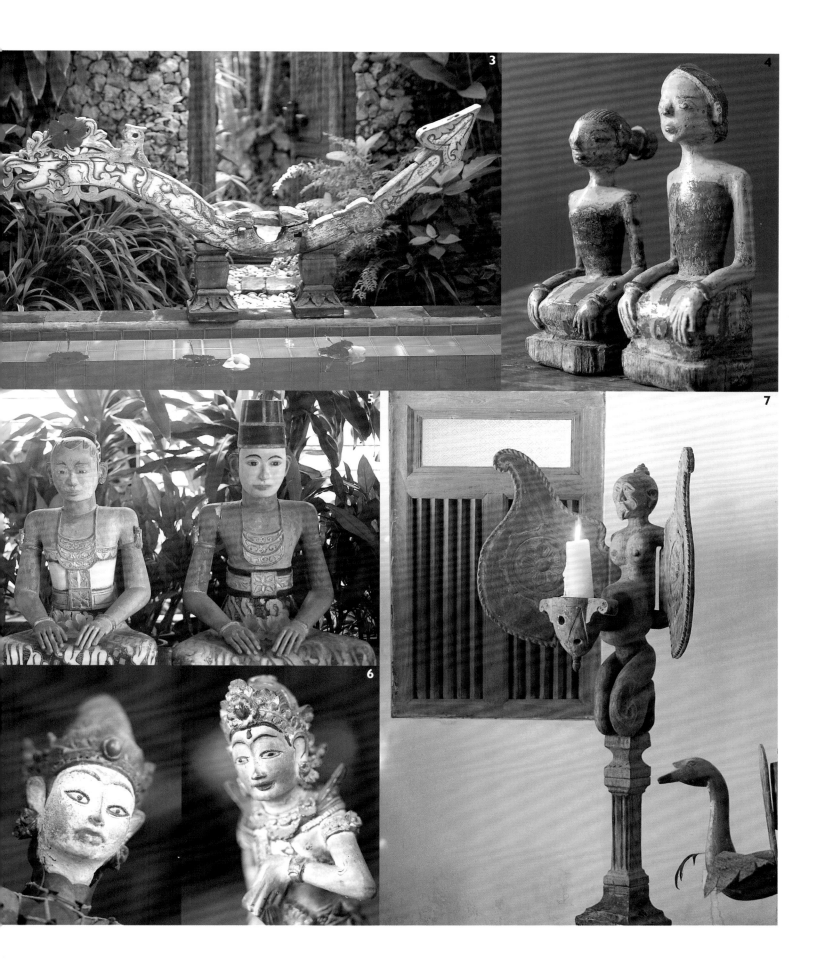

acknowledgements

The author, photographer and publisher would like to thank the following
for their hospitality and help during the production of this book:
Francois and Olivia Richli from Amanjiwo; Bradley and Debbie Gardner,
Cheong Yew Kuan and Peter Wynne of Begawan Giri Estate; Daniel
Meury at Chedi Bandung; Fabrice Garrigues of the Coralia Novotel
Lombok; Gabriella Teggia of Losari; Diana Von Cranach and Gusti
of Puri Ganesha; Anhar Setjadibrata and Wedya Julianti of Tugu Hotels.

Our deepest thanks, also, to those who opened their homes to us
and our cameras: Annelies and Jean-Jacques Audureau; Jean-Francois
Fichot; Hendra Hadiprana; Jaya Ibrahim; Hugo Jereissati; Nicholas and
Claire Morley; Carole Muller; James Murdoch; Dimitri Pantazaras;
Warwick Purser; David Salman and Jed Frost; Yusman Siswandi.

Special thanks to: Nengah and Nova Arnawa; Bill Bensley; Nick
Blackbeard; Luc and Barbra Darras; Julian Davison; Luis and Soraya
Fernandez; David Fox; John Flood; Pak Gede; Guy and Tracy Heywood;
Kerry Hill; Ivanka Jeffrey; David And Anna King; Kevin McGrath; Rory
McTiernan; William Milberger; Nils Normann; Magdalene Ong; Frank
Pinckers; John Saunders; Wendy Thomas and Yos Deni-Mus Malelaky;
Made Wijaya; and everyone at Bin House, Jalan Teluk Betung 10, Jakarta.

To Nigel Simmonds, for his zest for life and sense of adventure.
To Kim Inglis, whose patience, commitment and organization skills
are unmatched.
And to Pia Marie Molbech, who keeps the sun shining, even after dark.